ART DECO

Publisher and Creative Director: Nick Wells
Development: Sarah Goulding
Picture Research: Melinda Révész
Project Editor: Polly Willis
Editor: Julia Rolf
Designer: Lucy Robins

Special thanks to: Chris Herbert, Helen Tovey, Claire Walker

FLAME TREE PUBLISHING

Crabtree Hall, Crabtree Lane
Fulham, London, SW6 6TY
United Kingdom

www.flametreepublishing.com

First published 2005

06 08 07 05

3 5 7 9 10 8 6 4 2

Flame Tree is part of the Foundry Creative Media Company Limited

ISBN 1 84451 259 2

Printed in China

ART DECO

Text: Camilla de la Bedoyere Foreword: Alan Powers

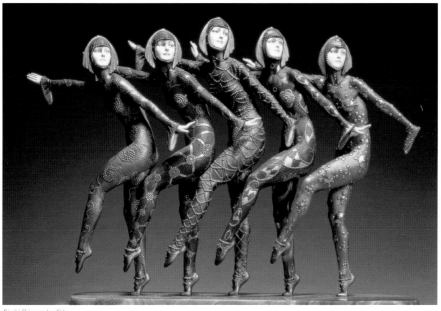

Dimitri Chiparus, Les Girls

FLAME TREE
PUBLISHING

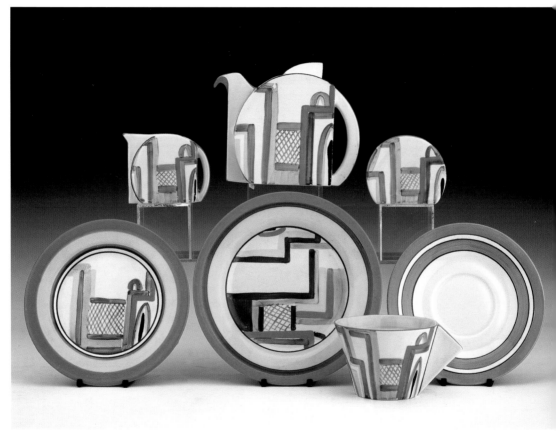

Clarice Cliff, *Tennis* pattern (tea for one and plate)

Contents

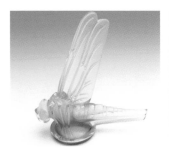 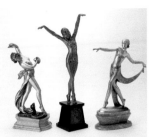

Edgar Brandt, silvered bronze clock; Edouard Bénédictus, Book Plate 3, from *Relais*, Quinze Planches Donnant Quarante–Deux Motifs Décoratifs; Maurice Dufrène, commode with *verdi antica* marble top

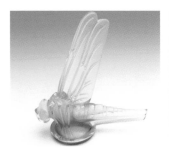 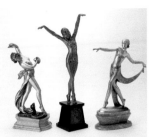

René Lalique, Grande Libellule car mascot; Chiparus, Lorenzl & Rossi, Egyptian figures; Jean Dunand, Panneau de Laque d'Or Gravé

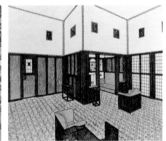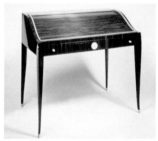

Eileen Gray, bedroom from E1027; Raymond Hood, Rockefeller Center: allegorical figure; Daniel H. Burnham Jr, et al, the Chrysler Building at the Chicago World's Fair

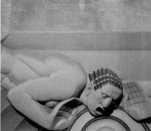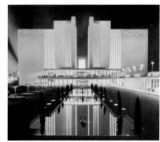

Edgar Brandt, 'Les Cigognes d'Alsace'; Josef Hoffman, Hall (design) from C.H. Baer, Farbige Raumkunst; Jacques-Emile Ruhlmann, roll-top desk

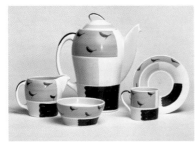

Susie Cooper, *Kestrel* coffee set; Norman Bel Geddes, Patriot Midget Radio;
Play Boy furnishing fabric

How To Use This Book

The reader is encouraged to use this book in a variety of ways, each of which caters for a range of interests, knowledge and uses.

- The book is organized into five sections: **Movement**, **Society**, **Places**, **Influences** and **Techniques**. The text in all these sections provides the reader with a brief background to the work, and gives greater insight into how and why it was created.
- **Movement** broadly covers the development of Art Deco, providing an snapshot of how the movement progressed and the artists and mediums involved.
- **Society** shows how the wider world in which the artists of the period lived had a bearing on their work, and explores their different interpretations of it.
- **Places** looks at the different geographical locations in which Art Deco became prominent, and what effect this had on the artists of the time.
- **Influences** reveals who and what provided the greatest influences for Art Deco artists, and how they in turn were a source of inspiration and ideas for one another.
- **Techniques** delves into the different techniques used in the Art Deco movement. Always experimental, artists often had to come up with new ways in which to express themselves, using many different techniques and mediums.

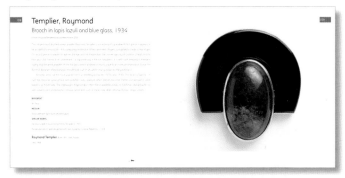

2. Name of artist, by surname then forename

1. Title of work

3. Date of work (if known)

4. Information about the work and the context in which it was created

11. Picture credit

330 Lalique, René

Nanking Vase, 1925

Courtesy of Private Collection/www.bridgeman.co.uk © R/HP, Paris and DACS, London 2005.

René Lalique trained as a jeweller, and he carved out a very successful career in this field while also experimenting with glass as a medium for jewellery. Most of his glass jewellery was created using the *pâte-de-verre* process, in which powdered glass is put into a mould and heated until it fuses, giving a milky hue to the finished product.

In 1907 well-known perfumer François Coty (1874–1934) commissioned Lalique to design the fabricated stoppers for his perfume bottles. Finally, he awarded the skilled craftsman the commission for the bottles themselves, and Lalique's legendary relationship with glassware was soon put to the test by the mass market.

In 1910 Lalique bought the glassworks at Combs-la-Ville in France, which were famous for the supply of sand nearby. It was especially suitable for glass-making because it had a high silicon content. The perfume bottles were hugely popular and, thanks to his mass-production techniques, Lalique's business venture was commercially successful. Up until the First World War, Lalique's designs followed the Art Nouveau aesthetic. After the war, however, Art Deco designs were in vogue, and Lalique demonstrated his versatility by responding to the market and producing geometric and abstract designs, such as the one seen here.

MOVEMENT
Art Deco

MEDIUM
Mass-produced art glass

SIMILAR WORKS
Au Coeur des Calices scent bottle for Coty by Lalique, pre-1914

René Lalique Born 1860 Ay, France
Died 1945

10. Name of the movement to which the painting and artist belongs

9. Medium in which the work was created (if relevant)

5. Date of artist's birth and place of birth (if known)

8. Similar works, either by the featured artist or another artist of the period

7. Name of artist by forename, then surname

6. Date of artist's death

Foreword

In the summer of 2003, the Victoria & Albert Museum in London held a major exhibition of Art Deco works. This event, one of the most popular decorative arts shows of its kind, was a sign that Art Deco had at last been accepted as an authentic style of the twentieth century, rather than being viewed suspiciously as an invention of the 1960s that was too diverse to allow meaningful definition.

Even so, the organisers of the V&A exhibition found the task of defining Art Deco almost impossible. You don't have to be an expert to recognise the characteristic forms, or to pick up the flavour of glamour and luxury that has given the style such a wide following among the grandchildren and great-grandchildren of the men and women who were young in the period between the two world wars. Although we may all be able to spot aspects of Art Deco, the edges of the style, where it changes into something else, are harder to pin down. To one side are the historical styles, which remained popular in furniture and interiors. To the other side is the Modern movement of the Bauhaus and Le Corbusier, which repudiated the superficiality of applied decoration in its search for a deeper underlying reality. Some designers, such as Eileen Gray, moved from Art Deco into Modernism, but even in her work that moment of transition, considered by some historians to be of the utmost importance, is not at all clear.

The term 'Art Deco' only became current in the 1960s, achieving its main notoriety in a short book of that name by Bevis Hillier in 1968. Before then, recognition of the style depended on a number of labels, most of which mixed the word 'modern' with other qualifying terms, producing pejoratives like 'jazz modern' which indicate the distaste that surrounded Art Deco during its heyday, at least in the rather conservative culture of Britain.

In this book, Camilla de la Bedoyere has taken a broad view by including paintings and interiors going back as far as 1900. In some respects, the roots of Art Deco can be found even further back, in the Victorian attempt to make a synthesis of all the decorative styles of the past in order to escape from the imitation of particular styles. Often this involved flattening patterns into pure geometry and straight lines. To these elements, the inter-war period applied the social trends of the time: technology, speed, the liberation of women and dance crazes.

Even in a changing twenty-first century world, these things are still exciting. We travel faster, although our technology seldom dresses itself so romantically as it did in the 1930s. Women have certainly become more liberated, although disciplined social dancing has long vanished from our lives, but we still feel the need for some glamour.

The desire to preserve Art Deco buildings has grown since Oliver Bernard's mirror and chrome entrance to the Strand Palace Hotel in London was rescued in fragments from the demolition gang in 1969. In Miami Beach in 1976, Barbara Capitman and Leonard Horowitz founded the Miami Design Preservation League, and started the regeneration of the two mile strip of hotels along the Atlantic seaboard. An international network of Art Deco societies grew up around Barbara's magnetic personality, convening every two years for the World Congress on Art Deco.

These societies represent some of the cities around the world that have large numbers of Art Deco buildings, including major cities such as Cape Town and Sydney, and others, such as Napier, New Zealand, where a small town was completely rebuilt in the style following an earthquake.

In Britain, the Twentieth Century Society (originally the Thirties Society) has worked since 1979 to protect buildings in all styles after 1914, Art Deco being prominent among them. There was a major victory in 2004 when the Regent Palace Hotel, containing Oliver Bernard's best surviving interiors, was listed when under threat of total demolition.

Art Deco is attractive to people (and suspect to moralists and puritans) because it is about pleasure. One of the star attractions of the V&A exhibition was a film of Josephine Baker doing her famous dance in a feather skirt and little else in Paris in the 1920s, suggesting, as one reviewer wrote, that "the right style can make good times better, whether on an ocean liner or in a glitzy nightclub". If that is the place where you would like to be, then Art Deco is your style, and you will find much here to enjoy.

Alan Powers, *2005*

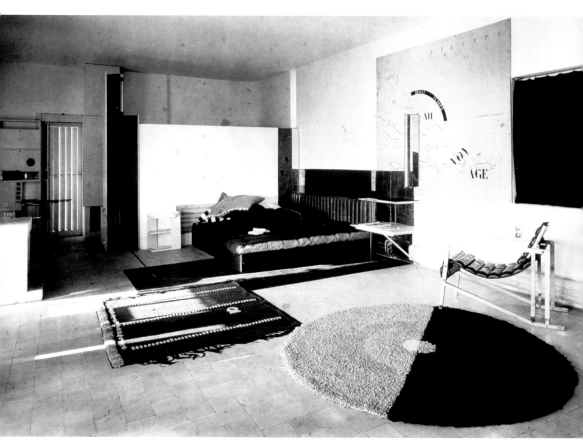

Eileen Gray, interior of E1027, © Estate of Eileen Gray/RIBA Library Photographs Collection

Introduction

The Art Deco style, or Style Moderne, is a glorious amalgam of art and crafts that originated in the early years of the twentieth century and lasted until the Second World War. It reached its apotheosis during the 1920s and 1930s, when the Art Deco style doctrine achieved something unique: it succeeded in finally removing the distinction between art and craft and brought a design aesthetic to an entire society. Although the term 'Art Deco' evokes an era of luxury, opulence and excess, the greatest achievement of this modern style was to usher in a new age of holistic design. The movement influenced fashion designers, architects, textile designers, sculptors, jewellers, cabinet-makers and many other artists and artisans. For the first time, the broad brush of a design ethic was swept across everyday objects for ordinary people, as well as the luxury *objets* enjoyed by the wealthy elite.

The movement grew, of course, from what came before. Art Nouveau was an organic style that flourished in Europe and the United States between 1890 and 1910. Using flowing, undulating motifs from nature, proponents of Art Nouveau and the Arts and Crafts movement, such as William Morris (1834–96), sought to create a unifying force in the applied arts. Art Deco absorbed this aesthetic unity of design but employed different techniques and styles to achieve its aim: decorative effects were well-defined, not willowy; sleek, not sinuous. Like Art Nouveau, however, the new vogue embraced contemporary influences. Numerous sources have been cited for the Art Deco style, but in reality it would be almost impossible to define a single style that encompasses the era and the reason for this, to some extent, finds its roots in that variety of influences.

Tribal art was a dominant influence at the beginning of the twentieth century, and this is inextricably linked with colonialism and the relatively new fields of archaeology, anthropology and ethnography. Exhibitions of tribal art were commonplace in Europe and doubtless influenced the artists who visited them. Archaeological discoveries in Egypt, particularly that of Tutankhamen's tomb in 1922, opened a rich seam of inspiration for designers. The Ballet Russes, founded by Sergei Diaghilev (1872–1929), provided an important source of inspiration from Eastern Europe, with its opulent fabrics, exotic stage sets and innovative dance and music. The effects of these inspirational events were broad; sculpture, fashion, textiles, glassware, jewellery and interior design all bore these themes and a new, adaptive and innovative approach developed.

As Art Deco emerged from its roots, it began to reject historical influences and instead embraced the modern. The Bauhaus school in Germany played an important part in this development. Founded in 1919 by architect Walter Gropius (1883–1969), Bauhaus rejected the Arts and Crafts ideal of achieving good design for the masses through the individual hand-crafting of luxury items. Instead, Gropius believed that good design could only become accessible to all when it was cheap – and that required mass production. Manufacturing, by its nature, respects the materials that are employed in the various industrial processes and it was this understanding of materials, old and new, that helped create a modern aesthetic: functionality. The Swiss architect Le Corbusier (1887–1965) famously said "A house is a machine for living in", and his functional approach towards design – and the use of reinforced concrete – was to play a decisive role in the development of modern architecture from the 1920s until today. It was the fusion of the decorative arts with the functionality and modernism of the emergent 'Machine Age' that came to define the style of the Art Deco era.

The Art Deco period is often described as belonging to the inter-war years, but this definition is too restricted, as objects in the Art Deco style were also created prior to the First World War. However, this cataclysmic event naturally hindered the development of the movement. At the beginning of the twentieth century Paris was the epicentre of design, and a grand exhibition had been planned to celebrate the city's success in the field of applied art. The war necessitated a delay and the Exhibition opened, eventually, in 1925. Grandly named the *Exposition Internationale des Arts Décoratifs et Industriels Modernes*, the event showcased many designers. By this time the luxury goods market, for which the French won much acclaim and commercial success, was suffering in the face of competition from other countries. Germany, for example, was producing decorative work that was cheaper, innovative and more accessible to the middle classes.

The organisers of the Paris Exhibition sought to encourage their local designers to rise to the challenge and an emphasis was placed on modern, rather than traditional influences. As a result, the Exhibition not only reflected contemporary society, it influenced it. The Roaring Twenties are now regarded as a time when the exotic, erotic and esoteric were celebrated. The ambience in wealthy society was one of elegance, cynicism and iconoclasm. A new sexual freedom prevailed and there was a vibrant liberty in speech and behaviour. This was, after all, the era of Josephine Baker, F. Scott Fitzgerald, Cole Porter and "Anything Goes".

The Paris Exhibition was a defining moment in the development of the Art Deco aesthetic. Commercialism was as much as a driving force as artistic inspiration and, as a result of this and a wide variety of contemporary artistic influences, a huge range of styles emerged. Some of the stylized motifs that are now regarded as iconic of the era were emerging at

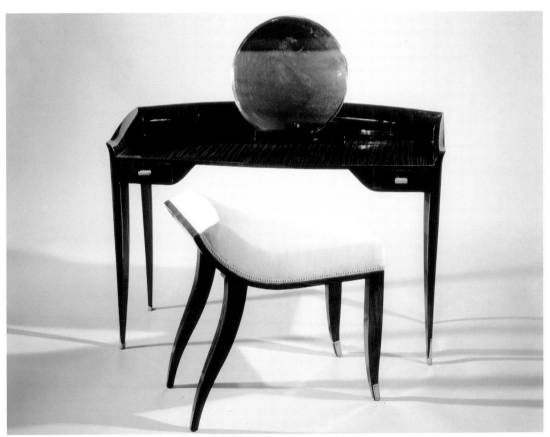

Jacques-Emile Ruhlmann, dressing table & stool. © The Art Archive/Private Collection/Dagli Orti

this time: sun rays; slender and unnaturally elongated animals, such as deer and greyhounds; nude female figures; and the repeated geometrical patterns, so commonly associated with Art Deco, became increasingly popular after 1925.

Despite the highly disparate nature of the exhibits, however, visitors recognized that there lay, behind the glamorous showcase, a powerful movement that propelled design out of drawing rooms and into all areas of modern life. Art Deco became international and was the first truly global fashion: Australia, India, Japan, Latin America and South Africa all benefited from the glorious Art Deco vogue, particularly in architecture. It was in the United States, however, that Art Deco really took off. During the 1920s, the American ideal exploded onto the world stage as a *tour de force*: richer than ever before; the nation was young, brave and ready for change. Even when the Great Depression descended in 1929, industry and building projects ticked over, waiting for the recovery which saw the democratization of Art Deco. Financial necessity meant that quality hand-made goods, made from opulent materials for the wealthy few, gave way to the factory production of well-designed goods in cheap materials for everyone.

The Paris Exhibition had offered an opportunity for Parisian designers to show their art, which is now often referred to as 'high' Art Deco: the finest craftsmanship was married with quality materials to create exquisite, luxury

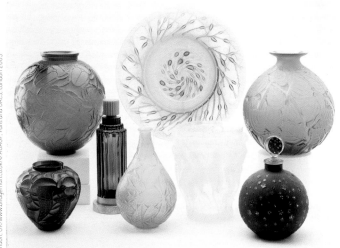

items. As soon as the Exhibition was over, however, Modernists pushed the Art Deco aesthetic to a new level. They argued that good design could be applied to mass-production and thereby become accessible to all. It was believed that through industrial processes the intrinsic beauty found within form and structure could flourish, without extraneous decoration. The development of new materials such as plastics and improved manufacturing processes facilitated the development of this trend into the 1930s and 1940s.

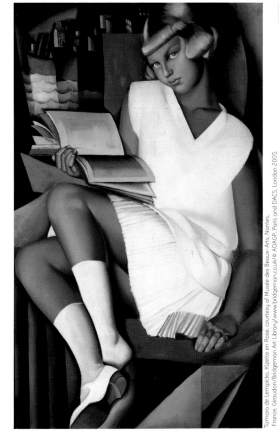

Thus the Art Deco period curiously combines distinct but related themes: in the early years it was exemplified by sumptuous, expensive and hand-crafted objects and interiors, but by the Second World War mass-produced ceramics and Bakelite radios were found in homes across Europe and the United States. It was in the US that the modern approach to architecture became most widely embraced. Skyscrapers became the monumental embodiments of the nation's growth, and the ground-breaking designs of Frank Lloyd Wright introduced a novel and highly influential style of design for space and living. Streamlining became a common theme: concrete, chrome, stainless steel, plastics and innovative use of mirrors and glassware celebrated the power of the Machine Age and the changes that it wrought in everyday life. Through Hollywood, television, photographs and written media, the Art Deco style permeated societies all over the world, and by the 1940s it had become a truly international style.

The advent of the Second World War removed the gloss from all things modern. During the 1939 New York World's Fair in Flushing Meadows, the organizers dreamed of 'The World of Tomorrow'. The idealized faith that the Machine Age could solve all of society's ills and create equality quickly perished as Europe and its citizens fell to the rise of Fascism. An appetite for the urbane tomorrow was lost as society grappled with its gritty today – and Art Deco, for a while, fell from favour. Since the 1960s, however, a renewed interest in an aesthetic that fused no-nonsense form and utility with frivolous, and sometimes necessary, decoration has been welcomed by new generations.

Art Deco

Movement

Mackintosh, Charles Rennie
Master Bedroom at Hill House, Scotland, 1902

©Anthony Oliver

Charles Rennie Mackintosh is widely celebrated as one of the world's greatest architect-artists. His work marked a transition from Art Nouveau and the Arts and Crafts movement to the beginning of an exciting new style era, known today as Art Deco.

As the nineteenth century drew to a close, the cultural world was embarking on a new period of modernity. Society was changing at a pace rarely experienced before as the Machine Age took hold of everyday life. Mackintosh developed a reputation for innovative style. He broke with tradition by designing light, elegant interiors and furnishings with a holistic approach, while still drawing on the Arts and Crafts aesthetic of superb craftsmanship and quality materials.

Mackintosh and his designer wife Margaret Macdonald (1865–1933) created architectural projects and furnishings that aimed to "clothe in grace and beauty the new forms and conditions that modern developments of life – social, commercial and religious – depend upon." At Hill House in Helensburgh, Scotland they achieved that goal and more – they captured the imagination of artists and architects throughout Europe and influenced a design movement that is as popular today as it was a hundred years ago.

MOVEMENT

Art Nouveau

SIMILAR WORKS

Windyhill, Kilmacolm by Mackintosh, 1899–1901

The Willow Tea Rooms by Mackintosh, 1904

Charles Rennie Mackintosh *Born* 1868 Glasgow, Scotland

Died 1928

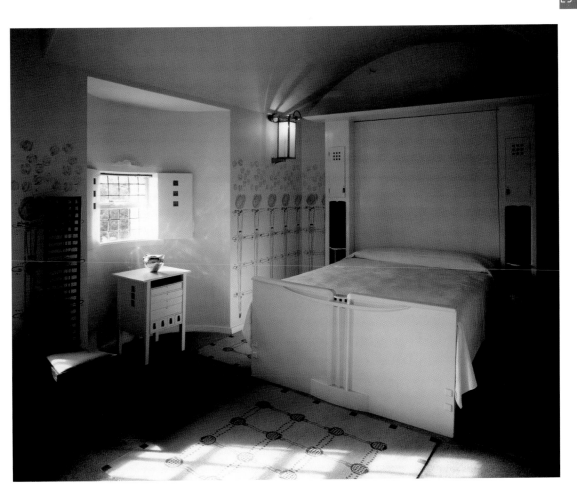

Wiener Werkstätte
Silk dress fabric, c. 1910–20

The early stages of the Art Deco movement were marked by a range of different styles. While Scottish architect and designer Charles Rennie Mackintosh was elegantly decorating interior furnishings with leaded glass panels and stylized motifs, the *Wiener Werkstätte* in Austria were creating artefacts and architectural designs that were characterized by their geometrical simplicity.

The *Wiener Werkstätte*, or Viennese workshops, were founded in 1903 by Josef Hoffman (1870–1956) and Koloman Moser (1868–1918) to produce high quality, luxury goods. They believed that artists should be involved in every part of production, overseeing their projects from design to completion. In this respect, they were furthering the work of the Viennese Secession – an art movement founded by Gustav Klimt (1862–1918) in reaction to the traditional culture of the time.

Although the early work of the *Wiener Werkstätte* tended towards simple forms with geometrical patterns, later works became more decorative and often drew inspiration from local folk art. The workshops had a textile department run by 80 members and produced more than 1,800 designs. These were used principally for furnishings and clothing, and inspired later Art Deco designers such as the French couturier Paul Poiret (1879–1918).

MOVEMENT

Wiener Werkstätte

MEDIUM

Block-printed silk

SIMILAR WORKS

Lacquered wood and mother-of-pearl table and chairs by Joseph Urban (head of the *Wiener Werkstätte* in Manhattan), 1921

Palais Stoclet, Brussels by Josef Hoffman, 1908

Bakst, Leon

Costume design for a Bacchante in 'Narcisse' by Tcherepnin, 1911

Art Deco was a style that pervaded many aspects of cultural life during its incumbency and drew on numerous sources of inspiration during that time. Leon Bakst was a highly influential designer, whose original and flamboyant works stamped their mark on couture during the Art Deco period.

Bakst was born in Russia but divided much of his working life between Paris and St Petersburg. Trained at the Imperial Academy of Arts in St Petersburg, Bakst found employment as a scenery and costume designer for Sergei Diaghilev (1872–1929), the founder of the Ballets Russes. When Diaghilev brought his ballet company to Paris, the bold and vibrant colours of the sets and costumes sent shockwaves through the world of fashion. The subdued, tasteful and classic colours of Art Nouveau suddenly appeared dowdy and dull compared to the outrageous sumptuousness of Bakst's designs. Drawing his inspiration from the art of the Orient, Bakst decorated his exotic costumes with beads, appliqué and feathers. Fashion designers such as Paul Poiret and the Callot sisters were quick to incorporate these new ideas in to their own work.

MOVEMENT

Art Deco

MEDIUM

Watercolour on paper

SIMILAR WORKS

Harem pants and 'lampshade' hats by Paul Poiret, 1913

Leon Bakst *Born* 1866 St Petersburg, Russia

Died 1924

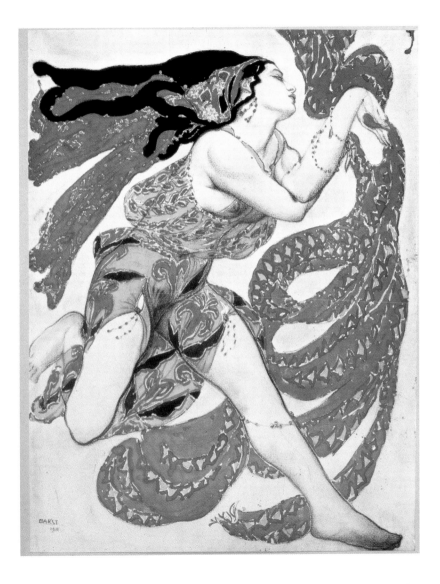

Cappiello, Leonetto
Contratto, 1922

During the Art Deco period, the advertising poster was still a relatively new art medium. Thanks to the invention of lithography, a revolutionary printing process, modern posters had begun to appear in the 1860s. By the turn of the century an entirely new art form was established – one that reached its zenith during the Art Deco period.

Commercial and theatrical posters of the Art Deco world provide snapshots of how the decorative and performing arts were conveyed to people on the streets. Leonetto Cappiello was one of the earliest – and arguably one of the greatest – poster artists of the twentieth century. His work captures the immediacy of the age and marked a radical movement away from the organic forms and subtle colours of Art Nouveau and Cappiello's predecessor, Alphonse Mucha (1860–1939).

Throughout the 1920s the art form of the commercial poster continued to develop, aided by ever-improving printing techniques. Commercial art became a profession in its own right and led to the new field of graphic art. As the Machine Age churned out new and exciting products, so advertising had to constantly reinvent itself with powerful symbols and memorable images.

MOVEMENT

Art Deco

MEDIUM

Lithograph in colours

SIMILAR WORKS

Stars: The Moon, The Evening Star, the Pole Star, the Morning Star: poster by Alphonse Mucha, 1902

Cinzano: poster by Cappiello, 1920

Leonetto Cappiello *Born* 1875 Livorno, Italy

Died 1942

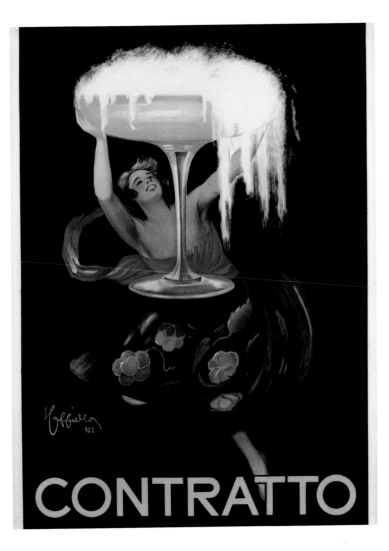

Gray, Eileen
Screen in lacquered wood, 1923

The artists of the Art Deco period sought inspiration from other cultures. Colonial expansion was at its peak and European countries had footholds in the Americas, Asia and the Middle East. The fields of archaeology and anthropology were expanding as fast as new cultures and excavations could be pillaged, and artefacts from all over the world were brought back to be exhibited in museums and galleries.

At the turn of the century, artists were taking inspiration from tribal African art. In 1922 the discovery of Tutankhamen's tomb in Egypt led to 'Nilemania', and designers decorated their furnishings and fabrics with scarab beetles, cobras and pyramids. In the inter-war years, China and the East became a burgeoning source of inspiration. Lacquer, as featured on this screen by Eileen Gray, had hitherto only been produced by Asian craftsman. Its deep lustre and the recurring pattern of the wooden panels perfectly embody popular Art Deco aesthetics of modernity: it is streamlined and sleek, and its intrinsic beauty lies in its form and shape. The pivoting panels could reflect light in countless ways – an exciting concept in the early days of electric lighting.

MOVEMENT

Art Deco/Modernist

MEDIUM

Lacquered wood and brass rods

SIMILAR WORKS

Wood, glass and tubular table by Grey, c. 1930s

Interior decoration of Radio City Music Hall by Donald Deskey, 1932

Eileen Gray *Born* 1878 Enniscorthy, Ireland

Died 1976

Brandt, Edgar
Silvered bronze clock

Courtesy of Christie's Images Ltd/© ADAGP, Paris and DACS, London 2005

The Art Deco period was a time of great flux in industry, technology and manufacturing, and metalwork exemplifies these changes well. At the beginning of the era, wrought-iron, bronze and copper were the primary metals used for decorative purpose, but by the 1930s aluminium, steel and chrome were favoured. Mass-production techniques and new ways of creating metal alloys also revolutionized the materials available for use by artisans.

The 1930s were a period of light and space, and materials that reflected light emphasized the sleek and smooth lines that were associated with modernity. Streamlined shapes in household ornaments echoed the technology of speed that was transforming transport by sea, road and rail. Edgar Brandt, designer of this silvered bronze clock, was the Art Deco master of metalwork. Already successful by the 1920s, Brandt exhibited at the 1925 *Exposition Internationale des Arts Décoratifs et Industriels Modernes* in Paris and received numerous commissions for his architectural and ornamental metalwork from France and abroad. He established a New York arm of his business, Ferrobrandt, and received commissions for the Madison-Belmont Building in New York and the Cheney Brothers showroom.

MOVEMENT

Art Deco

MEDIUM

Bronze coated in silver

SIMILAR WORKS

Entrance door to the Montreal Chamber of Commerce by Brandt, 1923–26

Bronze jardinières with cobras by Brandt, *c.* 1920s

Edgar Brandt *Born* 1880 Paris, France

Died 1960

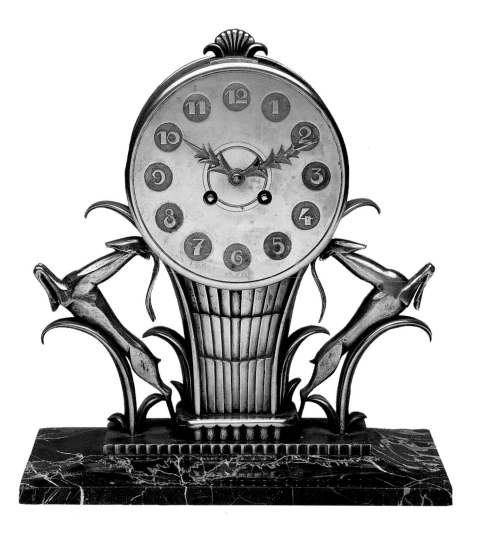

Pryse, Spencer Gerald

Poster for the British Empire Exhibition, 1924

This poster, designed by Spencer Gerald Pryse, advertised the largest and most ambitious exhibition ever staged in the world at the time – the British Empire Exhibition. Conceived in the depressing aftermath of the First World War, the aim of the Exhibition was to celebrate the achievements of colonialism in the Empire and highlight the bright future anticipated for it. Of the 58 countries that composed the British Empire at the time, 56 took part in the Exhibition, which was staged in the North London suburb of Wembley. The Empire was perceived as a great British success but few people attending the Exhibition would have guessed that, within just 40 years, the Empire would be all but dissolved.

The effect of colonialism on European culture at this time cannot be underestimated. Many European countries had strongholds in Africa, Asia and the Americas, and the influence of art imported from those regions can be felt in the work of Art Deco designers such as Pierre Legrain (1888–1929) and Eileen Gray (1878–1976).

MOVEMENT

Art Deco

MEDIUM

Lithograph in colours

SIMILAR WORKS

The Only Road for an Englishman: World War I recruiting poster by Pryse, *c.* 1915

Gathering Cocoa Pods: poster by Pryse, 1927

Spencer Gerald Pryse *Born* 1882, France

Died 1956

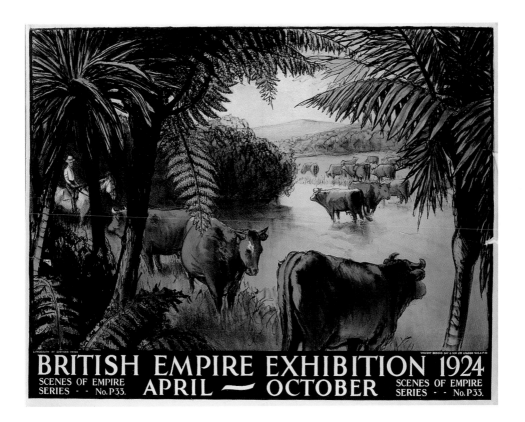

BRITISH EMPIRE EXHIBITION 1924
SCENES OF EMPIRE
SERIES - - No. P33. APRIL ⁓ OCTOBER SCENES OF EMPIRE
SERIES - - No. P33.

Wright, Frank Lloyd
Charles Ennis House, 1924–25

Art Deco was principally a modern movement and it was in the field of architecture that some of the most radical changes took place. Buildings were designed without reference to the past – the approach was functionalist and the techniques innovative.

The Viennese architect Adolf Loos (1870–1933) designed one of the first domestic houses built from rendered brick (Steiner House, 1910) and eschewed all forms of ornamentation. In Germany, Walter Gropius (1883–1969) became the Director of the Arts and Crafts School (later called the Bauhaus) at Weimer in 1919, and created one of the most important centres of modern design. The Bauhaus aesthetic favoured Cubism and Constructivism: artisans were encouraged to learn practical skills and gain knowledge of technological developments that could be applied to their crafts.

While modern architecture grew and developed in Europe, it flourished in the USA under the guardianship of Frank Lloyd Wright. One of the most influential and innovative architects of the era, Wright became famous for his 'prairie architecture', using concrete and steel posts to construct domestic and commercial buildings. His work was entirely new and contained few references to earlier styles. Wright believed in honouring the aesthetics of his settings and the integrity of his materials in order to achieve flowing, unrestricted living spaces.

MOVEMENT

Modern

SIMILAR WORKS

Larkin Office Building by Wright, 1904

Frank Lloyd Wright *Born* 1867 Wisconsin, USA

Died 1959

Bonfils, Robert

Poster for the Paris Exhibition, 1925

This poster by Robert Bonfils was used to advertise an event that was to become one of the most significant of the Art Deco period. Officially named the *Exposition Internationale des Art Décoratifs et Industriels Modernes*, this exhibition is now often referred to simply as the Paris Exhibition of 1925.

In 1924, Britain had put on a grand exhibition to celebrate its Empire. Meanwhile, the French were preparing for an exhibition that would establish the importance of their luxury goods and design. Whereas the British Empire was soon to begin crumbling, French design was in a strong position at the forefront of modernity. The USA, by contrast, did not exhibit in Paris in 1925 on the grounds that they had no modern design to show.

The Paris Exhibition brought together displays of modern design from around Europe, and the 16 million visitors who attended it were left in no doubt that Paris was the most fashionable and exciting of cities. Manufacturers, department stores and boutiques celebrated the new consumerism and market for luxury goods. The Exhibition was devoted to the decorative arts and was an influential event in the development of the style we now call Art Deco, even to the extent of providing the movement's name.

MOVEMENT

Art Deco

SIMILAR WORKS

Illustrations for the *Gazette du Bon Ton* by Bonfils, c. 1925

Modes et Manieres d'Aujourd'hui: illustration by Bonfils, 1922

Robert Bonfils *Born* 1886 Paris, France

Died 1953

Ruhlmann, Jacques-Emile

The Grande Salon at the Paris Exhibition, 1925

The Art Deco period saw the development of an entirely new profession: that of the ensembliers. These artist-decorators took on the task of creating entire designs for an interior. The aim was to encourage artists, designers and craftsmen to collaborate in achieving a harmonized look for an interior. An ensemblier would ensure that all of the elements in a room, from wall coverings to light fittings, complemented one another and, in their totality, achieved a stylized and united interior.

One of the greatest ensembliers of the Art Deco period was Jacques-Emile Ruhlmann. Despite having no formal training, Ruhlmann is considered to be one of France's greatest cabinet-makers. His talents lay in his design and vision; Ruhlmann did not make any of his furniture himself but instead employed highly skilled cabinet-makers to carry out his detailed and exacting plans.

Ruhlmann exhibited at the Paris Exhibition in 1925, and his Hôtel d'un Collectionneur, from which this design came, was an enormous success. It contained furniture designed with the characteristic Ruhlmann attention to detail – sleek, modern and crafted from the finest woods. Decorations were delicate, elegant and sophisticated to match the fine tapering lines of the desks, tables, cabinets and chairs.

MOVEMENT

Art Deco

SIMILAR WORKS

Designs for a library by Pierre Chareau for the Paris Exhibition, 1925

Lacquered table with *coquille d'oeuf* (crushed eggshell) by Jean Dunand, *c.* 1925

Jacques-Emilie Ruhlmann *Born* 1879 Paris, France

Died 1933

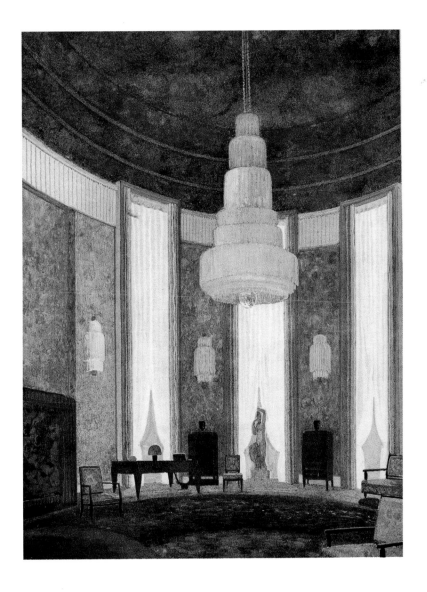

Dufrène, Maurice

Commode with *verdi antico* marble top

At the beginning of the Art Deco movement, furniture was commonly characterized by its sheer elegance, opulence and exquisite ornamentation. Designers such as Jacques-Emile Ruhlmann and Maurice Dufrène paid homage to styles that went before them and were influenced by the cabinet-makers of Louis XV and Louis XVI. They employed the most talented craftsmen to execute their designs and looked to Africa, Asia and South America for luxury woods, such as Macassar ebony, and exotic inlays, such as ivory and shell.

By 1912, influential clients of these designers, such as Jacques Doucet (1853–1929) and Jeanne Lanvin (1869–1946), began to look to other, more avant-garde designers for their collections. A trend was developing towards the modern; mass production and new technologies saw the market begin to move away from single, deluxe pieces of furniture towards those that reflected the new aesthetic of functionalism and a desire to be true to the material itself. Eileen Gray combined both the opulence of the early Art Deco period with a passion for sleek chrome and glass items, and much of her furniture looks as modern today as it did in 1920s and 1930s.

MOVEMENT

Art Deco

MEDIUM

Macassar and rosewood

SIMILAR WORKS

Zebra chaise-longue by Pierre Legrain, 1925

Bronze chair with leopard-skin cushion by Armand-Albert Rateau, *c.* 1925

Maurice Dufrène *Born* 1876 Paris, France

Died 1955

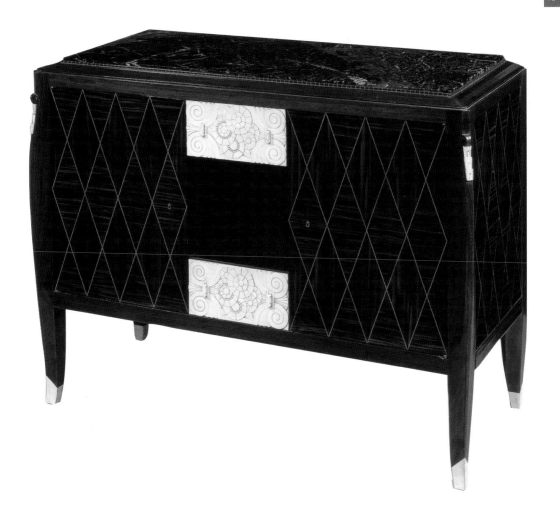

Cassandre, A.M. (Adolphe Jean-Marie Mouron)

Nord Express, 1927

Cassandre is the pseudonym of Russian-born Adolphe Jean-Marie Mouron, one of the greatest commercial artists of the twentieth century. He was influenced by the avant-garde artists of the era: Paul Cézanne (1839–1906), Pablo Picasso (1881–1973) and Georges Braque (1882–1963). During the first two decades of the new century, contemporary art was in a huge state of flux as artists experimented with Dadaism, Surrealism, Cubism, Futurism and Bauhaus. Cassandre drew on these influences and his innovative graphic designs created a bridge between commercial art and fine art.

Cassandre studied in Paris and worked as a theatre designer, painter and typographer. It was in the relatively new medium of commercial posters, however, that his work was to have the greatest impact. Cassandre understood that, in advertising, symbols and messages need to be exaggerated to be effective, and that abstract art could be used to achieve this.

MOVEMENT

Art Deco

MEDIUM

Lithograph in colours on paper

SIMILAR WORKS

Poster for the French Line crossing to New York by Cassandre, 1935

High Society: poster by Sané, 1928

A.M. Cassandre *Born* 1901 Kharkov, Ukraine

Died 1968

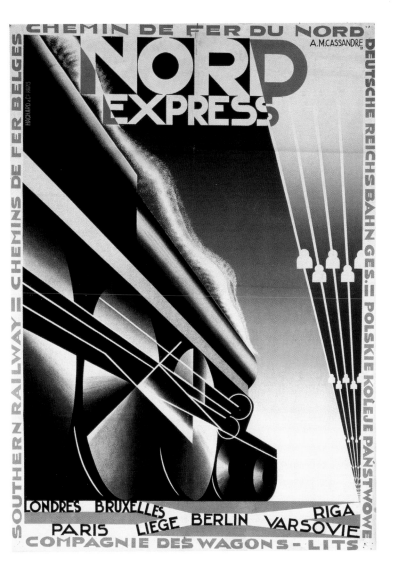

De Lempicka, Tamara

Young Girl in Green, 1927

The Art Deco movement is one that encompasses a huge array of styles and trends, and paintings of the era exemplify this particularly well. Art Deco is not, after all, a single aesthetic, but a range of contemporary and various art forms, as disparate as the restrained elegance of Charles Rennie Mackintosh and the avant-garde Cubist work of Georges Braque. The term is usually restricted to the decorative arts rather than fine art, but the works of some artists, such as Tamara de Lempicka, nevertheless typify the Art Deco period with their stylized images and dramatic compositions.

Tamara de Lempicka was born in Warsaw and lived in Russia before moving to Paris to escape the Bolsheviks towards the end of the First World War, just as the Art Deco movement was flourishing. She painted more than 100 portraits between 1925–39. Her works, many of them nudes, are regarded as the pinnacle of Art Deco paintings; they are decorative objects in themselves but draw heavily on the influences of the Modernist and avant-garde artists of the time. Stylized and enigmatic, her figures often appeared in bold colours, set against an angular background of skyscrapers.

MOVEMENT

Art Deco

MEDIUM

Oil on canvas

SIMILAR WORKS

Portrait of Arlette Boucard by de Lempicka, 1928

Tamara de Lempicka *Born* 1900 Warsaw, Poland

Died 1980

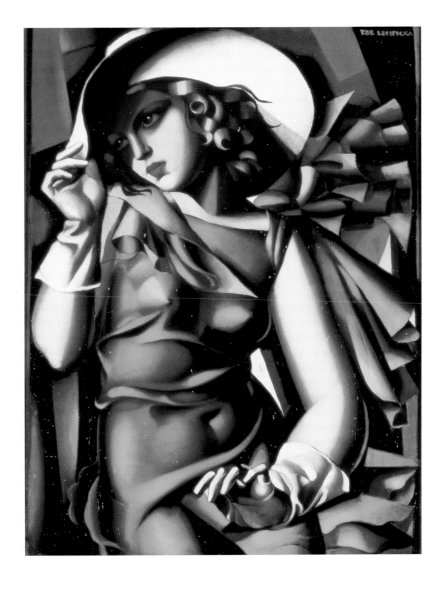

Bouraine, Marcel
Papillon, *c.* 1928

Glassware of the Art Deco movement reflects the period's obsession with light and space. Many pieces demonstrate classic French motifs of elegant, slender women, often shown with animals such as gazelles, storks and greyhounds. This delicate figure was designed by Marcel Bouraine and executed by master craftsman Gabriel Argy-Rousseau (1885–1953).

Rousseau was a specialist in the techniques of *pâte-de-verre* and *pâte-de-cristal*, media which had enjoyed revived popularity during the Art Nouveau period. These techniques were originally developed by the ancient Egyptians and involved mashing powdered glass in to a paste before moulding and firing it. This allows the glass to combine colour and transparency and, in this instance, is able to show the stylized figure of a woman/butterfly in all its sensuousness.

Glassware in the Art Deco period was produced throughout Europe. The Swedish glassware firm Orrefors received international acclaim at the Paris Exhibition in 1925, while Czechoslovakia and Italy (Murano in particular) were already famous for their glassware products. They rapidly absorbed the Art Deco aesthetic into their designs and became important contributors to the variety of decorative glass and crystal artefacts created at the time.

MOVEMENT

Art Deco

MEDIUM

Pâte-de-cristal sculpture

SIMILAR WORKS

Pâte-de-verre vase featuring fishes by Gabriel Argy-Rousseau, 1925

Figure with drape in amber glass sculpted by Bouraine and moulded by Argy-Rousseau, *c.* 1928

Marcel Bouraine *Born* 1886 Pontoise, France

Died 1948

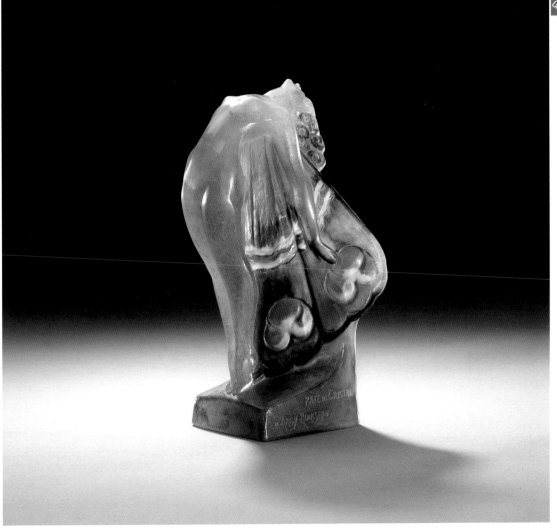

Dunand, Jean

A Grand and Fine Lacquered Wood Panel, c. 1929

Courtesy of Christie's Images Ltd/© ADAGP, Paris and DACS, London 2005

The artists and designers of the Art Deco period absorbed cultures from every direction. The eclectic charm of the decorative arts of the early part of the twentieth century owes much to the fine arts and crafts of Japan and China. The Far East had been exerting its influence upon Western art since trade had been established between the two regions in the sixteenth century, and during the Art Deco period, Western artists became increasingly drawn to the bright colours, geometric shapes and bold motifs of Eastern art.

It was not, however, only the images themselves that were influential. The artistic techniques employed by Eastern craftsmen became an important ingredient in the search for deluxe, splendid and ornamental effects. Lacquering is an Asian technique for ornamenting wood that found particular favour with Art Deco designers such as Jean Dunand and Eileen Gray.

Lacquer is an organic substance that is extracted from the sap of trees indigenous to East Asia. After refinement, the lacquer becomes a syrupy liquid that hardens to produce a beautiful sheen that lends itself well to decoration, especially on inlaid woods.

MOVEMENT

Art Deco

MEDIUM

Lacquered wood panel

SIMILAR WORKS

Lacquered works for three ocean liners: *Ile de France* (1928), *L'Atlantique* (1931) and *Normandie* (1935) by Dunand

Jean Dunand *Born* 1877 Switzerland

Died 1942

Reeves, Ruth
Manhattan furnishing fabric, *c.* 1930

Ruth Reeves was an influential and original contributor to the Art Deco movement in the USA. The field of textile and carpet design was one in which women of the period were able to participate and exert their influence; this era, after all, was the beginning of female emancipation and enfranchisement in the Western world.

At this time, carpets, rugs and fabrics provided a perfect medium for experimenting with the colours and patterns that were becoming popular through modern art and the work of the artist-designers. Bold, geometric and abstract patterns found their way on to rugs intended for both domestic and commercial buildings. Similarly, clothing fabrics were used to reflect the variety of trends and influences that were operating in the decorative arts at the time.

This furnishing fabric by the celebrated designer Ruth Reeves clearly shows the influence of the Cubist artist Georges Braque. The sombre palette of subtle blues and greys unites the vivid images of the Manhattan skyline, which are juxtaposed with Cubist angularity. Reeves is celebrating modernity and the Machine Age; the design includes images of skyscrapers, telephone exchanges, cruise liners and locomotives, a common theme of the era.

MOVEMENT

Modern

MEDIUM

Block-printed cotton

SIMILAR WORKS

Textiles for Radio City Music Hall by Reeves, 1932

Ruth Reeves *Born* 1892 California, USA

Died 1960

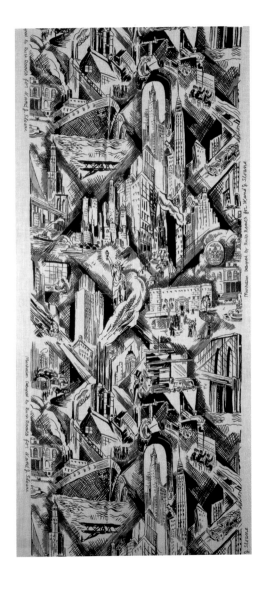

Lalique, René

Car mascots, ashtrays and paperweight

There is no one style of glassware that defines the Art Deco movement, as many new techniques and styles were developed in the years preceding and following the First World War. In the early years of the twentieth century, glassware was used as a means of artistic expression and was often highly ornamental and decorative. Maurice Marinot (1870–1953) was a French artist who began creating decorative glassware around 1910. His approach was experimental and he developed new and exciting ways to decorate glassware internally and externally, particularly with enamels. As his style matured, Marinot eschewed superficial decoration and concentrated more on glass sculptures.

Marinot's influence on Art Deco glassware was great, but it was his contemporary, René Lalique, whose glasswork remains the benchmark for the period. At the beginning of the Art Deco period the emphasis was on hand-crafted, high quality artefacts that displayed wealth and sophistication. By the time of the Paris Exhibition in 1925, however, the Machine Age was in full throttle and the possibilities provided by mass manufacturing appealed to many artists. Lalique aimed to combine mechanized production and hand-crafting in an effort to make good design more accessible and commercial.

MOVEMENT

Art Deco

MEDIUM

Glass

SIMILAR WORKS

Pavilion and Fountain at the Paris Exhibition by Lalique, 1925

Etched glass vases by the Daum glassworks in Nancy, 1920s and 1930s

René Lalique *Born* 1860 Ay, France

Died 1945

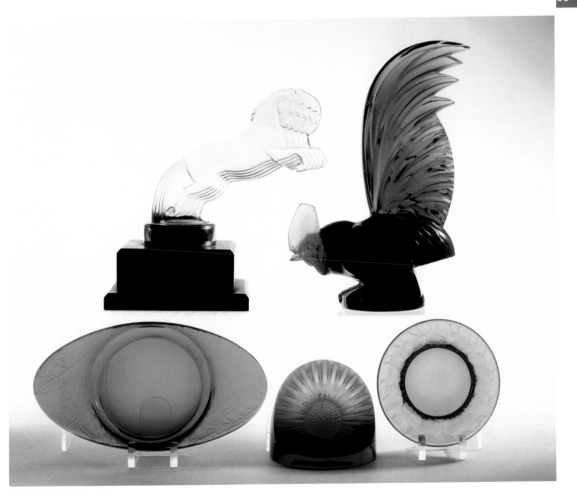

Van Alen, William
Chrysler Building, 1927–30

In the years following the First World War, architecture underwent great changes, particularly in the USA. France and Britain did not embark on major building projects; their cities and towns had long histories and displayed rich architectural pasts. In Europe, renovation was considered preferable to demolition and new builds. The USA, however, was ripe for architectural innovation. Business was enjoying a boom and there was an almost infinite requirement for new commercial and domestic buildings.

In 1923 the *Chicago Tribune* had awarded a prize of $50,000 to John Howells (1868–1959) and Raymond Hood (1881–1934) for their design for a modern office building of 'great height'. Their gothic building was a rich ferment of ornamentation that had been inspired by the Woolworth Building, designed by Cass Gilbert (1859–1934) in 1913. Over the subsequent years a rich variety of commercial buildings began to tower in America's commercial centres, especially New York.

Architects had to design their buildings within the constraints of the New York zoning laws, which dictated that buildings would have to narrow as they grew taller, permitting light to fall to the street. The Chrysler Building is a typical example of how skyscrapers tapered upwards to conform to these laws.

MOVEMENT

Art Deco

SIMILAR WORKS

Woolworth Building by Gilbert Cass, 1913

Empire State Building by Shreve, Lamb and Harman, 1929–30

William Van Alen *Born* 1883 New York, USA

Died 1954

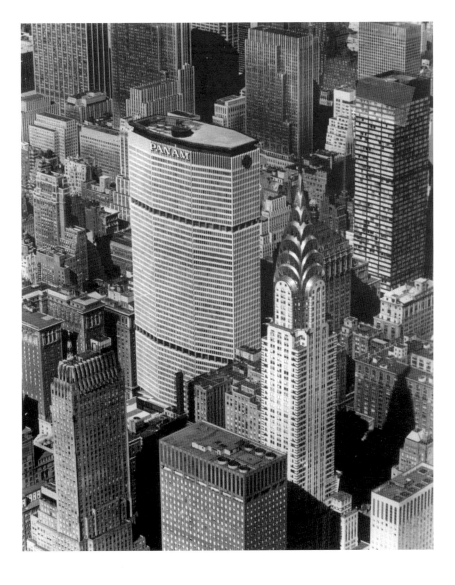

Templier, Raymond

Cigarette case in red and black lacquer on silver, 1930

As the Art Nouveau movement quietly sailed into the twentieth century, it brought with it a new style of jewellery and accessories, lighter, more frivolous and more modern than those of the Victorian era. This trend continued with the Art Deco movement, which saw jewellery further liberated from tradition.

As fashion changed, so too did jewellery and accessories, such as vanity cases, handbags, lighters and cigarette cases. New techniques in the craft of setting gemstones in precious metals were developed, and jewellers also mastered new methods of cutting stones, creating the baguette, square and trapezium cuts. Style, form and colour were influenced by many cultural trends, from the flamboyant Ballet Russes and a fascination with the Orient to Central and South America.

French jewellery makers, such as Raymond Templier and Jean Fouquet (1862–1957), took the craft of jewellery design and turned it into an art form that quickly spread throughout Europe and the USA. This silver cigarette case has been lacquered, a technique that had been imported from the Far East and used as a decorative finish. The design is reminiscent of Mayan architecture, an inspirational style for Art Deco artists.

MOVEMENT

Art Deco

MEDIUM

Red and black lacquer on silver

SIMILAR WORKS

Bracelet in gold and onyx by Jean Fouquet, 1925

Gold vanity case with precious stones, mother-of-pearl and enamel by Cartier, 1925

Raymond Templier *Born* 1891 Paris, France

Died 1968

Bénédictus, Edouard

Book Plate 3, from *Relais*, Quinze Planches Donnant Quarante-Deux Motifs Décoratifs, 1930

© Victoria and Albert Museum, 2005

Parisian artist-decorators of the 1920s and '30s applied a Modernist and innovative approach to the field of carpet and textile design as enthusiastically as they did to all other areas of the decorative arts. Ensembliers, or interior designers, viewed the whole design process as a collaborative one and they drew on the skills of artisans such as glassmakers, weavers and sculptors to achieve the harmonious and stylized effects they were after. The patterns of artists such as Raoul Dufy (1877–1953) and the American designer Donald Deskey (1894–1989) adorned fabrics, wallpapers and rugs. Fabric designers such as Edouard Bénédictus and Robert Bonsfils created folios of their designs that could then be referred to by the ensembliers. *Relais*, from which this print comes, was just one of the folios that Bénédictus created.

Patterns and prints of the Art Deco movement exhibit great variety and demonstrate the huge range of influences then prevalent. The prints of Bénédictus frequently contained complex geometric patterns and motifs.

MOVEMENT

Art Deco/Modern

MEDIUM

Colour pochoir

SIMILAR WORKS

Woollen carpet in decorative motifs by Bénédictus, 1925

Braintree: cotton gimp by Alec Hunter, 1932

Edouard Bénédictus *Born* 1878 Paris, France

Died 1930

Chiparus, Dimitri
Girl Dancing

Sculpture was one of the most popular art forms of the Art Deco movement. While some sculptures, especially those from the early days of the style, are reminiscent of African tribal art, those that most typify the period exude sheer elegance. A combination of bronze and ivory – known as chryselephantine – has become almost synonymous with Art Deco sculpture.

The Ballets Russes, under the directorship of Sergei Diaghilev, were performed in Paris from 1908. The shows, featuring the great Vaslav Nijinsky and Anna Pavlova, were phenomenally successful. With their flamboyant and sumptuous sets and costumes designed by Leon Bakst, the Ballet Russes proved a fresh source of inspiration, especially for couturiers. Ballet emphasized the beauty of the young human form, and during the 1920s designers such as Paul Poiret designed clothes for women that celebrated the natural female shape, rather than constraining it in corsets. However, the fashions, which included sheath dresses, tended to suit slender women rather than voluptuous ones – and so it was the thin, agile, elegant and idealized women who were immortalized in the decorative sculpture of the time. Figures were frequently shown in movement – a theme that was often emphasized by secondary figures or creatures such as prancing gazelles.

MOVEMENT

Art Deco

MEDIUM

Bronze and ivory

SIMILAR WORKS

Pierrot et Pierrette: sculpture in bronze and ivory by Chiparus, c. 1925

Towards the Unknown: sculpture by Claire Jeanne-Roberte Colinet, c. 1920s

Dimitri Chiparus *Born* 1888 Romania

Died 1950

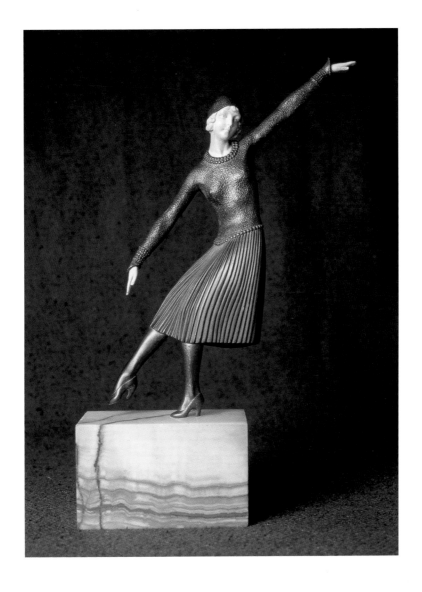

Cooper, Susie

Teapot, made by Crown Works, Burslem, 1930s

Art Deco ceramics demonstrate the diversity of styles associated with the movement. In general, ceramics of the nineteenth century had been dull, staid and often poor in quality. The ceramicists of the Arts and Crafts movement challenged this status quo and set about raising the standards of both production and artistry.

At the beginning of the Art Deco period decorative ceramics were executed by skilled potters and artists. By the 1930s, however, innovative designs were being applied to industrially created tableware for use in the home by ordinary people, not the wealthy elite. This was due, in part, to the efforts of the artisans who worked in the *Wiener Werkstätte* (Viennese workshops). They had toured American cities and introduced their peers to modern designs and production techniques.

Susie Cooper was trained in ceramics in her native Staffordshire and began work at a local pottery. By the early 1930s she had established her own successful business, designing tableware that was sold in major London department stores. Cooper and her contemporary, Clarice Cliff (1899–1972), produced bold and exuberant designs that achieved both commercial success and artistic acclaim.

MOVEMENT

Art Deco

MEDIUM

Ceramic

SIMILAR WORKS

Biarritz by Clarice Cliff, 1934

Dresden Spray by Cooper, c. 1935

Susie Cooper *Born* 1902 Stoke on Trent, England

Died 1995

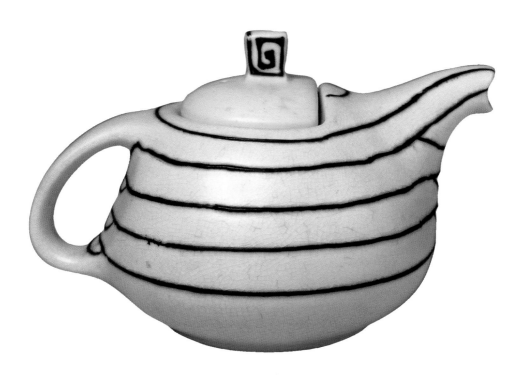

Manship, Paul

Prometheus Fountain, Rockefeller Center New York, 1934

Figurative artwork in the early part of the twentieth century drew on a number of sources for inspiration. Sculptors of small decorative pieces, such as Dimitri Chiparus and Claire Jeanne-Roberte Colinet, concentrated on creating figures of elegant and highly idealized women. The figures were often scantily dressed but otherwise chic in every respect.

The Cubists and abstract artists were also exploring the medium of sculpture. Their works are contemporary to those of Chiparus and Colinet, yet dramatically different. They were not interested in creating pieces of sculpture to decorate an interior; they were experimenting with light, shape and form to achieve a work of art that existed entirely in its own right — independently of its surroundings and the space that it occupied. Paul Manship, whose statue of Prometheus guards the entrance to the Rockefeller Center in New York, was America's premier figurative sculptor of the Art Deco period. He was inspired by the classical Roman and Greek art that he had studied during his travels through the ancient world.

MOVEMENT

Art Deco

MEDIUM

Bronze

SIMILAR WORKS

Diana and Acteon: bronze sculptures by Manship, 1921–25

Gates to Bronx Zoo by Manship, 1923

Paul Manship *Born* 1885 Minnesota, USA

Died 1966

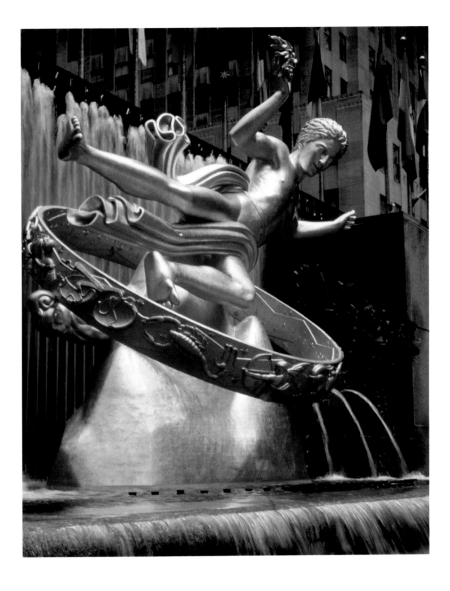

Hood, Raymond
The Rockefeller Center, 1932–40

New York's Rockefeller Center is considered to be one of the greatest architectural achievements of the twentieth century, and it is a testament to the high quality of design that the Art Deco movement engendered.

During the 1920s, American business centres encompassed a wide array of commercial buildings. It was acknowledged that a building no longer simply housed an organization – it also advertised it, and therefore its design needed to capture the public's imagination. There were those who thought that the gothic excesses of Raymond Hood's American Radiator Building in New York and Cass Gilbert's Woolworth Building had taken ornamental decoration too far, and throughout the 1930s there was a growing trend towards a sleek, modernist approach, perhaps influenced by the geometric styles of Robert Mallet-Stevens (1886–1945) and Frank Lloyd Wright.

The Rockefeller Center was designed by Raymond Hood, among others. It was commissioned by the multi-millionaire John D. Rockefeller Jr (1874–1960), whose original plans for an opera house had to be abandoned after the stock market crash of 1929. The Center's slab-like skyscrapers were austere but spectacular Art Deco effects, and serve to demonstrate how modernist architecture can accommodate, and be uplifted by, the frivolity of ornamentation.

MOVEMENT

Art Deco/Modern

SIMILAR WORKS

Atlas at the Rockefeller Center by Lee Lawrie and Rene Chambellan, 1937

Raymond Hood *Born* 1881 Rhode Island, USA

Died 1934

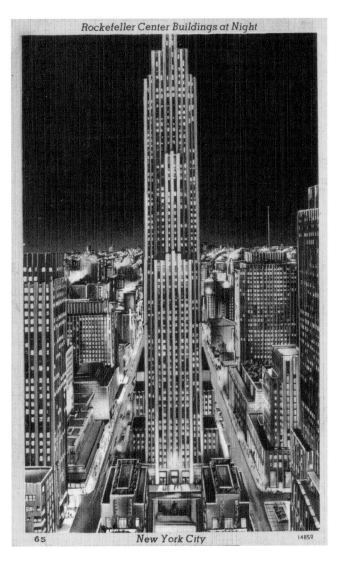

Rockefeller Center Buildings at Night

New York City

65 14859

Dupas, Jean

Illustrated view of the Grand Salon on the *Normandie* (from *L'Illustration* magazine), 1935

© Estate of Jean Dupas/Private Collection/Archives Charmet/www.bridgeman.co.uk

The *Normandie* was launched in 1932. The greatest and fastest ocean liner yet constructed for the transatlantic route, her maiden voyage took place in 1935, with interiors designed by some of the greatest artist-decorators of the period. By this time, Art Deco had become a truly international style. Magazines, cinema and burgeoning leisure travel introduced it around the globe, while new techniques, skills, machine production and a flamboyant, innovative approach to design all served to keep the style fresh and new.

Following the discovery of the tomb of Tutankhamen in 1922, the Art Deco world had embraced Egyptian motifs, patterns and colours, and the decorators of the *Normandie* were no exception. Jean Dunand, for example, created five huge lacquer panels that were gilded and covered in Egyptian style bas-reliefs for one room. This room – the Grand Salon – was designed by Dunand and his contemporary Jean Dupas, a fabulous, extravagant example of Art Deco excess.

MOVEMENT

Art Deco

MEDIUM

Colour lithograph

SIMILAR WORKS

Chariot of Aurora: monumental doorway designed for *Normandie* by Dupas, Jean Dunand and Roger-Henri Expert, 1935

Les Perruches by Dupas, 1935

Jean Dupas *Born* 1882 Lyon, France

Died 1964

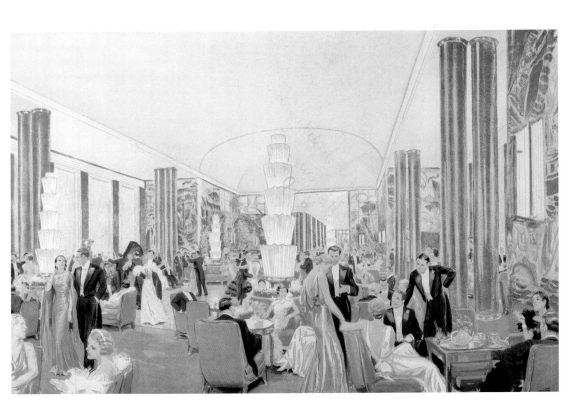

Cliff, Clarice

Vase, teapot and coffeepot in *Sunray* pattern

The ceramics of Clarice Cliff have become great favourites with collectors. Art Deco ceramics reflected a wide array of design and technique but Cliff's unusual, sometimes bizarre, patterns have become for many synonymous with the Art Deco period.

Clarice Cliff studied ceramics at the Burslem School of Art in England, as did her contemporary ceramicist Susie Cooper. By 1927 she was decorating tableware at A.J. Wilkinson's Royal Staffordshire pottery and she subsequently unveiled her first collection, aptly named *Bizarre*. Cliff's designs were bold, vibrant and bright with stark, geometric motifs. Aided by moderate prices and good marketing, Clarice Cliff's abstract ceramics became very popular. Widely available, her work brought innovative designs in to ordinary homes, in a way that the luxury furniture of Ruhlmann or the bronze sculptures of Chiparus could not.

Clarice Cliff not only revolutionized the colours and patterns that appeared on everyday tableware, she challenged her customers to question the essential shape and form that plates, cups and vessels were given. Angular handles and spouts may not be ergonomic, but they are stylish.

MOVEMENT

Art Deco

MEDIUM

Ceramic

SIMILAR WORKS

Bizarre by Cliff, 1927

Age of Jazz: a series of cut-out figures by Cliff, 1930

Clarice Cliff *Born* 1899 Staffordshire, England

Died 1972

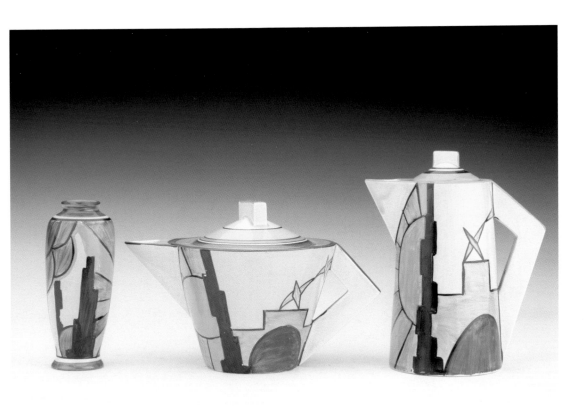

Follot, Paul
Giltwood tub chair

Paul Follot was a master of the early Art Deco period, a period that is today sometimes classified as 'pure' or 'high' Art Deco. As Modernism swept through Europe and America in the 1920s, some designers stuck firmly to their belief that the qualities of beauty and fine decoration were valuable in themselves. This viewpoint (called 'Moderne') remained popular and perhaps helped to prevent an excesses of functionalism, which threatened to remove all that is frivolous and fun in decoration. As Paul Follot said in 1928: "We know that the 'necessary' alone is not sufficient for man and that the superfluous is indispensable... or otherwise let us suppress music, flowers, perfume... !"

The pure Art Deco period had produced some great craftsmen, particularly in France where the master designer Jacques-Emile Ruhlmann created high quality furniture from exotic materials. His designs were often Neoclassical but changing trends forced him, eventually, to adopt more modern materials and styles. Paul Follot, like Ruhlmann, designed not just single items of furniture but created entire living spaces in his role as an ensemblier. The sweeping curves and finely tapered legs of this chair show how Follot combined classical sensibilities with the modern style.

MOVEMENT

Art Deco/Moderne

MEDIUM

Giltwood frame with upholstered back and squab cushion

SIMILAR WORKS

Two-desk table in palmwood and metal by Eugène Printz, c. 1930

Paul Follot *Born* 1877 Paris, France

Died 1941

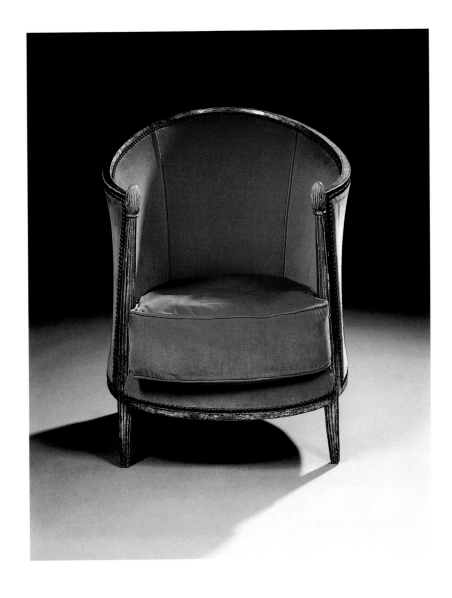

Teague, Walter Dorwin
Polaroid desk lamp, 1939

© Estate of Walter Dorwin Teague/Christie's Images Ltd

The early Art Deco style was characterized by stylish furnishings, produced in the finest materials by skilled artisans, and by boldly colourful and innovative fashions – all designed with the wealthy elite in mind. However, towards the end of the Art Deco period, society had largely eschewed such fanciful aesthetics. Instead, the world was moving towards a modern, streamlined future where the intrinsic shape and form of an object, or a building, was valued more than its ornamentation.

Walter Dorwin Teague was just one of a new breed of industrial designers. Their aim was to marry materials to function; they took ordinary objects and transformed them, by means of material and technique, into sleek, simple objects with an immediate visual impact – the antithesis of the Gallic style. They spoke of the future and the dawning of a new age, when machinery would remove the daily grind of the common people. In 1940 Teague wrote of his belief in the 'World of Tomorrow': "A better world than we have ever known can and will be built. Our better world may be expected to make equally available for everybody such rare things as interesting, stimulating work, emancipation from drudgery and a gracious setting for daily life."

MOVEMENT

Art Deco

MEDIUM

Bakelite and aluminium

SIMILAR WORKS

Tubular chair in chromed steel and painted wood by Hans and Wassili Luckhardt, 1931

Walter Dorwin Teague *Born* 1883 Indiana, USA

Died 1960

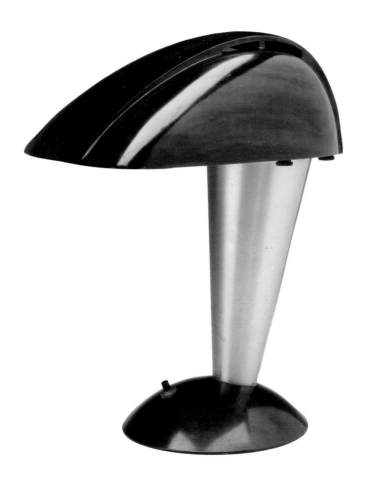

Atherton, John

Poster for New York World's Fair, 1939

The New York World's Fair was planned by corporate America in 1935, during the depths of the Depression. Its stated mission was to demonstrate the interdependence of all states and countries in the twentieth-century world, but it achieved much more than that.

In the 1930s, American business was dying on its feet. The Depression had taken hold and a group of successful and prominent businessmen were awarded the task of creating an exposition to boost consumerism and confidence. The nominal aim of the New York World's Fair was to celebrate the 150th anniversary of George Washington's presidential inauguration in New York (then the nation's capital). But this was the excuse for the Fair, not its *raison d'être*.

Grover Whalen, President of the New York World's Fair Corporation, travelled widely to sell the event and persuaded 60 nations and 33 states to participate. A plot of land was set aside in Flushing Meadows, where design and construction began. The Fair was set to become the culmination of the inter-war period, during which the American population had enjoyed the full range of the Art Deco movement and suffered the desperate circumstances of economic recession and mass unemployment.

MOVEMENT

Art Deco

MEDIUM

Offset lithograph in colours

SIMILAR WORKS

Hawaii: poster for Pan American Airlines by Atherton, 1948

John Atherton *Born* 1900 Minnesota, USA

Died 1952

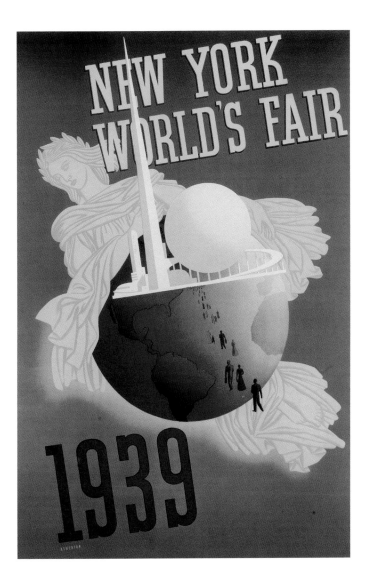

Staehle, Albert

Poster for New York World's Fair, 1939

The Design Board for New York's World Fair included notable industrial designers such as Norman Bel Geddes (1893–1958), Raymond Loewy (1893–1986), Henry Dreyfuss (1904–72) and Walter Dorwin Teague — who decided that a move towards modern, clean and sleek forms would increase consumerism. They believed that the World's Fair could become an ideological showcase for the Machine Age; there was an unqualified faith that science and technology could foster economic prosperity and personal freedom. Albert Einstein (1879–1955) visited the Fair and gave his approval for these ideologies: "If science, like art, is to perform a mission totally and fully, its achievements must enter, not only superficially but with their inner meaning, in to the consciousness of the people."

The Fair offered a much-needed antidote to the Depression, together with an invaluable commodity: hope. John Cowley, commentator and film-maker, summed up the Fair's success: "I think that there are moments where you can see the world turning from what it is in to what it will be. For me, the New York World's Fair is such a moment. It is a compass rose pointing in all directions, towards imaginary future and real past, false future and immutable present, a world of tomorrow contained in the lost American yesterday."

MOVEMENT

Art Deco

MEDIUM

Offset lithograph in colours

SIMILAR WORKS

A Reluctant Butch: drawing with colours by Staehle, 1957

Albert Staehle *Born* 1899 Munich, Germany

Died 1974

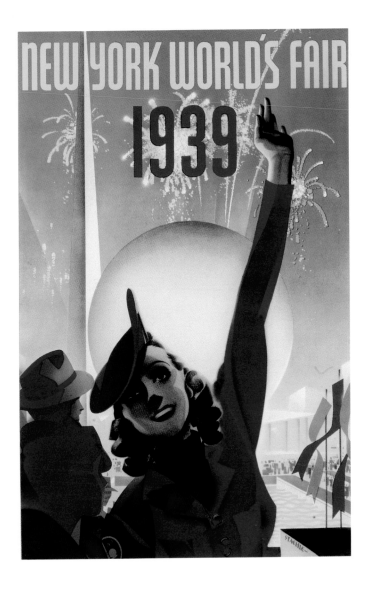

The New York World's Fair, 1939–40
(Photographer unknown)

The New York World's Fair stood on the threshold of a new era. It was hoped, by all those involved in its construction, that the Fair would usher in the Machine Age, in which society itself could be elevated by a modern approach to production and consumerism. By 1940, however, there was a tangible tension between the futuristic ideals being marketed by the Fair's Corporation (which consisted of industrial giants hoping to promote American business) and the very real and less bright future that loomed for Europe.

When the Fair re-opened in May 1940, some major changes had taken place. Despite its great popularity, the Fair was not making money, so the entrance fee was reduced to entice more visitors and the omnipresent socialist theorizing was downplayed, amidst accusations of 'dumbing down'. These efforts, however, were largely irrelevant; by June, France had fallen to Germany.

Once the Second World War had begun, Americans no longer wanted to contemplate a future that appeared to promise more death and destruction. The New York World's Fair had been called 'The World of Tomorrow' but no one could really believe in the make-believe world it evoked while Europe succumbed to the Nazis. The Fair closed in October 1940 and the organizing corporation was declared bankrupt.

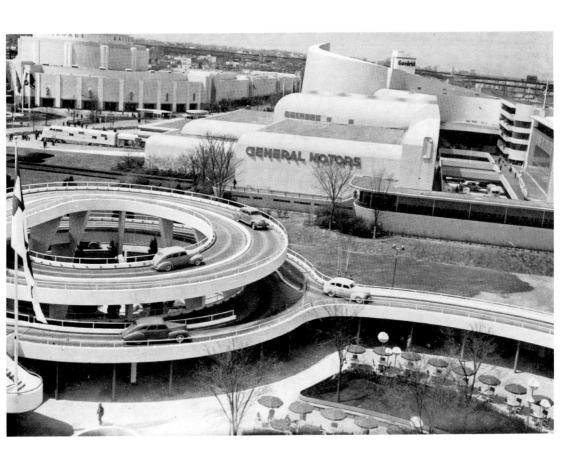

Ragan, Leslie
Poster of New York Central System, 1951

Leslie Ragan was an illustrator who became well-known for one field: his paintings invariably showed machines (normally trains) moving fast through the landscape. During the 1940s, the New York Central System was one of the leading lines connecting the Eastern seaboard with the Midwestern cities. A range of posters was created to emphasize the sleek beauty and power of the locomotives, as this method of transport had been in decline for some time. However, despite the aggressive advertising, the decline continued after the war owing to the rapid growth in travel by road and air.

This was just one of many changes that society confronted during and after the Second World War. The Art Deco aesthetic had come to an end, but its influence remains. Originally an art movement that celebrated ornamentation, it eventually came to incorporate the bare-bones approach of modernism and mass production, and architects today are able to draw on such disparate influences of the period as Charles Rennie Mackintosh and Frank Lloyd Wright. Art Deco was possibly the world's first global style; the movement may have died, but the effect of it lives on.

MOVEMENT

Modern/Streamlining

MEDIUM

Offset lithograph in colours

SIMILAR WORKS

Series of posters for the New York Central System by Ragan, 1940s

Leslie Ragan *Born* 1897 Iowa, USA

Died 1972

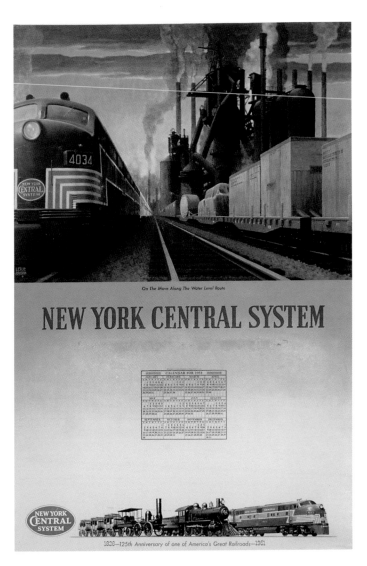

On The Move Along The Water Level Route

NEW YORK CENTRAL SYSTEM

CALENDAR FOR 1951

1826—125th Anniversary of one of America's Great Railroads—1951

Art Deco

Society

Lalique, René
Selection of scent bottles

Courtesy of Private Collection/Bonhams, London, UK/www.bridgeman.co.uk/© ADAGP, Paris and DACS, London 2005

Today, the name of René Lalique is most closely associated with glassware of the Art Deco period, but he typifies the talented artist-designers of the time who were limited neither by an art movement or a medium. Lalique began his career as a jeweller, receiving commissions from celebrities of the day such as Sarah Bernhardt (1844–1923). He made his name at the 1900 Paris Exhibition, from which he emerged as a triumphant success. By 1905 Lalique was producing mirrors, patterned fabrics and small objects made from glass.

In 1906 Lalique received a commission to design perfume bottles for François Coty (1874–1934) and went on to concentrate on the glassware for which he has become so famous; by 1918 he was working almost exclusively in glass. Lalique had his own pavilion at the famous 1925 Paris Exhibition, and in the 1930s he designed chandeliers and glass panels for the luxury cruise ship the *Normandie*. Lalique's glassware appealed to the high society of the 1920s. During this time, luxury and opulence were the quintessential marks of success; displaying one's wealth through one's couture and home furnishings was no longer considered vulgar, but an indication of refined taste.

MOVEMENT

Art Deco

MEDIUM

Glass

SIMILAR WORKS

Sandblasted vases with mirrored finishes by Jean Luce, *c.* 1920s

Glassware in the Ruba Rombic pattern by the Consolidated Lamp and Glass Company of Pennsylvania, 1928

René Lalique *Born* 1860 Ay, France

Died 1945

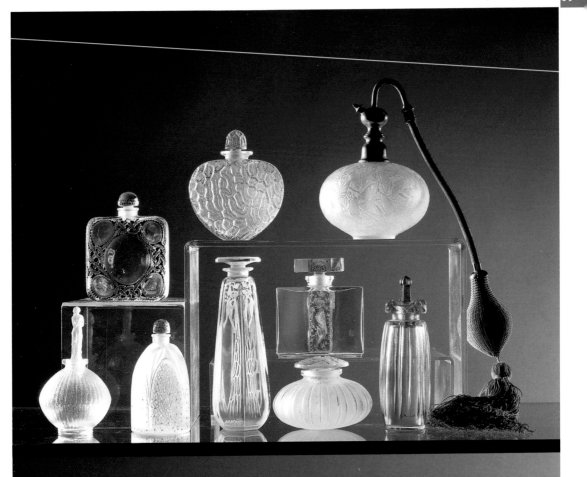

Lalique, René
Suzanne (au Bain), *c.* 1932

This exquisite figurine, made from moulded glass, celebrates the essential frivolity and joy of the French Art Deco movement. At a time when the hoi polloi still lived in relative poverty, the wealthy sought out *objets* to furnish their apartments. Lalique, however, was unusual; although his designs were of the highest quality, he endeavoured to include machine production in to his repertoire of techniques, thus making his glassware more widely available than that of his contemporaries such as Maurice Marinot (1882–1960).

This sculpture of Suzanne having her bath celebrates the female body; the intricate folds of the draped fabric refracts light passing through it, adding to the shimmering effect of the opalescent glass. In Paris during the 1920s and 1930s, American-born Josephine Baker (1906–75) was thrilling visitors with her 'exotic' cabarets. Nudity was in vogue and the 'perfect' human body became something to celebrate. Also apparent in European and American societies at the time was a dark side to this obsession with perfection: eugenics. This popular movement advocated selective breeding to remove 'undesirable' characteristics, such as non-white skin colour and Jewish features.

MOVEMENT

Art Deco

MEDIUM

Opalescent moulded glass

SIMILAR WORKS

Glass and chrome clock by Ernest-Marius Sabino, 1928

Oiseau de Feu by Lalique, 1925

René Lalique *Born* 1860 Ay, France

Died 1945

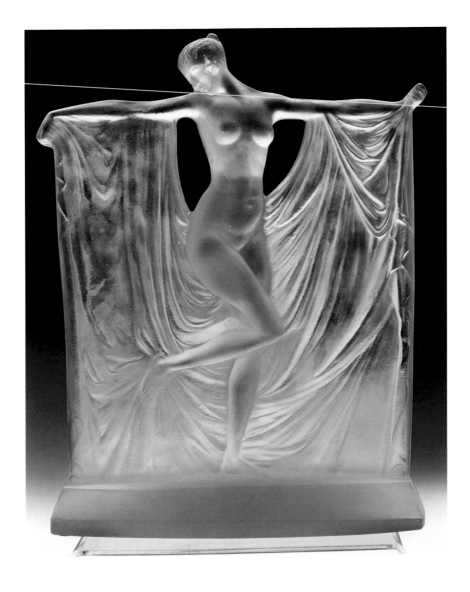

Lalique, René

Selection of vases & bowl: Gros Scarabees, Anvers, Milan, Forest, Danaides, Sauge, Bacchantes, Farandole

Courtesy of Private Collection/Bonhams, London, UK/www.bridgeman.co.uk/© ADAGP, Paris and DACS, London 2005

Glassware of the inter-war period became highly innovative, and the artisans who were designing and creating it were experimental in their approaches. Stylish and versatile, glass lent itself well to the wide array of decorative styles that were being employed at the time. The heavy, dour interiors of the nineteenth century were a thing of the past; new interiors celebrated light and space. With electric lighting a relatively new medium, designers found that placing a light source behind a piece of glassware could instantly transform it into something vital and exciting and could provide a focus in a room.

Lalique adopted new methods of mass production, such as press moulding and machine blowing. This helped to keep the prices of his glassware down and as a result they were hugely popular. The intricate designs also meant that Lalique's pieces were always associated with glamour and sophistication – essential attributes in the seduction of consumers.

MOVEMENT

Art Deco

MEDIUM

Glass

SIMILAR WORKS

Deux Paons (peacocks): lamp by Lalique, *c.* 1925

René Lalique *Born* 1860 Ay, France

Died 1945

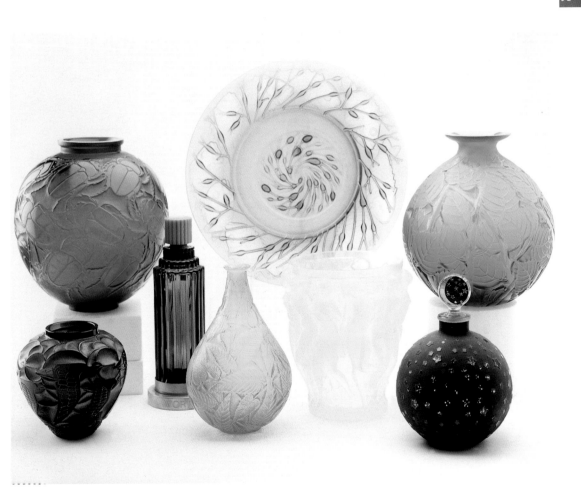

Lalique, René

Grande Libellule (Large Dragonfly) car mascot, 1928

By the end of the 1920s, one in five residents of the United States owned a car; nearly 30 million motor vehicles were on the road by 1929 – the result of mass production and mass consumption. The Roaring Twenties were, especially for America, a time of huge economic growth, and a modern, middle-class economy developed.

Mass production was appealing because it kept prices low and increased the number and type of products available. The downside of mass production, however, is that items – such as cars – seem unremarkable and it becomes harder for a person to demonstrate their individuality through ownership. The Art Deco period had an answer to this in its quirky approach to decoration and ornamentation. By purchasing novelty items, a consumer could prove that they still had an eye on what was cutting-edge and fashionable. René Lalique's car mascots suited this objective perfectly.

Lalique produced 29 car mascots in total. They mostly depicted animals or motifs and figures that typified the age: *Victoire*, *Comete* and *Vitesse* are a few examples. The mascots would be mounted at the front of a car and could even be illuminated by attaching a simple light to the car's wiring system.

MOVEMENT

Art Deco

MEDIUM

Glass

SIMILAR WORKS

Victoire (1928) and *Faucon* (1925): car mascots by Lalique

René Lalique *Born* 1860 Ay, France

Died 1945

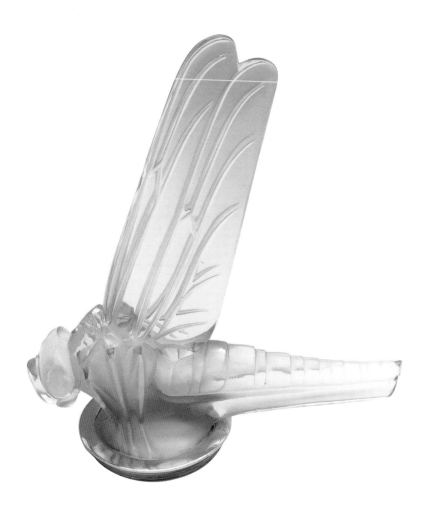

Lalique, René

Whirlpools vase, 1926

The designs of René Lalique's glassware capture the diversity of the decorative arts at the beginning of the twentieth century. Some of his most popular creations are delicate and exquisite sculptures, depicting svelte female forms whose bodies seemed to flow with the molten glass. Over his long career, however, Lalique was able to experiment with different styles and some of his pieces clearly exhibit the tension that existed between the highly decorative style of 1920s Art Deco and Cubism. This modern art form had been developed by Georges Braque (1882–1963) and Pablo Picasso (1881–1973) and it was part of the avant-garde movement that informed the work of many artists at the time.

Avant-garde art challenged the nature of decoration and demanded that the artist consider the materials he was using as part of his construction. The artist was expected to be true to his materials rather than disguise them underneath unnecessary ornamentation. As a result, abstract art became an influential force in the cultural world of the 1920s. This vase by Lalique celebrates the shape created by a press mould; the decoration is not superficial, but is part of the form and emphasizes space and light.

MOVEMENT

Art Deco/Moderne

MEDIUM

Press-moulded glass decorated with black enamel

SIMILAR WORKS

Harlequin Vase (enamelled) by Marcel Goupy, *c.* 1925

René Lalique *Born* 1860 Ay, France

Died 1945

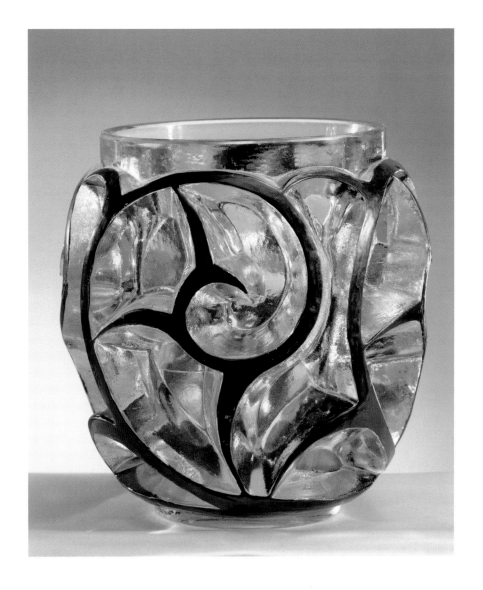

Cliff, Clarice

Tennis pattern (tea for one and plate), *c.* 1930

"Colour seems to radiate happiness and the spirit of modern life." This was the explanation Clarice Cliff gave for her predilection for bold colours in 1930. It is easy to imagine how so many people, during the difficult years of the 1930s, found pleasure from the tableware that Clarice Cliff designed. Her patterns were often modern and abstract and her colours bright: a far cry from the dreary, dull tableware with which most people would have grown up. One newspaper reporter was not impressed by Clarice's *Bizarre* range of ceramics, writing that it looked like "a Russian ballet master's nightmare." The *Pottery Gazette* was more perceptive and printed in 1931 that Cliff was "a pioneer of advanced thought."

By 1931 Clarice Cliff employed 150 people to produce her ceramic wares. Women painted the designs by hand, resulting in subtle variations from piece to piece, especially noticeable when the copy book was not available and the artist painted from memory. This set by Clarice Cliff is decorated in the *Tennis Pattern*, so called because it features a net design that is framed in an abstract array of lines and circles.

MOVEMENT

Art Deco

MEDIUM

Ceramic

SIMILAR WORKS

Bizarre by Cliff, 1927

Kestrel by Susie Cooper, 1930s

Clarice Cliff *Born* 1899 Staffordshire, England

Died 1972

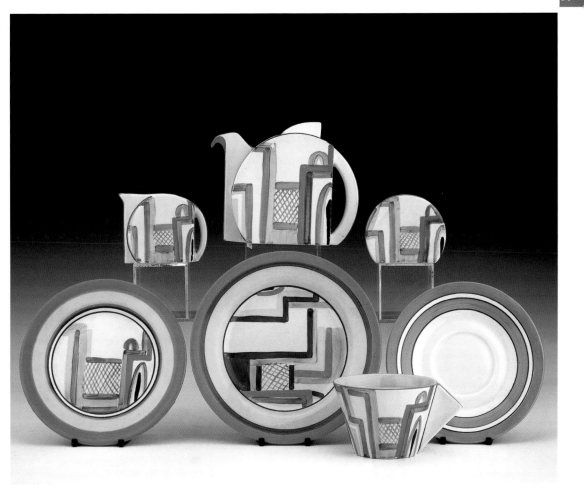

Cliff, Clarice

A double conical vase featuring the *Blue W* pattern, 1929–30

Women were the primary purchasers of Clarice Cliff's ceramics and the skilled British designer was well aware that what appealed were the bright, bold designs. "Colour and plenty of it... I cannot put too much of it in to my designs to please women", she explained. Clarice Cliff's considerable talent did not just lie in her formidable design skills. With an eye to the Modernist art movement, she concentrated on innovative patterns and marketed her wares well. Entrances to London department stores became Clarice Cliff grottos, as painters transformed simple white ware to gloriously extravagant pieces while shoppers watched. Women in the early 1930s were in need of cheering up, and Cliff understood what they wanted.

In the inter-war years Britain was beset with industrial problems; the Victorian heyday was long since gone and factories faced growing difficulties with ageing machinery and an economic slump. In 1926 the General Strike had hit the nation hard, and by 1930 there were more than two million unemployed people in Britain. Nevertheless, mass consumerism was a growing trend.

MOVEMENT

Art Deco

MEDIUM

Ceramic

SIMILAR WORKS

Geometric Buttons by Clarice Cliff, 1929–30

Clarice Cliff *Born* 1899 Staffordshire, England

Died 1972

Cliff, Clarice

Ginger Jar, *c.* 1925

This ginger jar was designed by the innovative British ceramist Clarice Cliff early in her career, and demonstrates a classic approach to her craft that would change once she had been exposed to the artistic influences of the day.

Cliff began work as an apprentice at the local potteries in her native Staffordshire when she was just 13 and joined A.J. Wilkinson's Royal Staffordshire Pottery in 1916. She was zealous in her approach to work and learned as much as she could about ceramics. Cliff's determination brought her to the attention of the factory's owner, Colley Shorter, and he moved her from the factory floor to the design studio in 1925 – the year of the Paris Exhibition that was to provide a showcase for the Art Deco world.

Colley nurtured the emergent talent that he had witnessed in Cliff and took her to Paris and London where she briefly studied at the Royal School of Art. Cliff absorbed the Art Deco influences that were making their mark on the cultural world of the Jazz Age. She later said "I did what I expect all other people who are interested in their trade or profession to do; I utilised every opportunity to study the products of other people more advanced than I."

MOVEMENT

Art Deco

MEDIUM

Ceramic

SIMILAR WORKS

Wall Plaque by Cliff, pre 1930

Saxbo stoneware vase from Denmark, *c.* 1930

Clarice Cliff *Born* 1899 Staffordshire, England

Died 1972

Cliff, Clarice
Stamford teapot, c. 1931

Clarice Cliff, the British designer of ceramic tableware, was part of a new breed of women. In the years following the First World War, the role of women in society was beginning to change. In 1918 British women over the age of 30 were given the vote (if they were householders) and by 1921 all women were finally enfranchised. This social revolution had come about partly because of the war; prior to this cataclysmic event women had not been expected to undertake paid work, except as domestic servants or in manufacturing within industrial areas. The war had necessitated a new approach to women's work, and ordinary women from all social classes were given jobs in manufacturing, transport and agriculture – jobs that had been left vacant by men who had left Britain to fight.

Cliff was one of the few women who were able to contribute to the artistic and cultural world of the Art Deco period. The trend for women to exercise themselves artistically was growing; once they had proved themselves to be just as capable as their male peers, the slow process of acceptance began.

MOVEMENT

Art Deco

MEDIUM

Ceramic

SIMILAR WORKS

Appliqué range of *Bizarre* tableware by Cliff, 1930

Clarice Cliff *Born* 1899 Staffordshire, England

Died 1972

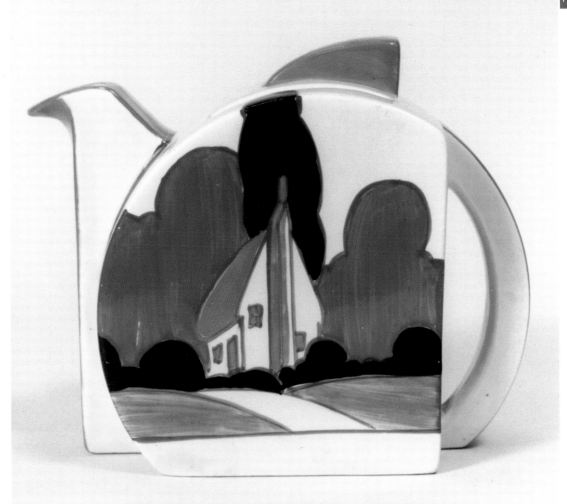

Templier, Raymond
Cigarette case in red and black lacquer

The use of lacquer was widespread during the Art Deco period. Derived from plants, this syrupy liquid was treated and applied to wood or silverware in layers to build up a glossy finish. Raymond Templier was skilled in the technique and he specialized in small, fashionable accessories, often experimenting with other decorative finishes such as eggshell and enamel.

During the 1920s Parisian jewellers, such as Templier and Jean Fouquet (1899–1984), turned the craft of jewellery making in to an art form. The roots for this transformation, however, had begun earlier when traditional forms of art had been challenged. In the first decade of the twentieth century, Cubist painters such as Georges Braque and Pablo Picasso had depicted the human shape as two-dimensional through the use of overlapping planes. Piet Mondrian (1872–1944), a Dutch painter of the De Stijl Movement, took Cubism a stage further when he created Neoplasticism – an art movement that rejected any form of natural inspiration for a work of art. Without reference to nature, he believed, art could emerge from purely abstract forms, following rules of geometry and colour. This cigarette case by Raymond Templier demonstrates how avant-garde art, like that of Mondrian, influenced many areas of cultural life in the Art Deco years.

MOVEMENT

Art Deco

MEDIUM

Red and black lacquer on silver

SIMILAR WORKS

Bracelet in onyx, white gold and yellow gold by Jean Fouquet, 1925

Raymond Templier *Born* 1891 Paris, France

Died 1968

Templier, Raymond
Brooch in lapis lazuli and blue glass, 1934

This simple brooch by the Parisian jeweller Raymond Templier is something of a paradox. At first glance it appears to be an abstract composition – it is a pleasing combination of two geometric shapes, juxtaposed to create a new shape. On second glance, however, it captures the eye and the imagination: the convex lapis lazuli could be a head and the blue glass that frames it an adornment – a Japanese wig or African headdress. It is with such simple but intelligent styling that the great jewellers of the Art Deco period achieved so much more than mere ornamentation. It was the desire of designers of the period to elevate their craft to art, and in many instances they achieved it.

Brooches were not the most popular items of jewellery during the 1920s and 1930s. The Roaring Twenties, or Jazz Age, became synonymous with a dance-crazy society in which dresses became shorter and skimpier to allow freedom of movement. The lightweight, draping fabrics that shimmered beautifully as a woman danced were not well-suited to pins and brooches. Instead, ornaments such as these were often attached to hats, straps or belts.

MOVEMENT
Art Deco

MEDIUM
White gold with lapis lazuli and blue glass

SIMILAR WORKS
Earrings in gold, ivory and enamel by Templier, c. 1925

Bangle and clips in gold, decorated with rock crystal by Suzanne Belperron, c. 1935

Raymond Templier Born 1891 Paris, France
Died 1968

Templier, Raymond Brooch set with diamonds

Fouquet, Jean Brooch in enamel and white gold set with diamonds

Fouquet, Georges Pendant necklace in coral, black onyx and diamonds

© Estates of Raymond Templier/Jean Fouquet/Georges Fouquet/Christie's Images Ltd

Jewellery of the 1920s and 1930s was dramatically different to that of the preceding years. With changing fashions in couture, women demanded a new style of jewellery to accessorize their new clothes. A flatter, more streamlined silhouette was in vogue, thanks to couturiers such as Paul Poiret (1879–1944) and the Callot Soeurs. Necklines were lowered, hems raised and sleeves became shorter or disappeared, showing off more flesh that called out for adornment. The Parisian jewellers led the vanguard of new designs and the Paris Exhibition of 1925 gave them an opportunity to startle the world with their geometric, Egyptian and oriental schemes of metalwork, colour and pattern. New techniques for stone-cutting and a fresh approach to combinations of colours produced startlingly original pieces of jewellery.

Parisian jewellers sought inspiration from the exotic: Egyptian motifs adorned pendants and bangles, while the Ballets Russes, under the artistic guidance of Sergei Diaghilev and Leon Bakst, introduced a new palette of bold colours and a flamboyant vibrancy to artisans such as Templier, Cartier and the house of Fouquet.

MOVEMENT

Art Deco

Raymond Templier Born 1891 Paris, France

Died 1968

Georges Fouquet Born 1862 Paris, France

Died 1957

Jean Fouquet Born 1899 Paris, France

Died 1984

Belperron, Baume & Mercier, Templier
Jewellery

A wealthy woman of the 1920s and 1930s who followed fashion would have needed quite different jewellery to her mother's heavy, ornate and dour collection. The influence exerted by movies and magazines encouraged women to aspire to a radical new look; dresses were often made of lightweight materials, were sleeveless and had plunging necklines and backs. The jewellery of the era needed to complement this style.

The bracelets and bangles that adorned bare arms mimicked those brought from overseas colonies. Tribal artefacts from Africa, Egyptian motifs and Eastern European folk craft all influenced designers, and wide bangles soon became popular. They were often worn above the elbow and bore geometric patterns or gemstones. Wealthy heiress Nancy Cunard (1896–1965) became famous for the enormous ivory bangles that covered her forearms, and helped to set a trend. Gloves were no longer in vogue and a fashion for large rings developed. Wristwatches for women also appeared at this time, but pendant watches that attached to a woman's dress proved more popular.

Wealthy women could buy jewellery that boasted diamonds, rubies and other rare gems, possibly set in platinum, a metal that had only become workable in the 1900s. Their less wealthy peers made do with paste jewellery, which imitated the fashionable designs using cheaper materials.

MOVEMENT

Art Deco

CLOCKWISE FROM TOP

Templier, Raymond
Diamond Brooch

Belperron, Suzanne
Ruby, Diamond and Rock Crystal Ring

Belperron, Suzanne
Emerald and Rock Crystal Ring

Belperron, Suzanne
Diamond and Rock Crystal Brooch

Baume & Mercier
Diamond Watch-Ring

Chiparus, Dimitri
Les Girls, c. 1930

Dance – particularly jazz and ballet – became a hugely influential art form for the Art Deco world; the 1920s were even nicknamed 'The Jazz Age', and the associated style was called 'Jazz Moderne'. Ballet, a traditional dance form, had undergone a revolution in the hands of Sergei Diaghilev and the Ballets Russes, first performed in Paris in 1908. Diaghilev had brought together some of the greatest talents of the era, hoping to create something radical from their collaboration. He succeeded: Leon Bakst sought inspiration from the Orient and Middle East and designed stage sets and costumes that were alive with colour and texture; Michael Fokine (1890–1942), a talented choreographer, worked with the musical scores of Igor Stravinsky (1882–1971), Sergei Prokofiev (1891–1953) and Claude Debussy (1862–1918); and the principal dancers were the legendary Vaslav Nijinsky (1890–1950) and Anna Pavlova (1881–1931).

On opening night the curtain did not just raise on a dance spectacle, it was raised on an entirely new era of influence for the painters, sculptors, couturiers and interior designers of the day. Dancers became popular icons for sculptors in particular, who saw in their slender, lithe bodies the embodiment of all that 'high' Art Deco valued.

MOVEMENT

Art Deco

MEDIUM

Bronze and ivory

SIMILAR WORKS

Pierrot et Pierrette: sculpture in bronze and ivory by Chiparus, c. 1925

Towards the Unknown: sculpture by Claire Jeanne-Roberte Colinet, c. 1920s

Dimitri Chiparus *Born* 1888 Romania

Died 1950

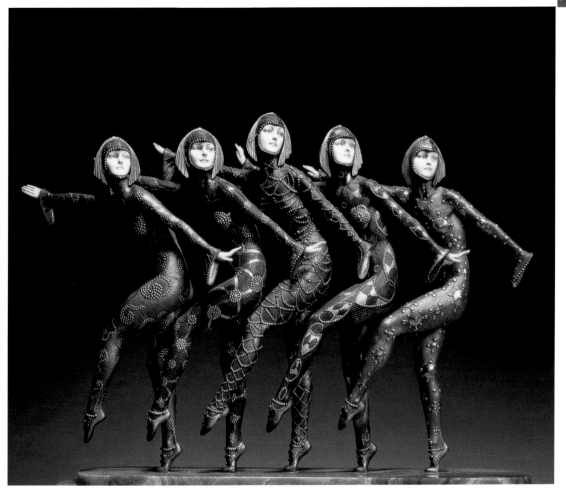

Chiparus, Dimitri

Dancer of Kapurthala

Ballet was the most influential dance movement of the years leading up to the First World War. In the 1920s, however, jazz became the obsession of the 'smart set'. The result of a fusion of European and West African dance forms, American blues and ragtime, jazz set the world swinging with its syncopated rhythms that were fitting to the geometric design fixations of the day.

The design world had sought inspiration from African tribal art, and in the music of jazz, which had strong roots in African-American music, it found a similar source of inspiration and *l'art nègre* became part of the music scene. Jazz had an enormous effect on the popular culture of the time. It crossed the boundaries of colour and class and jazz clubs opened up everywhere.

In Paris in 1925 Josephine Baker, an African-American performer, showed Parisians the true power of dance when she began performing at *La Revue Nègre* and later at the infamous *Folies Bergère*. Baker's dances were erotic, wild, primitive and sexually charged. She inspired many artists to design their figures, especially in sculpture, as skimpily clad and in erotic poses.

MOVEMENT

Art Deco

MEDIUM

Gold painted gilt bronze and ivory

SIMILAR WORKS

Aspects of Negro Life: Song of the Towers by Aaron Douglas, 1934

Josephine Baker by Paul Colin, 1927

Dimitri Chiparus *Born* 1888 Romania

Died 1950

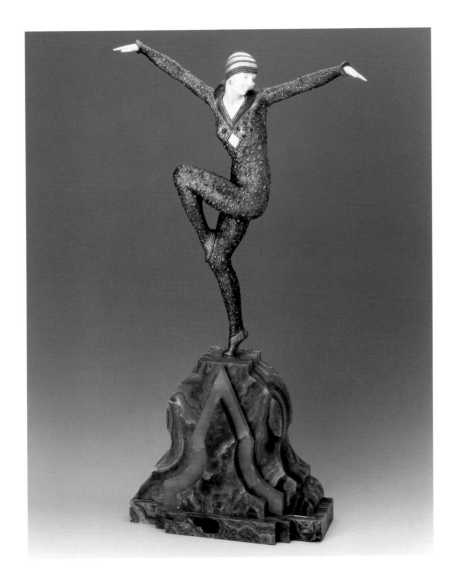

Chiparus, Dimitri
The Squall

Figures portrayed by sculptors such as Dimitri Chiparus and Johann Preiss (1882–1943) are considered by many to embody the age in which they were created. They were often made from chryselephantine; this is a combination of materials, originally gold and ivory but the term can also describe ivory with other materials, such as metal, stone or wood. This medium, often matched with highly detailed painting, served to create some quite extraordinary pieces that have come to symbolize the Art Deco period. They are elegant and fluid, but occasionally decorated to an extreme that borders on vulgarity. The subjects for such figurines varied but were usually women. They were naturalistic but stylized, and occasionally humorous or erotic.

Dimitri Chiparus was born in Romania but worked in Paris, where he held his first exhibition at the *Salon des Artistes Français* in 1914. His early works often featured groups of children playing, but as his work matured he found inspiration in models of dancers and the French theatre. His pieces are characteristically worked in great detail and colour, unlike those of his contemporary Claire Jeanne-Roberte Colinet (1882–1940), who favoured a golden-toned patina on bronze.

MOVEMENT

Art Deco

MEDIUM

Bronze and ivory

SIMILAR WORKS

Kora: a gild and cold painted chryselephantine sculpture by Chiparus, *c.* 1930

Nude Juggler by Colinet, *c.* 1900

Dimitri Chiparus *Born* 1888 Romania

Died 1950

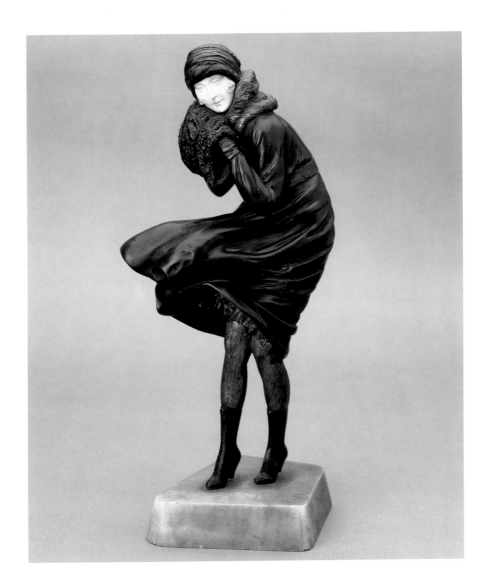

Chiparus, Lorenzl & Rossi
Egyptian figures

One of the foremost influences on Art Deco was the western world's newfound interest in all things Egyptian. This phenomenon resulted partly from the ambient mood that was looking beyond European boundaries for inspiration. Explorers, anthropologists and archaeologists were busy pillaging the cultures of far-away places, while improved methods of transport opened up the world to people through the burgeoning tourist and leisure industries.

As the 1920s got underway, the principle exotic influences on Art Deco came from the French colonies. By 1922, however, the tomb of Tutankhamen had been discovered by Howard Carter and Lord Carnarvon, and at the Paris Exhibition in 1925 the effect of 'Nile Style' was evident. Pyramid shapes, cobras and scarabs adorned jewellery, screens, stained glass and stage designs. The simple geometric shapes that adorned many Egyptian artefacts appealed to the modernists, too – they could be simplified, abstracted and repeated as simple, decorative motifs.

MOVEMENT

Art Deco

MEDIUM

Gilt bronze and ivory

Dimitri Chiparus *Born* 1888 Romania

Died 1950

Eduardo Rossi *Born* 1867 Italy

Died 1926

Joseph Lorenzl *Born* 1892 Austria

Died 1950

LEFT TO RIGHT

Rossi, Eduardo
The Snake Charmer

Chiparus, Dimitri
The Egyptian Dancer

Lorenzl, Joseph
Figure of a Dancer

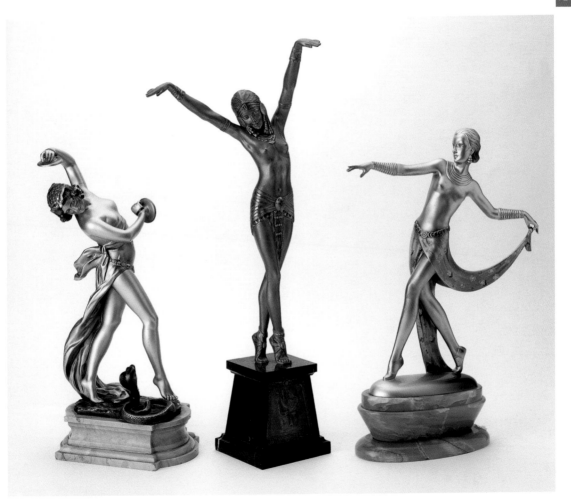

Dufrène, Maurice

Desk and chair inlaid with ivory

© Estate of Maurice Dufrène/Christie's Images Ltd

Domestic and commercial interiors of the Art Deco world were not just places to live or work. They were showcases of style and were often the result of collaboration between a set of skilled artisans, co-ordinated by an ensemblier or interior designer. Rather than vying for attention, the furniture, ornamental objects, lighting and textiles were meant to complement one another and create harmonious interiors.

Parisian designers and ensembliers are among the most celebrated of the Art Deco period, particularly prior to the Modernist influences. French designers such as Jacques-Emile Ruhlmann (1879–1933) and Maurice Defrène were noted for their choice of materials: they used the best, most expensive and frequently exotic woods and inlays. At the time, many European countries had colonies in Africa, South America and Asia, and tropical forests were readily exploited to keep the cabinet-makers supplied. In an age when hunting was considered to be a noble enterprise, there was no shortage of ivory being imported and other animals, including shelled sea creatures, snakes, crocodiles, turtles and tortoises, unwittingly contributed towards the aesthetic of the Art Deco world.

MOVEMENT

Art Deco

SIMILAR WORKS

Walnut and coromandel-veneered sideboard by Sergei Chermayeff, 1939

Maurice Dufrène *Born* 1876 Paris, France

Died 1955

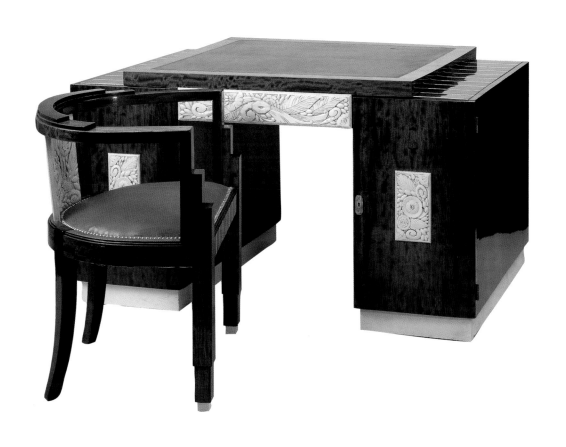

Dunand, Jean

Lacquered wood coiffeuse, for the boudoir at the
Salon des Artistes Décorateurs, Paris

At the beginning of the new century, the influence of Art Nouveau was still strong, but there were other emergent art forms and styles. Organizations were established that enabled artist-decorators to exhibit their works to their peers and potential clients. Prior to this, designers and their ilk had been expected to show their work at fine art shows, where their creations were considered the lesser of the two art forms. In 1901, the *Sociéte des Artistes Décorateurs* was formed in Paris. Members included influential artists of the Art Nouveau period, such as Eugène Grasset (1845–1917) and Eugène Gaillard (1862–1933). Over the following years, exhibitions continued to be shown at the *Salon des Artistes Décorateurs* and the *Salon d'Automne*, where in 1911 the exhibitors included a German contingent who had been invited to shake up the Parisian designers. Each German room had been designed by a single architect, creating a sense of unity and sophistication. The use of modern forms and bold colours achieved its aim of unsettling the French, and by the 1912 Exhibition French furniture designs were more innovative and less imitative of earlier styles.

MOVEMENT

Art Deco

MEDIUM

Lacquered wood

SIMILAR WORKS

Dressing table in oak with amaranth and mahogany veneer by Jacques-Emile Ruhlmann, 1925

Jean Dunand *Born* 1877 Switzerland

Died 1942

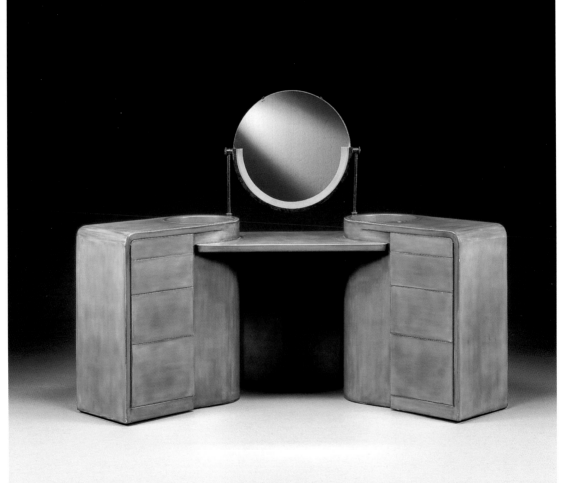

Dunand, Jean

Panneau de Laque D'Or Gravé (Gold-lacquered panel with engraving of a stallion's head with streaming mane)

Courtesy of Christie's Images Ltd/© ADAGP, Paris and DACS, London 2005

Jean Dunand was a master designer of the Art Deco period, whose skills only came to light in recent years following exhibitions highlighting his work. Despite this, Dunand enjoyed a high level of success in his lifetime. Born in Switzerland, Dunand trained in metalware and was showing his work in Paris by the late 1800s. By the 1920s he had perfected a new technique for hammering shapes out of a copper panel laid over a mould, a technique he used to create a range of sculptures and vases. Dunand found inspiration from the Japanese craftsman Seizo Sugawara, who trained him in the technique of lacquer-work; this quickly became a medium in which Dunand specialized. When the cruise liner *Normandie* undertook her maiden voyage in 1935, a mural by Dunand decorated the smoking room. He often worked in collaboration with other artists: Jacques-Emile Ruhlmann, for example, designed pieces of furniture that Dunand lacquered.

MOVEMENT

Art Deco

MEDIUM

Metal panel with lacquer

SIMILAR WORKS

Lacquered bed decorated with mother-of-pearl for Madame Bertholet by Dunand, 1930

Jean Dunand *Born* 1877 Switzerland

Died 1942

Dunand, Jean
Screen, 1920–25

Courtesy of Victoria and Albert Museum, 2005/© ADAGP, Paris and DACS, London 2005

In 1925, France displayed its supremacy in *objets d'art* to the world. Conceived before the First World War, the *Exposition Internationale des Arts Décoratifs et Industriels Modernes* took place in Paris. Now referred to as the Paris Exhibition, this enormous event was a showcase for French goods – although it had the appellation 'internationale', more than two thirds of the site was given over to French producers. Designers such as Dunand, Ruhlmann and Maurice Dufrène contributed to its success.

At the time, it was universally agreed that Paris was the only city that could boast exclusive boutiques, stocked with luxury items. Wealthy heiresses travelled great distances to visit these boutiques for their clothes, jewellery and other expensive accessories. The aim of the Paris Exhibition was to define the Gallic style and encourage modernism in design, but it was also unashamedly commercial. Exhibitions of previous years had made great displays of technology – the 1889 Exhibition even featured the Eiffel Tower – but the 1925 Exhibition drew the world's eye to the glory of Paris and the fun that shoppers could have amongst its streets and avenues.

MOVEMENT

Art Deco

SIMILAR WORKS

Rounded display cabinet, designed for the Paris Exhibition by Paul Follot, 1925

Pedestal table of palissander-wood veneer by Pierre Chareau, *c.* 1928

Jean Dunand *Born* 1877 Switzerland

Died 1942

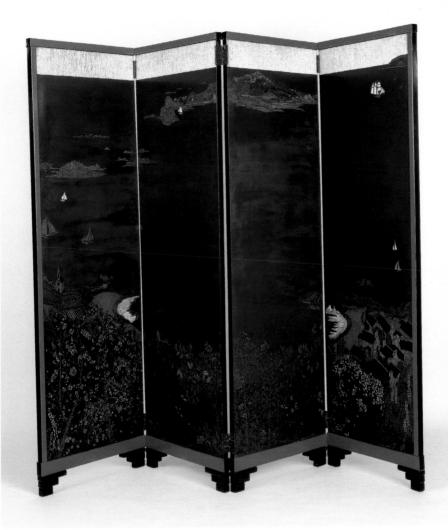

Saudé, Jean

Fumoir en Laque (Smoking room in lacquered panels, created for the *Ambassade Française* at the Paris Exhibition), 1925, from interior designs by Jean Dunand

In 1925, Paris staged the exhibition that set the parameters for the Art Deco world. It became the defining moment of the era and is widely believed to be the event that came to epitomize the fusion of decorative arts and styles that characterized the first part of the twentieth century. The aim of the exhibition was to publicize France's supremacy in the world of decorative arts and to inspire its artists and artisans to embrace modernity. A group of artists at the *Salon des Artistes Décorateurs* had supported the Exhibition, and they put together their own exhibit with some financial help from the Ministry of Fine Arts. The exhibit was called *Ambassade Française* and its stated intent was to create 'the reception rooms and private apartments of a French embassy'. Members of the society collaborated to produce the different rooms for the embassy and more than 30 were involved in the creation of the *Grand Salon*. Jean Dunand designed the smoking room created by Jean Saudé, with black and silver lacquered panels on the walls and fabrics inspired by African and abstract art.

MOVEMENT

Art Deco

SIMILAR WORKS

Bibliothèque by Pierre Chareau for the *Ambassade Française*, 1925

Lagrange, André

Le Fumoir (Smoking room created for the *Normandie*), 1935, from interior designs by Jean Dunand

Courtesy of Private Collection/Archives Charmet/www.bridgeman.co.uk/© ADAGP, Paris and DACS, London 2005

The French ocean liner *Normandie* came to epitomize the glory days of the wealthy elite, who enjoyed luxurious lives and indulgent means of travel before the Second World War. Conceived in 1928 and launched in 1932, the *Normandie* was, at the time, the largest object ever to be set in motion by man. The fastest, sleekest and most artfully designed cruise ship of its time, the *Normandie* sailed across the Atlantic with its berths occupied by members of the smart set; there were places for 848 first class passengers, 670 second class and a mere 54 for third class. Its maiden voyage took place in 1935.

Despite its glorious interiors, sumptuously designed by the greatest craftsmen and artists of the Art Deco world, the *Normandie*'s future was not grand. Her construction had taken place during the early days of the Great Depression, and as she embarked on her short career the world was only a few years away from the Second World War. She was returned to dock in New York to be refitted as a naval ship, but a careless accident led to a devastating fire on board and the *Normandie*, Ship of Light, sank.

MOVEMENT

Art Deco

MEDIUM

Colour lithograph (painted by André Lagrange)

SIMILAR WORKS

The Parisian apartment of Georges-Marie Haardt, by Jacques-Emile Ruhlmann, 1927

Dunand, Jean
Bateau bed

Paris was the epicentre for the decorative arts in the years up to the 1925 Exhibition, which aimed to highlight the French empire and assert France's position as the leading producer of luxury items. The *arts décoratifs* industry, including couturiers, lined the streets in the form of classy boutiques that attracted visitors from around the world. Shoppers were enticed by electric lighting, which illuminated the boutiques and avenues at night. They were also entranced by the showing of film, as this was the first international exhibition to feature the new medium.

By 1925, French artist-designers had been invited to create sets for the burgeoning film industry. While international exhibitions were a successful way to publicize a nation's wares, cinema proved to be the ideal advertising medium. When people visited the cinema they saw inside other people's – albeit make-believe – homes, and lost themselves in the dream of living other, more glamorous lives. Women, especially, desired homes, furnishings and fashions like those they saw on the silver screen; marketing and consumerism would never be the same again.

MOVEMENT

Art Deco

SIMILAR WORKS

Piroque day bed in lacquered wood and silver leaf by Eileen Gray, *c.* 1920

Chaise-longue in beechwood and upholstered in cream silk by Betty Joel, *c.* 1930

Jean Dunand *Born* 1877 Switzerland

Died 1942

Dunand, Jean

La Moisson (The Harvest), *c.* 1935

Jean Dunand was typical of many artist-decorators of his day in that, although originally educated and apprenticed in one medium, he proved adaptable and was able transfer his skills to different areas of the decorative arts. It was this flexible approach that enabled artisans of the day to change society's perception of the decorative arts, as the line between this art form and fine art became less distinct. By developing his skills in different areas of design and technique, Dunand, like many of his contemporaries, was able to undertake large design schemes that brought harmony to an interior. Thus the interior designer, or ensemblier, worked to ensure that all the furniture, fabric, lighting, sculpture and art within a living space complemented one another.

Dunand had originally intended to become a sculptor when he arrived in Paris in 1896. Six years later, his attention had turned to developing *dinanderie* – the technique of applying bronze-coloured alloys to decorative work. After ten years of successful metalwork, Dunand studied the craft of lacquering, an Eastern technique used to apply a vegetable-based resin to metal or wood, creating a glossy finish. Besides these many talents, Dunand was also an accomplished artist and painter.

MOVEMENT

Art Deco

MEDIUM

Lacquered panel

SIMILAR WORKS

Book cover in eggshell lacquer for *Histoire de la Princesse Boudour* by Jean Dunand, 1926

Jean Dunand *Born* 1877 Switzerland

Died 1942

Cassandre, A.M. (Adolphe Jean-Marie Mouron)

Travel poster advertising New Statendam, the Holland-America Line, 1928

Society in the 1920s was emerging from the horrors of the First World War with a joy for life that was unbounded. The older generation wanted life to return to its former slow pace, but the younger generation had other ideas. Fashionable society set out to challenge every convention: women drank and smoked in public, cocktail parties replaced dinner parties, and social and racial barriers began to break down as members of the smart set began to marry outside their social class.

While the image of 'bright young things' lounging on chaises-longues at cocktail parties presents an attractive picture of the Roaring Twenties, the reality was very different for a great many people who lived in poverty and experienced unemployment. While the wealthy set enjoyed deluxe travel and joined cruise ships to cross the Atlantic, those at the other end of the social scale queued up at soup kitchens for their daily ration.

MOVEMENT

Art Deco/Streamlining

MEDIUM

Colour lithograph

SIMILAR WORKS

Venezia: poster by Cassandre, 1930s

A.M. Cassandre *Born* 1901 Kharkov, Ukraine

Died 1968

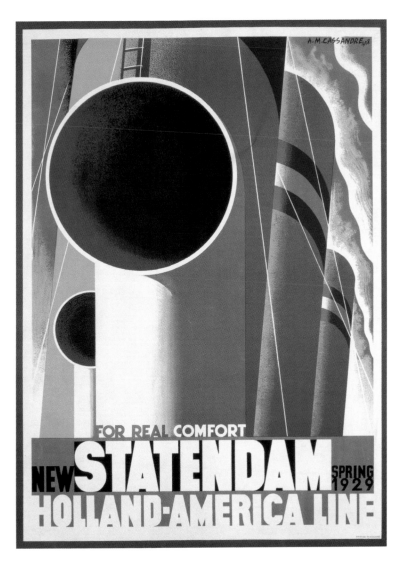

Cassandre, A.M. (Adolphe Jean-Marie Mouron)

Advertisement for Les Vins Nicolas, 1935

© Estate of A.M. Cassandre/Private Collection, Giraudon/www.bridgeman.co.uk

Advertising came of age during the 1920s and 1930s, especially in America where consumerism became not just fashionable but desirable. Prior to the 1920s, people hoped to improve their lot by improving themselves – they believed that by working harder, becoming more self-disciplined and doing the 'right thing' their lives could get better. During the '20s and '30s, however, these attitudes began to change. People began to reject the improvement of character and instead embrace the improvement of personality: knowing the right things about fashion, movies and books, and having the right possessions, such as clothes, cars and household goods, became all-important.

After the First World War, America swiftly became the richest society the world had ever known. Credit became more readily available and people were able to buy radios, cars and household appliances. Consumerism in the US, and to a lesser extent in Europe, was on a roll and advertising reflected this. Posters had been an essential advertising tool at the beginning of the twentieth century, but their importance began to fade as radio and magazine advertising took over.

MOVEMENT

Art Deco

MEDIUM

Colour lithograph

SIMILAR WORKS

Dubonnet: poster by Cassandre, 1932

A.M. Cassandre *Born* 1901 Kharkov, Ukraine

Died 1968

Cassandre, A.M. (Adolphe Jean-Marie Mouron)

Poster for *L'Etoile du Nord Pullman*, Paris-Brussels-Amsterdam, 1927

This poster by Cassandre shows how stylized posters had become towards the end of the 1920s – different in every respect from the Art Nouveau posters of Alphonse Mucha (1860–1939), which had been filled with sensuous curves, natural colour and refined decorative elements. Instead of creating art for art's sake, poster designers had, by necessity, begun to create designs and images that would startle the viewer, capture the imagination and sell a brand.

Russian-born Cassandre was one of the greatest and most innovative commercial artists of the twentieth century. His early paintings were influenced by Paul Cézanne (1839–1906), but by 1923 he was designing posters and won an award for his work at the Paris Exhibition in 1925. His strong designs often feature flattened imagery that creates a sense of perspective and speed: common themes during the era in which smooth and sleek forms were becoming fashionable.

MOVEMENT

Art Deco/Streamlining

MEDIUM

Lithograph in colours on paper

SIMILAR WORKS

Sensation Cigarettes: poster by Cassandre, 1930s

A.M. Cassandre *Born* 1901 Kharkov, Ukraine

Died 1968

Cassandre, A.M. (Adolphe Jean-Marie Mouron)

Poster for the *Chemin de Fer du Nord*

The inter-war years marked a transitional period in which there were two economies and two societies. Despite an economic recession which led to the Great Depression in the 1930s, living standards were, on the whole, rising. The US, in particular, typified the changing world. Transport was becoming more accessible to the ordinary people, especially transport by car – thanks to Henry Ford (1863–1947), who developed large scale production of his automobiles. Steam power was gradually being replaced by electricity, and – with the invention of early plastics and man-made fibres – mass production of consumer goods became a *tour de force*. Travel helped to broaden people's perspectives and gave them glimpses of other cultures.

The new economy was fuelled by increased levels of marketing and advertising. Funded by advertisements, magazines such as the *Ladies' Home Journal* and *Saturday Evening Post* were inexpensive and would be found in middle-class American homes. People were also exposed to a new range of entertainment media; radio carried marketing messages and up-to-date information on current affairs and music, with stars from the movie industry being paid to endorse products.

MOVEMENT

Art Deco

MEDIUM

Colour litho

SIMILAR WORKS

Grand Sport: poster by Cassandre, 1931

A.M. Cassandre *Born* 1901 Kharkov, Ukraine

Died 1968

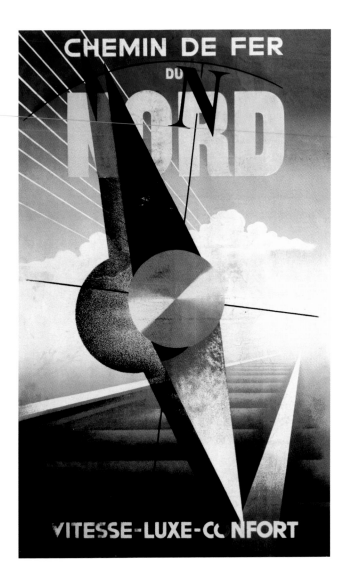

De Lempicka, Tamara

Self-portrait, *c.* 1925

This stylish self-portrait encapsulates much of what the Art Deco movement has come to represent. The image of a beautiful woman, driving her own car and clearly self-possessed, seems to be separated from the ethereal women of the Art Nouveau period by more than just twenty years. This defines the Art Deco woman as a consumer: her character is irrelevant, but her ownership of the green Bugatti marks her social success.

Many years later, this self-portrait was used to demonstrate how women of the 1920s and 1930s claimed their freedom. For independently wealthy women, of course, this was much easier than for those who were dependent on their husbands' often meagre income. But the tide was turning and at this point in history, women were rebelling. In England Dora Black (1894–1986), wife of the philosopher Bertrand Russell (1872–1970), published a handbook that aimed to promote a modern approach to marriage, which Black considered to be a contract of slavery for many women. Dr Marie Stopes (1880–1958) had published her guide to birth control for married women, while American-born Nancy Astor (1879–1964) became the first woman elected as a British Member of Parliament and campaigned for women's rights until 1945.

MOVEMENT

Art Deco

MEDIUM

Oil on wood

SIMILAR WORKS

Portrait of Arlette Boucard by De Lempicka, 1928

Moon in New York by Georgia O'Keeffe, 1925

Tamara de Lempicka *Born* 1900 Warsaw, Poland

Died 1980

De Lempicka, Tamara
The Orange Turban, 1935

The Art Deco movement was largely concerned with artifice, as the influence of avant-garde artists forced society to question its obsession with Neoclassicism, decoration, ornamentation and superficiality. Modern artists were more concerned with understanding and displaying art as a product of its materials and its relationship with light and space. Modern art did not try to be anything other than what it was.

De Lempicka's work is unusual because it fused the two elements that influenced the artists and artist-decorators of the time. Her paintings appealed to the wealthy and successful, who placed her portraits in their beautifully designed apartments. The paintings often carry the look of heartless elegance and icy social performance. The style de Lempicka chose, however, absorbed much from the avant-garde artists of the time. Her pictures often bordered on the surreal and contained angular images. She used a mixed palette of bright, unrealistic colours – as well as an excess of black and white – to achieve dramatic contrasts of light and shade. The central figures were often naked and arranged in sensual or suggestive poses.

MOVEMENT

Art Deco

MEDIUM

Oil on canvas

SIMILAR WORKS

Portrait of the Marquis d'Afflito by De Lempicka, 1925

Flamenco Dancers by Edward Burra, c. 1935

Tamara de Lempicka *Born* 1900 Warsaw, Poland

Died 1980

De Lempicka, Tamara
Kizette en Rose, 1926

The paintings of Tamara de Lempicka captured on canvas a whole generation of aristocrats, businessmen and celebrities from the Art Deco period. She was the most successful and glamorous portrait artist of her day, creating more than 100 portraits between 1925–39, and her distinctive style is still popular.

De Lempicka began her painting career in Paris in 1918, having studied painting in her native Warsaw. When her husband left her in the 1920s, the young artist decided to support herself and her young daughter Kizette (the subject of this portrait) by painting. She continued her studies in Paris while beginning a career that was to culminate, many years later, in a reputation as one of the finest Art Deco painters.

It is, however, difficult to categorize any artist as being truly Art Deco; it was an art movement that celebrated the decorative arts, not the fine arts. Interior designers such as Jean Dupas (1882–1964), who were also artists, created pictures that would complement a specific interior and become part of an ensemble, rather than producing works of art with independent qualities of existence.

MOVEMENT

Art Deco

MEDIUM

Oil on canvas

SIMILAR WORKS

Les Perruches by Jean Dupas, 1925

Tamara de Lempicka Born 1900 Warsaw, Poland

Died 1980

De Lempicka, Tamara
St Moritz, 1929

Art Deco paintings are often figurative. They were portraits that captured the images, tastes and styles of the period and its people in a way that other media, such as photography and film, would eventually replace almost entirely. Tamara de Lempicka was a successful and prolific portrait painter who began her career in Paris. During the Second World War she moved to Texas with her second husband, where she continued in a similar vein, painting Hollywood stars and moguls.

It is the modern art of the period that has become most associated with the first few decades of the twentieth century; artists such as Pablo Picasso, Mondrian and Kandinsky pushed the boundaries of art and challenged every aspect of the stale traditionalism that still existed at the turn of the century. But these were not the artists who were known to the ordinary people – the best-selling artists of the inter-war years were Maurice Utrillo (1883–1955) and Maurice Vlaminck (1876–1958), who painted landscapes, street scenes and buildings. Other popular artists of the period included Raoul Dufy (1877–1953) and Henri Matisse (1869–1954).

MOVEMENT

Art Deco

MEDIUM

Oil on panel

SIMILAR WORKS

New York by De Lempicka, 1930–35

Andromeda by De Lempicka, 1929

Tamara de Lempicka Born 1900 Warsaw, Poland

Died 1980

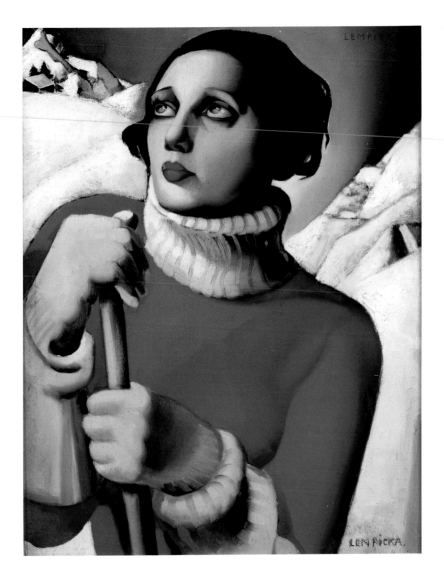

Art Deco

Places

Ruhlmann, Jacques-Emile
Couch, 1916

© The Art Archive/Private Collection/Dagli Orti

Art Deco is not a clearly defined art movement. It is generally accepted that it has two broad strands, which often appear to have contradictory characteristics. The first is the traditional, Neoclassical aesthetic that was prevalent in France, especially Paris. It grew out of the Art Nouveau movement and reached its pinnacle at the Paris Exhibition in 1925. This style, which is sometimes called 'high' Art Deco or 'Modernized Traditional', drew upon historical influences and relied upon exquisite craftsmanship and luxurious, modern materials. Furniture and other artefacts of the 'high' Art Deco period, like this couch by Jacques-Emile Ruhlmann, are typically elegant, chic, understated and sophisticated.

The second strand of the Art Deco movement drew upon contemporary sources of inspiration and is sometimes referred to as 'Modern Art Deco' or 'Decorative Modernism'. This style became increasingly prevalent after the Paris Exhibition and is associated with less ornamental designs, mass production and modern materials and techniques. Modern Art Deco was more widespread than 'high' Art Deco. It was developed by artists across Europe, but became especially popular in the United States.

MOVEMENT

Art Deco

MEDIUM

Burr amboyna and ivory

SIMILAR WORKS

Petite commode in mahogany and ebony with snakeskin 'veneer' and marble top by Paul Iribe, 1912

Spherical vase, planter and cocktail shaker in spun aluminium (American) by Russel Wright, 1934

Jacques-Emile Ruhlmann Born 1879 Paris, France

Died 1933

Nevinson, Christopher Richard Wynne

Poster for the British Empire Exhibition, 1925

The British Empire Exhibition was conceived after the First World War as an antidote to the apathy and cynicism that was rife following the death and destruction that had ravaged Europe. In 1918–19 Europe had suffered further loss when the Spanish Flu virus took the lives of more than 70 million people worldwide. It was hoped that the Empire Exhibition would, after so much despair, mark a new beginning by celebrating the achievements of British colonialism. Fifty-six countries took part and exhibits from Africa, Asia and the Americas doubtless inspired many artists and artisans of the day.

Nevinson was one of the first British artists to be affected by the European developments in art during the early years of the twentieth century. He studied at the London Slade School of Art from 1907–08, and then at the *Acadamie Julian* in Paris in 1912–13, where he was influenced by the Cubist and Futurist movements. Back in London, Nevinson contributed to *Blast*, a radical and iconoclastic magazine that had been set up by maverick artist and novelist Percy Wyndham Lewis (1882–1957). The aim of *Blast* was to stimulate its readers by rejecting old notions and worn-out ideas. In 1917 Levinson became a war artist, and was the first artist to draw from the air.

MOVEMENT

Art Deco

SIMILAR WORKS

La Mitrailleuse (The Machine Gun) by Nevinson, 1915

Aerial View from a Paris Plane by Nevinson, 1919–20

Christopher Richard Wynne Nevinson *Born* 1889 London, England

Died 1946

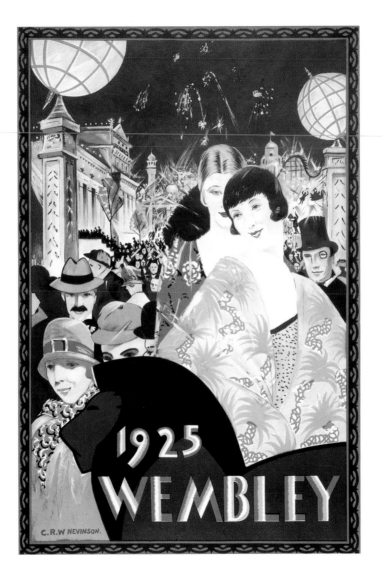

Artist Unknown

La Belle Personne, Robe du Soir de Worth: from Le Pavilion de L'Elégance: L'Exposition des Arts Décoratifs et Industriels Modernes, 1925

© Victoria and Albert Museum, 2005

Throughout the second half of the nineteenth century, fairs and exhibitions were organized on a huge scale to promote business and celebrate countries' achievements in commerce, industry and the arts. New York, Chicago, Milan and London had all hosted hugely productive exhibitions that showcased their indigenous talents. The Paris Exhibition of 1900 had been particularly successful in promoting the work of the Art Nouveau movement. As a result, the *Société des Artistes Décorateurs* (SAD) was established to repeat the success with another Paris Exhibition.

Despite France's acknowledged supremacy in the field of decorative arts, there grew a concern that artist-decorators were too dependent upon traditional styles and methods. German designers were threatening this French supremacy with bold and modern works. Thus the organizers of the Paris Exhibition determined that participants whose work relied heavily on traditional influences would be excluded – modernity would form a central theme.

The First World War delayed SAD's efforts, but the *Exposition des Arts Décoratifs et Industriels Modernes* finally opened in Paris in 1925 and instantly became a sensational *tour de force*.

SIMILAR WORKS

Reception room for the *Salon d'Automne* by Theodore Veil, 1910

L'Orgeuil by George Barbier, 1924–25

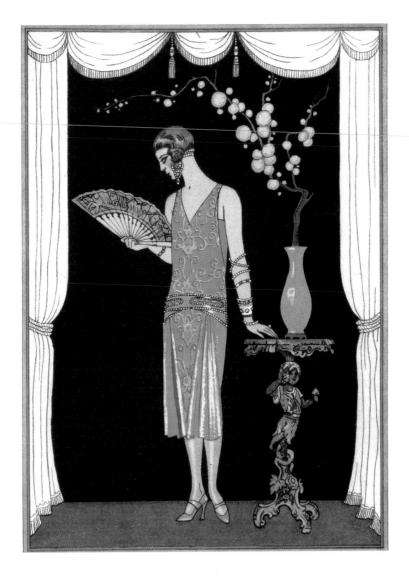

Rapin, Henri, et al.

A Salon for an Embassy (Architect's drawing for Rapin's design for *L'Exposition des Arts Décoratifs et Industriels Modernes*), 1925

© Mary Evans Picture Library

One of the stated intentions of the 1925 Paris Exhibition was to assert France's move in to modernity. The emotional strain of the First World War had left its mark on Europe and societies were impatient for the 'new'. Despite Germany's huge contribution to the art and architecture of the time, the organizers could not agree whether German designers should be invited to exhibit in Paris. There was a general unease about the newly defeated nation participating in the event and eventually an invitation was sent, but too late for the German contingent to organize any exhibits.

Henri Rapin was a painter and industrial designer who began his career as a painter of the Neoclassical school. He became Deputy Chairman of the *Société des Artistes Décorateurs* and was hugely involved in the design of many of the pavilions of the Paris Exhibition. He designed the hall and dining room of the *Ambassade de France* as well as the hall and garden for the *Manufacture de Sevres*. In 1929 Rapin was commissioned to design the interiors of the Residence of Prince Asaka, which is now preserved as the Tokyo Metropolitan Teien Art Museum.

MOVEMENT

Art Deco

SIMILAR WORKS

Residence of Prince Asaka by Rapin, 1929

Henri Rapin *Born* 1873 France

Died 1939

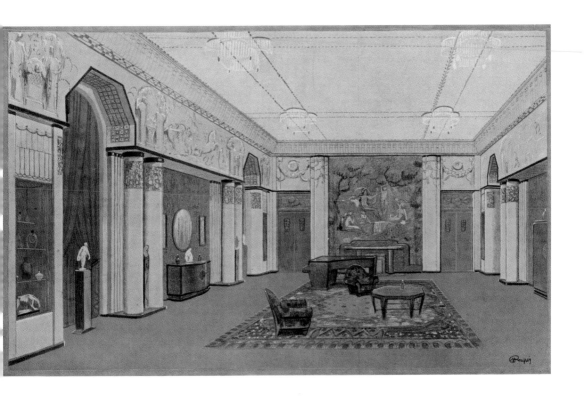

Ruhlmann, Jacques-Emile

Design for a Young Girl's Room, from Jean Badovici
Interieurs Français, 1925

© The Art Archive/Eileen Tweedy

Although the exhibitors at the 1925 Paris Exhibition were urged to show innovative designs with a modern emphasis, the importance of France's reputation for high quality and hand-crafted goods was still respected. It was hoped that the French artist-decorators could help to revive the subdued economic climate by re-affirming France's supremacy in the decorative arts, and that this could be achieved in part by introducing designers to some of the new means of industrial production.

When the Exhibition opened in 1925, it was a remarkable combination of the permanent and the temporary, the modern and the traditional, the ornamental and the geometric. Some pavilions were built in concrete and brick, but most were constructed in cheaper materials such as timber and reinforced plaster. Vibrant colours and superficial decorations, such as painted plaster reliefs, were used to counteract any hint of stringency. The interiors were unusually harmonious in design, although a number of critics found them charmless and too obsessed with novelty and exoticism. Overall, however, the new French style was greeted with enthusiasm: the artist-decorators had achieved harmony in their designs and combined the best of traditional craftwork with a modern approach to form and function.

MOVEMENT

Art Deco

SIMILAR WORKS

Chambre de Madame, for the *Ambassade de France* by André Groult, 1925

Jacques-Emile Ruhlmann *Born* 1879 Paris, France

Died 1933

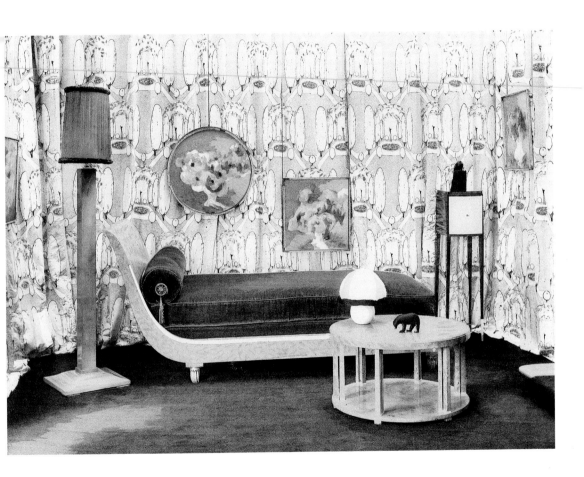

Ruhlmann, Jacques-Emile

Design for the Grand Salon, at *L'Exposition des Arts Décoratifs et Industriels Modernes*, 1925

© Victoria and Albert Museum, 2005

The Grand Salon of the Hotel d'un Collectioneur was designed by Jacques-Emile Ruhlmann and is an example of how artist-decorators applied the principle of harmony to the pavilions they prepared for the 1925 Paris Exhibition. It included the work of a number of leading designers and artists of the time. Their work was coordinated by Ruhlmann to create a luxury room from a townhouse, containing the very best of French design and suitable for an imaginary but wealthy connoisseur. The painting is entitled *Les Perruches* and it is the most famous by the artist Jean Dupas (1882–1964). Many critics have since claimed that the Grand Salon was the greatest achievement of the French Art Deco movement.

The Paris Exhibition was, however, not an unqualified success; it received particular criticism for failing to reflect the need for affordable design for working-class homes. Furthermore, German designers were not represented at the Exhibition and this drew negative comments from those who felt that the omission of their cutting-edge modernism was inexcusable. America had decided against representation at the Exhibition, on the grounds that they had nothing modern to offer – yet this meant that contemporary American designers did not have the opportunity to showcase their work, or the modern mass-production methods that were being developed in the US.

MOVEMENT

Art Deco

SIMILAR WORKS

Les Perruches for the Grand Salon by Jean Dupas, 1925

Jacques-Emile Ruhlmann *Born* 1879 Paris, France

Died 1933

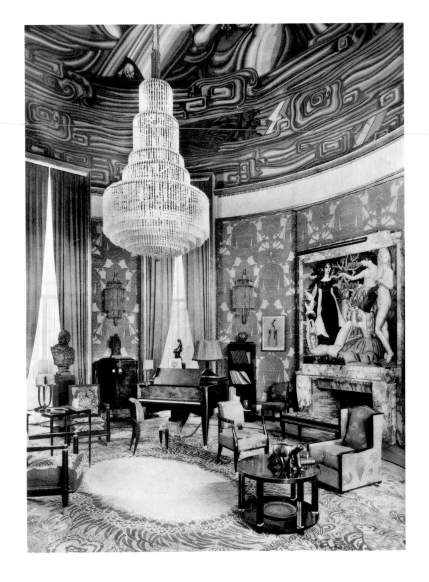

Ruhlmann, Jacques-Emile
Dressing table and stool, *c.* 1925

At the time of the Paris Exhibition in 1925, France, like Britain, had many colonies abroad, including French Indochina, parts of North Africa and a vast region in Central Africa. After the First World War, France had been given the former Turkish territories of what are now Syria and Lebanon and the former German territories of Togo and Cameroon. As a result of France's presence in these areas, the nation's furniture industry had access to an enormous range of cultural influences and materials. Quality woods, such as Macassar ebony, amboyna, maple and amaranth, frequently feature in the fine Gallic furniture of the period. Typical decorations include snakeskin, sharkskin, leather, ivory and shell.

It was this access to expensive and exquisite materials that helped to define the furniture style of the 'high' Art Deco period, especially at the Paris Exhibition. Craftsmanship was of huge importance to designers such as Ruhlmann, and every piece of furniture was created to celebrate the intrinsic qualities of the materials. Superfluous ornamentation was minimal or absent – the wood, veneer, lacquer or inlays were decoration enough. However, as Modernists took the Art Deco movement towards mass production and modern materials, many of the skills of the craftsmen began to disappear.

MOVEMENT

Art Deco

SIMILAR WORKS

Occasional table in exotic woods, shagreen (skin from sharks or small fish with bony, rough scales), ivory and mother-of-pearl by Clément Rousseau, *c.*1921

Jacques-Emile Ruhlmann *Born* 1879 Paris, France

Died 1933

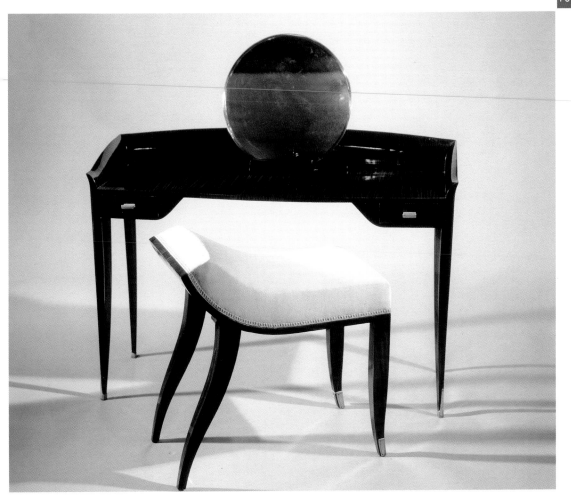

Ruhlmann, Jacques-Emile
Lady's writing desk with drop leaf, 1923

The exquisite, elegant furniture of the designer Jacques-Emile Ruhlmann was typical of France's contribution to its own Exhibition of 1925. Although the organizers had advocated a showcase for modern and innovative design, not all of the exhibitors complied. Several French designers, including Ruhlmann and Paul Follot (1877–1941), showcased work that had modern elements in style, but still drew heavily on traditional reminders.

Pavilions erected by foreign exhibitors were more complex and original in their interior designs, but also drew on their traditional cultures for inspiration. Folk art was commonly used by foreign designers, notably those from central Europe, but was brought up-to-date through translation in to contemporary, avant-garde design.

Throughout the exhibition, however, modernism remained the common theme, often demonstrated by simplified forms and a reductionist approach to design, exemplified by minimal ornamentation. The Exhibition was visited by 16 million people between April and October and its effect was, not surprisingly, great. French designers, in particular, found their work in demand and de luxe items were ordered for department stores worldwide – until the Wall Street Crash of 1929 virtually destroyed the luxury goods market.

MOVEMENT

Art Deco

MEDIUM

Macassar ebony and ivory

SIMILAR WORKS

Aage Rafn: furniture in the Danish pavilion of the Paris Exhibition by Otto Meyer and Jacob Petersen, 1925

Jacques-Emile Ruhlmann *Born* 1879 Paris, France

Died 1933

Ruhlmann, Jacques-Emile, et al.

L'Hotel d'un Collectionneur: Plate XII, 1924

Some years before the Paris Exhibition was due to open, discussions were held over a possible site. In the end it was decided that the exhibition would be placed in the heart of Paris itself, but that it would be temporary. And so an ephemeral city within an ancient city was planned – 23 hectares (55 acres) were allocated to the exhibition and an experienced French architect, Charles Plumet (1861–1928) was given the job of planning the layout.

The site was adjacent to many important cultural buildings and the views from the exhibition were of monuments within Paris. The pavilions were constructed in a variety of materials, including concrete, brick, timber and plaster, and were decorated with colourful plaster finishes and other sensational decorative effects. One of the most startling – and controversial – pavilions was designed by the great Swiss-born architect Le Corbusier (1887–1965). It was named L'Esprit Nouveau (The New Spirit) and was devoid of any ornamentation but filled, instead, with mass-produced objects. Le Corbusier favoured reinforced concrete as a building medium and called houses 'machines for living'.

MOVEMENT

Art Deco

SIMILAR WORKS

Pavilion du Tourisme designed for the Paris Exhibition by Robert Mallet-Stevens, 1925

Jacques-Emile Ruhlmann Born 1879 Paris, France

Died 1933

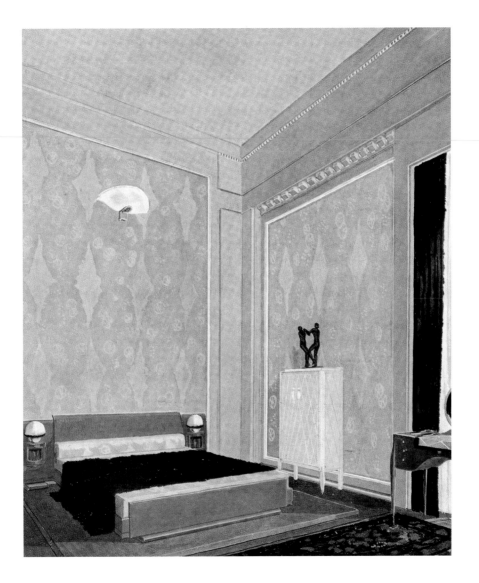

Gray, Eileen
Dressing table, c. 1920

© Estate of Eileen Gray/The Art Archive/Galerie J.J. Dutko Paris/Dagli Orti

Born to a wealthy family in Enniscorthy, Ireland, Eileen Gray became a renowned decorator and architect of the Art Deco period. She was one of the first women to be admitted to London's Slade School of Fine Art, where she studied from 1898–1901. She moved to Paris to continue her studies at a time when the paintings of Van Gogh (1853–1890), Toulouse-Lautrec (1864–1901) and Cézanne (1839–1906) were being exhibited. Although she had primarily studied painting and sculpture, Gray's early work focused on furnishings, particularly lights and screens. She learned how to apply Oriental lacquer to furniture to create a lustrous surface, and this finish is found on many of her works. She also designed rugs in abstract and geometric patterns. Her early work bore an Art Nouveau aesthetic, but during her career she progressed in to Art Deco and eventually her work displayed the characteristics of modern, streamlined design.

In 1922 Eileen Gray opened her own showroom in Paris, called *Jean Désert*. From here she sold lacquered furniture and rugs and operated a decorating service. By the 1930s, Gray's attention had shifted towards architecture; her buildings are now admired for their purity of design and attention to detail.

MOVEMENT

Art Deco

MEDIUM

Wood

SIMILAR WORKS

Bench in Macassar ebony, burr maple, amaranth and leather inlay by Gray, c.1923

Tall-fronted secretaire in sycamore and chromed metal by Pierre Legrain, 1930

Eileen Gray *Born* 1878 Enniscorthy, Ireland

Died 1976

Gray, Eileen
E1027, 1926–28

Irish-born artist Eileen Gray enjoyed a reputation as a skilled and creative designer during the 1920s. Her work with lacquered wood has remained a testament to her ingenuity and talent for this medium. The second half of her career, however, focused on architecture after being encouraged in this area by her lover, Jean Badovici (1893–1956). They had met in 1924 when Badovici, an architect, editor and critic, reviewed Gray's design work.

The first house that Gray built, between 1926–28, was for Jean Badovici and was given the curious name of E1027. This was a code: E stood for Eileen, 10 stood for the tenth letter of the alphabet (J for Jean), 2 stood for B (Badovici) and 7 stood for G (Gray). In this way, Gray's name encompassed her lover's, just as the home that she had made him would encompass him. Gray believed that a building should entwine with its occupants and become part of their bodies; a home had no meaning unless it contained the people for whom it was created.

MOVEMENT

Art Deco

MEDIUM

Leather and lacquered wood

SIMILAR WORKS

Armchair in mahogany, leather and ivory by David Blomberg of Stockholm, 1925

Armchair in aluminium and brass with red leather upholstery by Walter von Nessen, c.1928

Eileen Gray *Born* 1878 Enniscorthy, Ireland

Died 1976

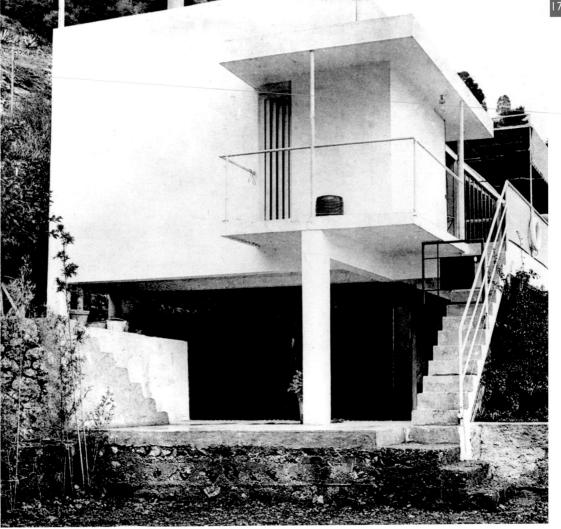

Gray, Eileen
Bedroom from E1027, 1926–28

Eileen Gray's modernist approach to simple forms and minimal ornamentation lent itself well to architecture. At the time, modernist groups, such as the Dutch De Stijl movement were experimenting with new techniques in building and Gray was greatly influenced by these.

Encouraged by her partner, Jean Badovici, Gray embarked on her first major architectural work in 1926. Inspired by the sunny, sea-filled vista at the French Riviera, Gray planned a modernist villa on the hills at Cap Martin, called E1027. The rooms flowed into one another uninterrupted, and the inclusion of terraces helped to dim the distinction between interior and exterior. The kitchen, although part of the main building, could only be reached by going outside, thus creating the impression that the outside was incorporated in to the building. Gray aimed for a 'mobile edifice' in her design; she believed that, once built, every room could change its purpose and be made and re-made according to the desire of its occupants. The bedroom was the central room and was not regarded as a private space – it could be used as an area for entertaining a group of friends as easily as a place to sleep.

Badovici lived at E1027 until his death in 1956. Shortly afterwards, it fell in to disrepair and was vandalized, but restoration work is planned.

MOVEMENT

Art Deco/Modernist

SIMILAR WORKS

Rue de Lota Apartment, designed by Gray, 1919

Eileen Gray *Born* 1878 Enniscorthy, Ireland

Died 1976

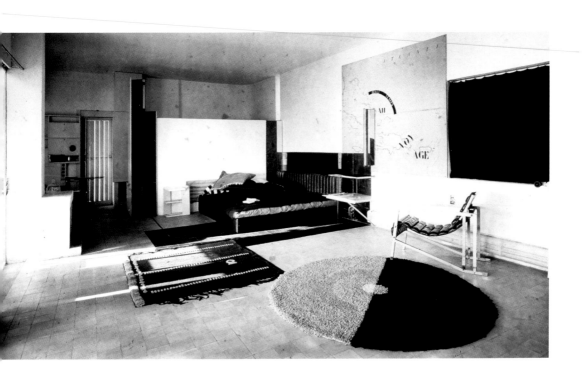

Gray, Eileen

Lacquered wooden screen, *c.* 1928

The Orient provided much inspiration for the Art Deco world. Travel and trade opened the doors for the traditional crafts of Asia to enter into the artistic lexicon of the modern designer, and bold and vibrant colours from Chinese art appealed in an era that sought to dispel the darkness of war and the gloom of nineteenth century interiors that was still prevalent. It was Oriental techniques and motifs, however, that truly inspired furniture designers to achieve superb decorative effects.

Japanese lacquer-work became particularly popular because it combined traditional expertise with the decorative effects that were in vogue. Fine craftsmanship was necessary to achieve the deep lustre and sensuality that lacquer promised, but when married with a contemporary obsession with form and decoration it achieved a modern look. The inspiration of the Orient did not stop at furniture: fashion and jewellery were also affected. The lifestyle of women in the inter-war years demanded a new approach to clothing, and loose Chinese garments offered freedom from restrictive corsets. Japanese kimonos and tube-like dresses, which inspired the 1920s 'flapper' style, found their way into fashion houses. Chinese dragons appeared as motifs on fabric, and jewellery sported jade, lapis lazuli and carved coral.

MOVEMENT

Art Deco/Modernist

MEDIUM

Lacquered wood with silver leaf and brass hinges

SIMILAR WORKS

Chimère: beaded silk evening gown with dragon motif by Jeanne Paquin, 1925

Eileen Gray *Born* 1878 Enniscorthy, Ireland

Died 1976

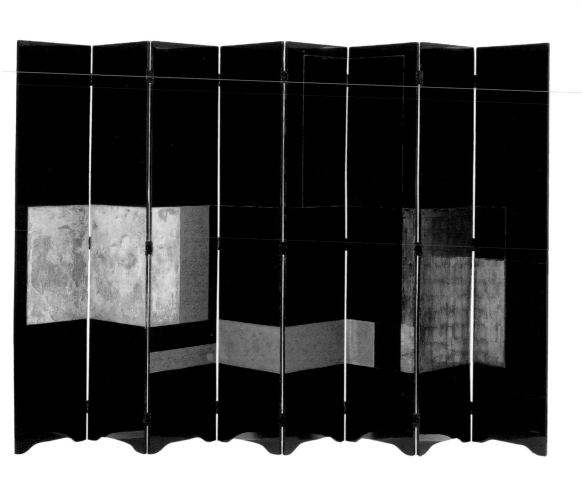

Lescaze, William and Gordon Carr, J.

Aviation Building, designed for the New York World's Fair, 1939

In 1935, a group of American businessmen decided to organize a World's Fair in New York to stimulate the economy, while also providing a welcome sense of optimism for the future and celebrating the modern Machine Age.

After the Wall Street Crash of 1929 and the Great Depression, corporate America needed to kick-start the country back into business. It was decided that a huge exhibition, on the site of Flushing Meadows outside New York, would provide an impetus for change. Titled 'A World of Tomorrow', the aim of the fair was to celebrate innovation, design and manufacturing and thereby increase sales and exports of American goods. It took four years to plan and build and more than $67 million was invested in the project. Although it was heralded as a great success, the fair only raised $47 million; when it closed on 27 October 1940, the organizing company was declared bankrupt.

The fair was arranged in a series of themes. The 'Theme Center' contained two landmark buildings, the Perisphere and Trilon. Themes included 'Communication' and 'Transport'. The most popular theme was 'Fun', which could be found at the amusement area and included a rollercoaster. The idea of arranging a fair as a series of themes later inspired the designs for Disneyland and the EPCOT Centre.

William Lescaze *Born* 1896 Onex, Switzerland

Died 1969

Harrison, Wallace K., Fouilhoux, André & Dreyfus, Henry

Trilon & Perisphere at the New York World's Fair, 1939

Trilon and Perisphere were two landmark buildings designed for the New York World's Fair, which opened on 30 April 1939 and closed permanently in October 1940.

The Perisphere was originally planned as a concrete structure, but cost restraints meant that it was eventually built from a steel frame with stucco, a type of plaster. Its theme was 'Democracity', or 'Planned City of Tomorrow, 2039'. Visitors reached it via a moving staircase and once inside they could travel its perimeter on a revolving balcony called 'The Magic Carpet'.

The Trilon was so named from the word 'tri' meaning 'three' and 'pylon' meaning 'monumental gateway'. It had three sides and was the tallest structure at the fair. Trilon was used as a radio and television antenna for the exhibition.

A more controversial exhibit at the fair was Salvador Dali's (1904–1989) *Dream of Venus*, in which nearly naked women frolicked in a surreal under-sea setting, much to the amusement of visitors. Dali had been outraged by a board of censors, who demanded that he modify some of his ideas. He hired a plane and flew over Manhattan dropping leaflets that declared 'an Independence of the Imagination and the Rights of a Man to his own Madness'.

Wallace K. Harrison *Born* 1895 Massachusetts, USA

Died 1981

André Fouilhoux *Born* 1879 France

Died 1945

Henry Dreyfus *Born* 1929 USA

Died 1972

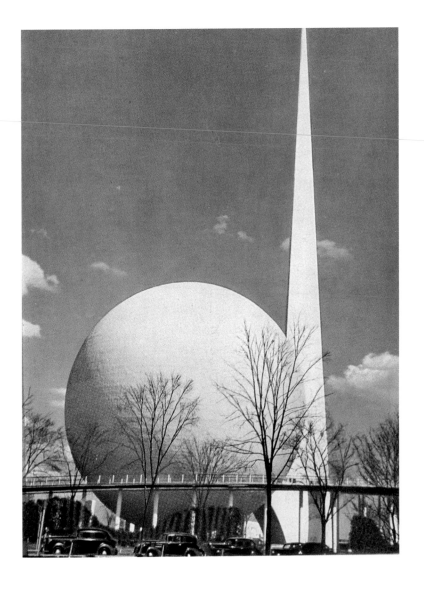

Budd, Edward

The Burlington Zephyr and Burlington Passenger Locomotive, 1934

© Topham Picturepoint

In 1932 a fortunate meeting between two men, coincidentally both called Budd, led to a revival of the ailing rail industry and helped to spark the 1930s obsession with streamlining – a common theme in Art Deco design.

Ralph Budd (1879–1962) was the president of Chicago, Burlington and Quincy, or Burlington, as it was commonly known. His train company was in decline, and when he met Edward Budd, an auto-body manufacturer, he realized that he had found someone who could help him to reverse the trend. Ralph Budd wanted to improve the speed, efficiency and appearance of his trains; Edward Budd used streamlining and stainless steel to achieve these aims.

By April 1934 the new train was ready. It was named Zephyr, after Zephyrus, the God of the West Wind and rebirth. The Zephyr, with its diesel engine and gleaming corrugated exterior, was considered a work of art. To the Modernists' delight, the train demonstrated how aesthetics and streamlining could combine to produce something intellectually and visually pleasing, as well as functional.

Despite its huge commercial success, the Zephyr and the trains that followed it could not permanently rescue the ailing rail industry. In 1946, 790 million rail journeys were made in the USA. By 1965 this had dropped to 298 million. In 1960, the Zephyr was retired from service.

MOVEMENT

Art Deco/Streamlining

Edward Budd *Born* 1870 Delaware, USA

Died 1946

Van Alen, William
The Chrysler Building, 1930

© Joesph Sohm/The Image Works/Topham Picturepoint

During the Art Deco period, new building in Europe was limited. European cities enjoyed a rich architectural heritage and work usually involved restoration and repair to existing buildings rather than demolition and new constructions. There was, however, a need for new buildings in specific commercial sectors; these often contrasted with their surroundings and bore no hint of tradition – cinemas, luxury hotels and media buildings often demonstrated their newness and modernity by their radical designs. The Strand Hotel in London, for example, had one of the world's most celebrated hotel interiors. Designed by Oliver Bernard (1881–1939), the foyer was a flamboyant blend of colours and materials. The walls were clad in pink marble, while moulded glass, chromed steel and mirrored glass adorned doorways, columns and balustrades.

During the 1920s in the USA there had been, by contrast, a huge building boom. In 1913 Cass Gilbert (1859–1934) designed the Woolworth Building in New York City. Despite the modernity of the concept, early skyscrapers looked to history for design ideas and the Woolworth Building was no exception; it was glorious in its Gothic ornamentation. When the Chrysler Building was erected 17 years later it was instantly recognized as a symbol of simplicity, beauty and wealth. It signified that America had truly embraced the modern age.

MOVEMENT

Art Deco

SIMILAR WORKS

The foyer of the Strand Hotel in London by Oliver Bernard, 1930

The foyer of the Daily Express Building in London by Robert Atkinson, 1932

William Van Alen *Born* 1883 New York, USA

Died 1954

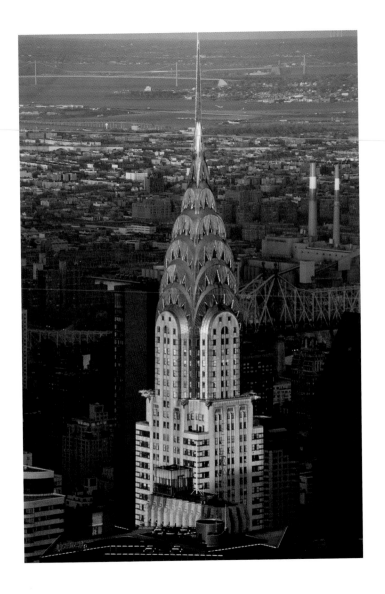

Van Alen, William
View of the Chrysler Building

William P. Chrysler (1875–1940) began his commercial career as a mechanic. In 1910 there were less than half a million cars on American roads; in just ten years this number had increased to more than nine million. Another ten years on, that number had trebled. Chrysler was an entrepreneur with foresight – he predicted the American love affair with the automobile. By 1927 he not only owned his own hugely successful business, but was also ready to commission a skyscraper in New York City in order to announce the fact.

Chrysler offered the commission to architect William Van Alen, and together they determined to create the tallest building in New York. At the time, Van Alen's former colleague H. Craig Severance (1879–1941), who had since become a rival, was building the 66-storey Bank of Manhattan Tower at 40 Wall Street. It was expected to reach 283 m (927 ft) in height, a fraction taller than Van Alen had planned to build the Chrysler skyscraper. Rather than face defeat, Van Alen assembled a 55 m (180 ft) finial inside the tower and erected it as the building work drew to a finish. For just a few months the Chrysler Building was the tallest building in New York, before being surpassed by the Empire State Building.

MOVEMENT

Art Deco/Modern

SIMILAR WORKS

The Chicago Tribune Building by John Mead Howells and Raymond Hood, 1925

Empire State Building by Shreve, Lamb and Harmon, 1930

William Van Alen *Born* 1883 New York, USA

Died 1954

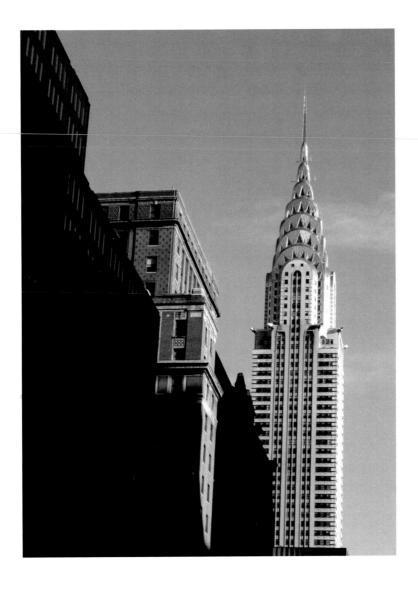

Van Alen, William

View across a Chrysler Eagle at one of the four corners of the Chrysler Building, 1930

© akg-images/Keith Collie

The Chrysler Building was an enormous success and is now regarded as the epitome of Art Deco skyscrapers. It captured the zeitgeist in New York in 1930, and has continued to represent the huge success that modern architecture can achieve when it pleases the eye and stimulates the imagination.

Although not entirely modern in design and structure, the Chrysler Building teemed with the spirit of modernization. The Sunburst Tower was clad in gleaming steel and the gargoyles, which decorated the corners of the sixty-first floor, were eagles – replicas of the 1929 Chrysler hood (bonnet) ornaments. The thirty-first floor was decorated with giant radiator caps. The building was a temple to business and it was proud to celebrate the fact.

William Chrysler, who had commissioned the project, envisioned his building being 'a city within a city' and, when complete, it boasted a beauty parlour, two hospitals, a restaurant and a gymnasium. It had 32 Otis elevators, powered by an advanced electrical system, and the heating system was unusually sophisticated for its time.

MOVEMENT

Art Deco/Modern

SIMILAR WORKS

New York Telephone Building by Ralph Walker, New York City, 1926

PSFS Building by Howe and Lescaze, Philadelphia, 1932

William Van Alen *Born* 1883 New York, USA

Died 1954

Ragan, Leslie

Poster for the New York Central Line, 1946

During the Depression, the US railway system suffered from a lack of investment and income from passengers. Ancient steam engines, with their Pullman carriages, were the standard rolling stock until the Burlington Zephyr temporarily revitalized railway transport in 1934. With its shiny, streamlined appearance and diesel engine, it had captured the spirit of modernity and people once again began to travel by train. Streamlining trains was not enough, however, to rescue the American railway system; streamlining had more to do with image than actually creating faster, more efficient trains.

In 1927 Charles Lindbergh (1902–74) had become the first person to fly solo across the Atlantic; dawn was breaking over a new era in transport. In 1933 Boeing launched the 247, a small plane that could carry ten passengers. Just five years later, the DC-4 was flown for the first time. This was a commercially viable passenger plane with a capacity for 52 people. Railway passenger services faced severe competition from automobiles and, increasingly, from aviation. Freight traffic continued to make use of the railways, thanks partly to the reliability and relatively low cost of this method of transport.

MOVEMENT

Art Deco

MEDIUM

Offset lithograph in colours

SIMILAR WORKS

Posters advertising the New Empire State Express, by Leslie Ragan c. 1940s

Leslie Ragan *Born* 1897 Iowa, USA

Died 1972

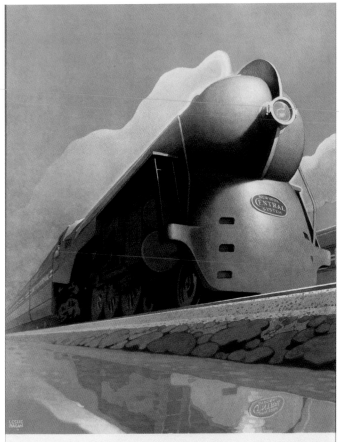

THE *New* 20TH CENTURY LIMITED

NEW YORK - *16 hours* - CHICAGO

NEW YORK CENTRAL SYSTEM

Hood, Raymond
The Rockefeller Center, 1932–40

© Topham Picturepoint

Skyscrapers were seen by some critics as examples of the excesses that had led the USA into the Great Depression. Furthermore, these 'steel behemoths' had triggered huge increases in the price of land, which meant that buildings had to be built even taller to become financially viable. Architects who designed skyscrapers were also criticized for creating an unsatisfactory urban environment.

Skyscrapers had their fans too, however; they were widely seen as the American equivalent to massive architectural achievements of other cultures – the palaces of Indian Moguls, the pyramids of Ancient Egypt and the Parthenon of ancient Greece. Skyscrapers were America's testimony to her own commercial success, and businessmen used this form of architecture to exalt themselves as the industrial 'rulers' of the 1920s and 1930s.

The Rockefeller Center in New York was an urban complex that was able to marry the grand statement of wealth implied by skyscrapers with the need for sensitive civic planning. It was built between 1932–40 and became America's largest privately owned business and amusement complex of the pre-war period.

MOVEMENT

Art Deco/Modernist

SIMILAR WORKS

Tribune Tower, Chicago by Hood, 1924

Raymond Hood *Born* 1881 Rhode Island, USA

Died 1934

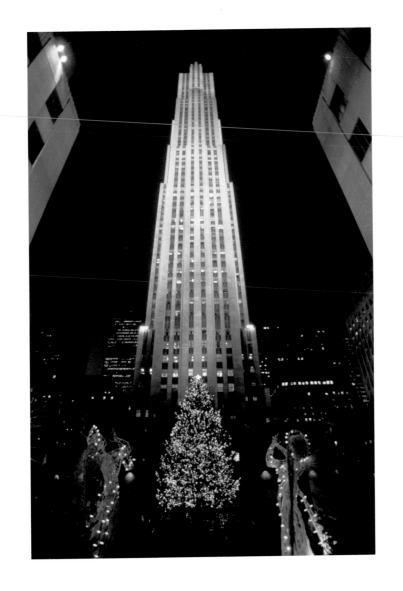

Hood, Raymond; Harrison, Wallace K, et al.; Lawrie, Lee

Rockefeller Center Entrance Portal to the RCA Building, 1932–40

© akg-images/Günter Lachmuth

The plot of land upon which the Rockefeller Center now stands was originally leased by John D. Rockefeller Jr (1874–1960) for a new Metropolitan Opera building. The plan was abandoned after the Wall Street Crash of 1929, so Rockefeller decided that, with the help of famed architect Raymond Hood, he would create a corporate complex to house the new radio and television companies – Radio City. When the plans for Radio City (now called the Rockefeller Center) were unveiled in 1931 they were not well received. Hood and Rockefeller had, however, produced an exceptional example of civic planning. The architect had understood that public spaces were as important as interiors, and had ensured that Radio City would be a pleasurable living space as well as an economically viable commercial centre. The RCA Building (now known as 30 Rockefeller Plaza) was 70 storeys high and boasted fast elevators, air conditioning and superb underground connections to the subway.

MOVEMENT

Art Deco/Modernist

MEDIUM

Sculpture/relief

SIMILAR WORKS

New York Daily News Building by Hood, 1929

Raymond Hood *Born* 1881 Rhode Island, USA

Died 1934

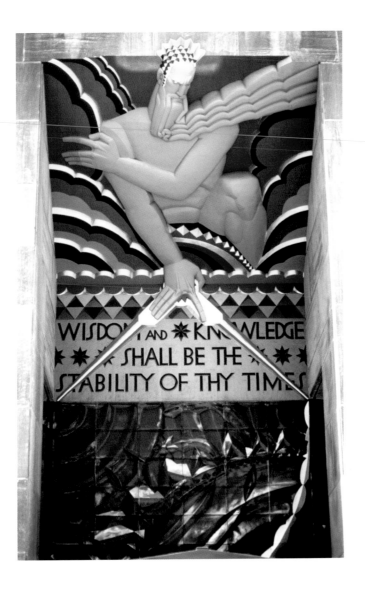

Hood, Raymond

Rockefeller Center: allegorical figure from the relief sculpture above the right entrance of the RCA building, 1932–40

© akg-images/Robert O'Dea

Combining the modern with the traditional, early American skyscrapers were gloriously and sumptuously decorated in the Neo-Gothic or Art Deco styles. By the 1930s, however, the austerity of the Modernist European architects was beginning to influence American architects. When Raymond Hood and his associates outlined their plans for Radio City, the simple lines and functional forms of the Modernists were in evidence. Hood was skilled in creating uniform, architectural designs that achieved beauty without superfluous detail. He designed the RCA Tower with setbacks, creating an elegant column, and lower buildings were arranged symmetrically around it. The RCA Tower lacked any ornamentation on its façades, but its austerity was relieved by numerous works of art and sculpture commissioned to decorate entrances and other areas at eye-level. As a result, the Rockefeller Center boasts some of the finest 1930s Art Deco/Modernist ornamentations.

MOVEMENT

Art Deco/Modernist

MEDIUM

Sculpture/relief

SIMILAR WORKS

American Radiator Company Building, New York by Hood, 1924

Raymond Hood *Born* 1881 Rhode Island, USA

Died 1934

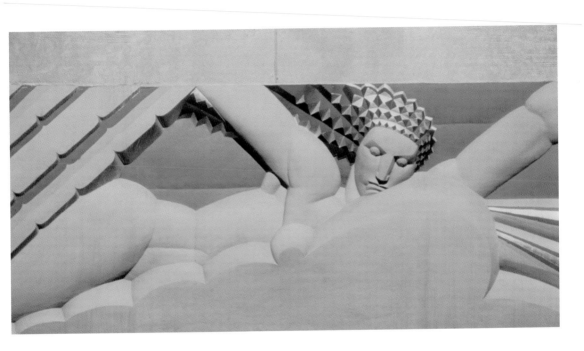

Hood, Raymond

Rockefeller Center: allegorical figure from the relief sculpture above the left entrance of the RCA building, 1932–40

© akg-images/Robert O'Dea

The Rockefeller Center was not just a place for commerce, it was conceived with the aim of creating an urban space that could achieve more than mere rental income. John D. Rockefeller Jr, who commissioned the design and building of the complex, wanted to create a city within a city: a place that provided an optimal working environment during the day but gained new life in the evenings. Long walkways between the buildings were decorated with fountains and trees, and buildings bore Art Deco friezes and sculptures at eye-level: people could enjoy an evening promenade as they made their way towards the huge Radio City Music Hall, which was also part of the complex. Its interior was a glorious celebration of Art Deco, with high ceilings, sumptuous swathes of fabric, chandeliers and mirrors.

Rockefeller was particularly interested in technology and international trade. He determined that some of the buildings in the complex would be rented out to international trade organisations, with a view to developing a worldwide marketplace. He believed that this was one way to create a global stability that would support peace and prevent war.

MOVEMENT

Art Deco/Modernist

SIMILAR WORKS

McGraw-Hill Building, New York by Hood, 1934

Raymond Hood *Born* 1881 Rhode Island, USA

Died 1934

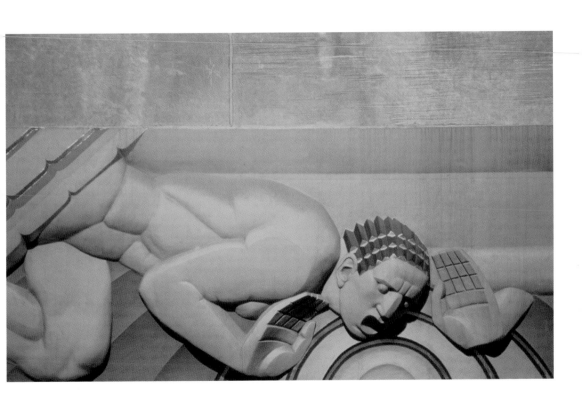

Wright, Frank Lloyd

Taliesin East, Wisconsin, designed 1925

Frank Lloyd Wright is one of America's most notable architects. He was born in Wisconsin, the son of an itinerant preacher and schoolteacher. Wright studied engineering for a short while, but was more interested in architecture. In 1887 he moved to Chicago, where he worked for several architectural firms before setting up his own business in 1893. Wright had married in 1889 and his family and business grew steadily over the next few years; he eventually had six children and employed ten assistants.

Frank Lloyd Wright's early commissions quickly earned him respect. Although he was almost entirely self-taught, the young man had great intuition and vision. He adopted a radical approach to modern architecture – he wanted to build homes and commercial buildings that eschewed ornamentation and compartmentalization.

In 1909 Wright left his wife and began a relationship with Mamah Cheney, the wife of one of his clients. He began work on a home for himself and Cheney, and by 1911 they were living together at Taliesin, near Spring Green in Wisconsin. Several years later, Cheney and her children were killed and Taliesin was destroyed by fire. It was rebuilt, struck by lightning in 1925, and again rebuilt. Wright built himself several other homes, including Taliesin West in Arizona.

MOVEMENT

Modernist/Prairie School

SIMILAR WORKS

Unity Temple: Unitarian Church of Oak Park by Wright, 1906

Frank Lloyd Wright *Born* 1867 Wisconsin, USA

Died 1959

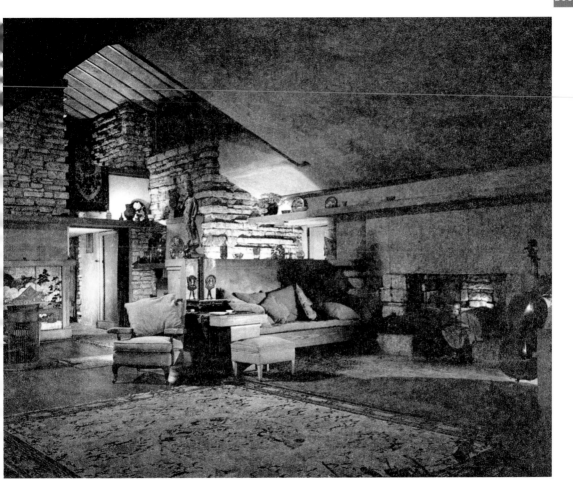

Wright, Frank Lloyd

Exterior façade of the Charles Ennis House, Los Angeles, built 1924–25

Courtesy of akg-images/Tony Vaccaro/© ARS, NY and DACS, London 2005

Frank Lloyd Wright's architectural style was Modernist and he was responsible for an innovative American trend in building. This school of architecture, called the Prairie School, was largely the product of Wright's vision; the houses featured plain walls and mass-produced building materials, with living areas that were open-plan, spacious and light. Wright built more than 50 Prairie Houses between 1900–10; they were characterized by their large, band-like windows that swept around corners, low roofs and an interior that flowed from one living space to another.

Frank Lloyd Wright eventually designed more than 800 buildings, but after leaving his family and embarking on a series of well-publicized affairs, he had difficulty in securing commissions and his work did not always receive the recognition it deserved.

Charles Ennis House was designed in 1923. The textured concrete blocks that clad the walls demonstrate how Wright did not deny the value of ornamentation. While many of his contemporaries, especially European Modernists, experimented with architecture that was devoid of decoration, Wright used it sparingly to create effect and accentuate form. The walls of the Charles Ennis House were stepped, suggesting the influence of Mayan or Aztec buildings and motifs.

MOVEMENT

Modernist/Prairie School

SIMILAR WORKS

Fallingwater Residence, near Pittsburgh by Wright, 1936

Frank Lloyd Wright *Born* 1867 Wisconsin, USA

Died 1959

Wright, Frank Lloyd

Panelled room from the Kaufmann office, designed 1937

Courtesy of Victoria and Albert Museum/© ARS, NY and DACS, London 2005

Although Frank Lloyd Wright had enjoyed a largely successful career up to and including the 1920s, the Wall Street Crash and subsequent Great Depression reduced the amount of money that people had available to commission new buildings. This period proved difficult for Wright, who had been unable to control his finances. In 1927 Taliesin, one of Wright's homes, was seized by the bank. Despite his difficulties, however, Wright's reputation as a leading architect continued to grow and he received praise from his European contemporaries. He continued to work as an architect, but also lectured and wrote to supplement his income and spread his philosophy of innovative architecture.

As the economy improved and America's wealth began to grow again, Wright found his work in great demand. In 1932 he established the Taliesin Fellowship, which aimed to provide training for architects and students. Wright taught 'organic' architecture; he believed that the structure of a building should respect its function and the properties of the materials that were used. Metal should not, for example, be twisted in to the shape of a flower and a library should not imitate a Greek temple.

This panelled office was designed by Frank Lloyd Wright for the Kaufmann Department Store in Pittsburgh, USA. He also designed the upholstery, textiles and furniture.

MOVEMENT

Art Deco/Modernist

SIMILAR WORKS

Florida Southern College at Lakeland, designed by Wright, built 1940–49

Frank Lloyd Wright *Born* 1867 Wisconsin, USA

Died 1959

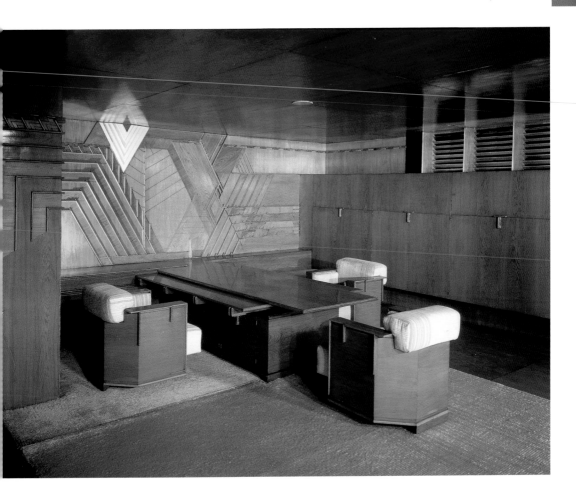

Burnham Jr, Daniel H., et al.

The Chrysler Building at the Chicago World's Fair, 1933–34

© akg-images

It must have seemed like rather bad timing when the Chicago World's Fair opened in May 1933 to celebrate 'a century of progress'. When the fair had been planned in 1926, the USA was enjoying an economic boom and the Machine Age was creating commercial opportunities on a scale that had never been witnessed before. America was growing exceedingly wealthy and there was a great deal to celebrate at the proposed 'extravaganza to end all extravaganzas'.

In 1933, the first year of Chicago's World Fair, the nation was still suffering the hardships of the Great Depression. The worst year – 1932 – was over but there was still a high level of unemployment, and financial uncertainty loomed for many people. The fair, nevertheless, went ahead. It was marketed as an 'Exposition of Science, Industry and Art', but it was industry that provided the greatest support, particularly the automobile industry. The Chrysler Corporation was the biggest exhibitor and its huge building was described at the time as 'belonging to the modern idealistic school of architecture'. Its exterior was illuminated at night, while the inside became the world's largest showcase of commercial enterprise: there was a working forge where car parts were made in view of the visitors, a steel furnace and a fully operational wind tunnel.

SIMILAR WORKS

Houses of the Future: exhibit by a selection of architects at the Chicago World's Fair, 1933–34

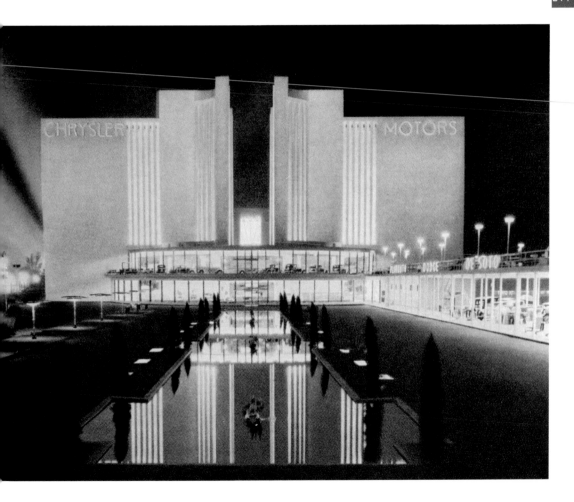

Wright, Frank Lloyd
Illustration of the Imperial Hotel, Tokyo, 1915–22

© Mary Evans Picture Library

When Frank Lloyd Wright died in 1959, he left behind a legacy of outstanding architectural achievements. He had not only been responsible for building numerous beautiful houses and workplaces, but he had also helped to invent Modern America and a new style of architecture. Wright had done more than advocate an aesthetic style – he had applied philosophy to his art and produced a set of beliefs, which he eventually described in his book *A Testament*. These principles tackled issues concerning the relationship of human scale to the landscape, and the achievement of space and light by the use of modern materials such as steel.

Ultimately, Frank Lloyd Wright believed that 'form and function are one'. He sought the underlying beauty in all materials and aimed to unify them in his building projects, referring to this as 'consistency'. Wright usually interpreted this consistency through geometry and by endlessly experimenting with new materials.

The Imperial Hotel in Japan was one of Frank Lloyd Wright's most significant projects. Wright respected Japanese traditions and honoured them in his design. He was pleased with the result, as he later explained: "The principle of flexibility instead of rigidity here vindicates itself with splendid results."

The Imperial Hotel withstood Tokyo's devastating earthquake in 1923 but was demolished in 1967.

MOVEMENT

Traditional Japanese/Modernist

SIMILAR WORKS

Hollyhock House, Los Angeles by Wright, 1921

Guggenheim Museum in New York designed by Wright and completed posthumously in 1959

Frank Lloyd Wright *Born* 1867 Wisconsin, USA

Died 1959

Art Deco

Influences

Hoffmann, Josef

Erlenzeisig, 1910–11 (designed)

This simple pattern of geometric motifs is printed on silk dress fabric. The designer, Josef Hoffmann, studied architecture at the Academy of Fine Arts under two influential architects: Carl von Hasenauer (1833–94) and Otto Wagner (1841–1918). They held the belief that buildings should be functional – a view that profoundly affected Hoffman's development as an artist and an architect.

Hoffmann was a founding member of a *fin-de-siècle* art movement called the Viennese Secession, which claimed the great artist Gustav Klimt (1862-1918) as its first president. In 1903 Hoffmann helped found the *Wiener Werkstätte*, an Austrian equivalent of the British Arts and Crafts movement. Craftsmen and designers produced luxury goods and interior furnishings using traditional and industrial methods. The textile department produced about 1,800 designs, characterised by their simplicity in style and vivid colours. These designs were strongly influenced by Eastern European art and the geometric shapes and bold colours of contemporary paintings.

By the late 1920s many designers had taken simple geometric shapes a step further. Abstract forms became popular and were soon decorating many internal furnishings. They were termed 'Moderne', 'Jazz Moderne' and 'Zigzag Moderne'.

MOVEMENT

Wiener Werkstätte/Modernist

SIMILAR WORKS

Palais Stoclet, Brussels by Hoffman, 1908

Purkersdorf Sanatorium, Austria by Hoffman, 1903

Josef Hoffmann *Born* 1870, Moravia (now the Czech Republic)

Died 1956

Legrain, Pierre

Book cover for *Essai dur Stendhal* by Paul Valéry (1871-1945), 1927

© The Art Archive/Private Collection/Dagli Orti

Art Deco reflected society's growing interest in other cultures. Colonialism had opened up new countries and regions, and their image was captured on film and brought to Europe and the US via the new movie theatres and cinemas. The art of Africa and Asia provided inspiration to many of the era's designers; bold geometric patterns were borrowed from African textiles, sculptures and shields and found their way on to fabrics, furnishings, paintings and even book covers.

Pierre Legrain adopted the African craze that swept through his native Paris in the 1920s and successfully adapted it to suit Parisian tastes. He created two distinct bodies of work, compiling more than 1,200 bookbinding designs and gaining a reputation as the designer of exquisite, expensive furniture. Legrain's work epitomized the essence of early Art Deco: he sought inspiration from other cultures and then pared down the designs to simple forms and geometric patterns. Legrain's work is typified by the use of rare and expensive materials. Examples of his book bindings include beige sharkskin framed by black calfskin, and citron leather decorated with inlaid gemstones.

MOVEMENT

Art Deco

SIMILAR WORKS

Taboure: a red lacquered stool designed for the couturier Jacques Doucet and carved from a single piece of wood.

Curule: a sharkskin-covered stool with five legs by Legrain, 1923

Pierre Legrain *Born* 1889 France

Died 1929

Wiener Werkstätte
Tea service, 1920

There were numerous influences that led to the style we now know as Art Deco. One of the most important influences was exerted by the *Wiener Werkstätte*, or Viennese Workshops. These were co-operatives formed by artists and craftsmen who mostly specialised in the field of applied arts, such as textiles, metalwork and jewellery. The workshops were themselves an off-shoot from the Viennese Secession, which had been formed by Gustav Klimt in 1897. Josef Hoffmann and Koloman Moser were the founding members of the workshops where they oversaw every aspect of design and production, believing that artists should be involved at every stage of the development of a product. Hoffmann had been influenced by the work of Charles Rennie Mackintosh who had exhibited in Vienna in 1900, and he recognised the value gained from using the best materials to achieve the geometric elegance that came to mean 'modernity'.

The bold design of this silver tea service demonstrates the ability of the craftsman to manipulate his materials with great skill. Artificial light was increasingly present in homes and commercial buildings, and the elegant curves of this silverware reflect light in many directions.

MOVEMENT

Wiener Werkstätte

MEDIUM

Silver and ivory

SIMILAR WORKS

Gilded metal bowl, Josef Hoffmann, 1924

Silver tea service, Josef Hoffmann, 1927-28

Bouraine, Marcel-Andre
Harlequin, 1925

The dynamic human form in sculpture is typical of the Art Deco period. This reflects the influence of new dance forms and celebrity ballet dancers, such as Isadora Duncan (1878–1927), Vaslav Nijinsky (1890–1950) and Anna Pavlova (1881–1931) upon the cultural world. The human body was liberated from the almost suffocating fashions of the late Victorian era: health, exercise and physical beauty were celebrated. Beautiful, perfectly formed women appeared in the movies and images of the idealized woman in advertising and film, for the first time in history, spread around the globe.

Sculpture was a popular medium for capturing the athleticism and beauty so valued at the time. Sculptured figurines were widespread, especially in Europe. While some sculptors worked in stone alone, other cast their designs in bronze. Particularly popular at the time was a type of sculpture known as chryselephantine, normally a combination of bronze and ivory. The Belgian Congo (now Democratic Republic of Congo) was exporting a huge amount of ivory under the control of Brussels, and ivory was a popular material at the time. The bronze sections of figurines like this harlequin were often polychromed in ornate patterns.

MOVEMENT

Art Deco

MEDIUM

Patinated and cold-painted bronze and ivory

SIMILAR WORKS

La Danse: Isadora Duncan and Nijinsky study for a relief for the Théâtre des Champ Elysées by Antoine Bourdelle, 1910-13

Woman with Gazelles: bronze by Jacques Lipchitz, 1911

Marcel-Andre Bouraine *Born* 1886 Pontoise, France
Died 1948

Bouraine, Marcel-Andre
Figure of a Female Warrior, *c.* 1925

Marcel-Andre Bouraine was a student of Jean-Alexandre-Joseph Falguiere (1831–1900) who had re-introduced realism to nineteenth-century sculpture. During the 1920s he exhibited his work at the *Salon des Artistes Décorateurs* in Paris and elsewhere.

Bouraine was commissioned to complete several monumental works, including a coloured cement low relief, 12 square metres (130 square feet) in size, for the 1937 Paris International Exhibition. His work most commonly celebrates movement of the human form, especially female nudes. He worked in bronze, marble, ivory and terracotta. Bouraine also produced lamps featuring idealized figurines of nude women, which he sometimes decorated with coloured enamel or coated with a patina of silvered bronze.

In its style, this figurine of a female warrior mimics the classic frieze found in Roman and Greek sculpture; it appears as a three-dimensional tableau that is best viewed from the front – a common feature of this type of Art Deco sculpture.

MOVEMENT

Art Deco

MEDIUM

Bronze

SIMILAR WORKS

Les Amis de Toujours: ivory sculpture by Dimitri Chiparus, 1920s

Bronze and ivory figurines by Ferdinand Preiss, 1920s

Marcel-Andre Bouraine *Born* 1886 Pontoise, France

Died 1948

Bouraine, Marcel-Andre

Danseuse, c. 1928

This glass figurine was created by Marcel-Andre Bouraine using a technique known as *pâte-de-cristal*, a popular technique of the Art Nouveau period. Crushed glass is mixed into a thick paste using binding agents and water. It can then be moulded or shaped and fired in a kiln. The process produces thousands of tiny air bubbles in the glass, ensuring each piece is unique, varying in colour and texture. Translucent pieces, like this one, were particularly effective when placed in front of a light. Electric lighting was becoming more commonplace during the 1920s and astute designers saw the new opportunities that this gave them. Wall lights, floor lamps and table lights provided the chance for metalworkers, ceramicists and designers in glass to collaborate in the creation of an entirely new area of interior furnishings. The advent of electric light also meant that reflective materials came into their own: chrome, silver, decorative beading and mirrors were all used to capture bright light and shine it back into a room in myriad different ways.

MOVEMENT

Art Deco

MEDIUM

Pâte-de-cristal

SIMILAR WORKS

Butterfly Dancers: ivory sculpture by Otto Poertzel, 1920s

Suzanne: glassware by René Lalique, c. 1922

Marcel-Andre Bouraine *Born* 1886 Pontoise, France

Died 1948

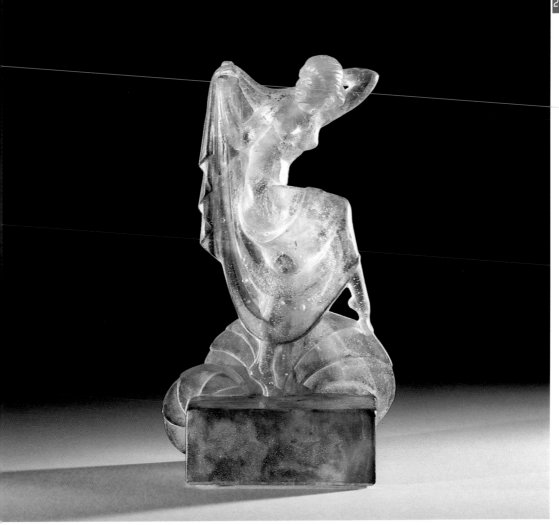

Bouraine, Marcel-Andre

Diana

At the beginning of the twentieth century, artists were looking to, and beyond, the classical Roman and Greek sculptors for inspiration. Archaeologists brought back artefacts from ancient civilizations that predated even the Greeks and provided archaic art forms that caught the imagination of sculptors such as Antoine Bourdelle (1861-1929), Georg Kolbe (1877-1947) and Paul Manship (1885-1966). The sculptures that resulted were often abstract, severe and 'solid'; a far cry from the delicate figurines that sculptors such as Bouraine and Dimitri Chiparus created.

Born in Pontoise, France in 1886, Marcel-Andre Bouraine became well known for his figurines, often cast in bronze or carved in ivory. They are characteristically elegant, delicate and frequently glorify the beauty of an athletic body in movement. Lithe and graceful, this figure of Diana – the Roman virgin goddess of the hunt – represents the archetypal woman of the era: athletic and self-assured. The gazelles, which adorn the stepped platform, are a popular motif in Art Deco design. Other creatures that often appeared in secondary relief on similar decorative pieces include borzois dogs and greyhounds.

MOVEMENT

Art Deco

MEDIUM

Bronze

SIMILAR WORKS

Dancer and Gazelles: bronze by Paul Manship, 1916

Marcel-Andre Bouraine *Born* 1886 Pontoise, France

Died 1948

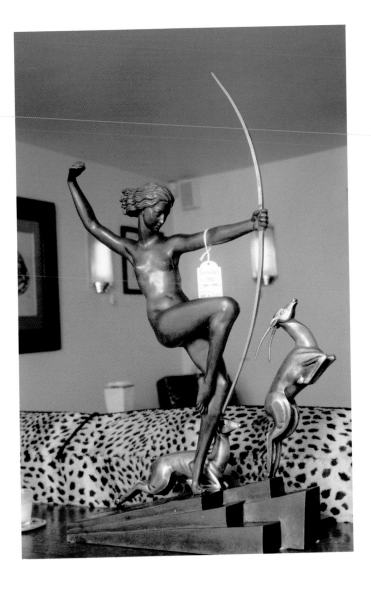

Brandt, Edgar

'Les Cigognes d'Alsace' (The Storks of Alsace) 1928 Panel for a lift cage at Selfridges & Co., London

Courtesy of Victoria and Albert Museum/© ADAGP, Paris and DACS, London 2005

Edgar Brandt was the master metalworker of the Art Deco era and his skilled use of metal, combined with an exotic iconography, influenced many other metalworkers of the period. Originally trained as a jewellery maker, Brandt set up his first studio in 1919 and exhibited at the *Salon des Artistes Décorateurs* and the *Salon d'Automne*. His reputation as a master craftsman and innovative designer was finally established at the 1925 Paris Exhibition. Brandt's success at this exhibition resulted in commissions in the US and his huge output of metalwork, which included stair railings, screens, chandeliers and furniture, featured prominently during the great building boom that continued into the 1930s.

This wrought-iron decorative panel is from an elevator cage at London's Oxford Street department store, Selfridges. It was designed in 1922 and reproduced for the store in 1928. The sunburst motif is a popular one in Art Deco iconography: during this time sunbathing and enjoying fresh air were seen as essential pastimes for good health. The motif has an added advantage of being relatively easy to reproduce in a factory and, like the fountain motif, was adopted internationally.

MOVEMENT

Art Deco

MEDIUM

Lacquer and metal (wrought iron and bronze panels) on wood

SIMILAR WORKS

Oak and wrought-iron dining table by Gilbert Poillerat, 1938

Edgar Brandt *Born* 1880 Paris, France

Died 1960

Brandt, Edgar
Wall light, c. 1922

One of the most innovative metalworkers of the Art Deco period, Edgar Brandt was influenced by the Art Nouveau style which relied heavily on the curvilinear form. Decorations of the time were often floral, slender and highly ornamental. The Art Nouveau movement, known as *Jugendstil* in Germany, *Sezessionstil* in Austria, *Stile Floreale* in Italy and *Modernismo* in Spain, flourished between 1890 and 1910 throughout the US and Europe. Flower stalks, curling tendrils and delicate asymmetrical undulating lines typified pieces produced during this period and the level of craftsmanship was high.

In 1922 Art Deco was still a luxury design style, as Art Nouveau had been. After the 1925 Paris Exhibition it underwent a transition that saw Art Deco become an industrial and mass-market phenomenon. This wrought-iron light fitting, however, is clearly meant for the wealthy consumer, not the hoi-polloi. When the English jeweller Henry Wilson (1864–1934) reviewed Brandt's work at the 1925 Paris Exhibition, he was in no doubt about the quality of the craftsmanship and design. He wrote that Brandt's work was "no longer pure smith work, but the product of the development of autogenous soldering" and that it was "taken up into the rhythm of design, when it comes subordinate to general form".

MOVEMENT

Art Deco

MEDIUM

Wrought-iron

SIMILAR WORKS

Wrought-iron floor lamp by Katona and Muller, 1925

Edgar Brandt *Born* 1880 Paris, France

Died 1960

Brandt, Edgar
Cobra, c. 1925

Art Deco embraced design ideas from many cultures, notably African tribal art, Assyrian art, Central American art and architecture, and ancient Egyptian culture. In 1922 a key development took place in the forming of the Art Deco style, when the tomb of the boy Pharaoh Tutankhamen was discovered by the archaeologist Howard Carter. The tomb proved to be a treasure trove of "wonderful things": Carter described how his flickering candle illuminated the tomb's dark interior to reveal "everywhere the glint of gold" and he wrote in his notebook that the find had resembled "the property room of an opera of a vanished civilization".

Shortly afterwards, rumours of a curse raised international interest in the discovery when Howard Carter's sponsor, Lord Carnarvon died suddenly. Tutankhamen and all things Egyptian remained in the public eye for a further decade as the excavation continued and numerous objects and artefacts were brought into the light and to the attention of the world's media. The effect on Art Deco was enormous: Egyptian motifs, such as this Cobra formed in wrought-iron, became commonplace in Art Deco furnishings, fabrics and building façades.

MOVEMENT

Art Deco

MEDIUM

Wrought-iron

SIMILAR WORKS

Egyptian Temple Gate Clock, by Cartier, 1927

Hoover Factory, London, designed by Wallis Gilbert and Partners in 1932–35

Edgar Brandt *Born* 1880 Paris, France

Died 1960

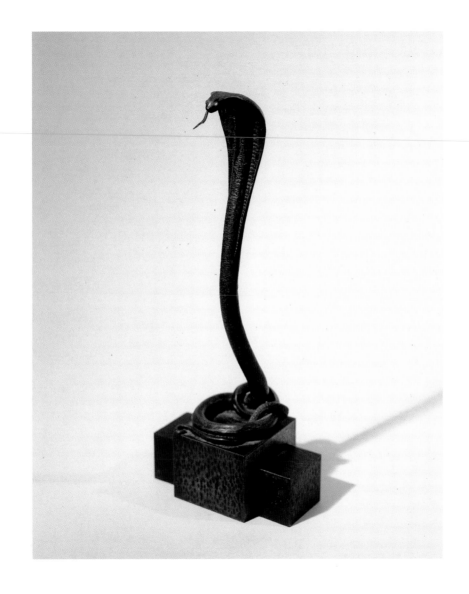

Brandt, Edgar

A pair of wrought-iron gates *c. 1925*

Courtesy of Christie's Images Ltd/© ADAGP, Paris and DACS, London 2005

Edgar Brandt was the leading metalworker of his age. He began his career working in jewellery and established his own studio in 1919. After exhibiting his work, particularly at the 1925 Paris Exhibition, his reputation soon spread. Brandt often collaborated with architects and glassmakers and it was not uncommon, during the Art Deco period, for metal to be combined with an array of other materials to achieve a richly textured effect. During the 1920s, wrought-iron, bronze and copper were used by metalworkers, but by the 1930s modern metals, such as aluminium, chrome and steel, were being favoured.

Brandt's work was characteristically delicate and often combined animal or plant forms that were arranged in geometric or flowing forms as seen in these gates. Greyhounds and gazelles suited the elongation of form that designers such as Brandt idealized. These gates – while superbly balanced – are subtly different; at first glance they appear symmetrical but closer inspection reveals their slight asymmetry. The gazelle's legs are impossibly long and slender – a style that is seen frequently in Art Deco sculptures of idealized female forms.

MOVEMENT

Art Deco

MEDIUM

Wrought-iron

SIMILAR WORKS

Stone and wrought-iron column with glass vase embellished with wrought iron, Edgar Brandt and Daum Glassworks, *c.* 1930

Metalwork by the Rose Iron Works, Cleveland, Ohio

Edgar Brandt *Born* 1880 Paris, France

Died 1960

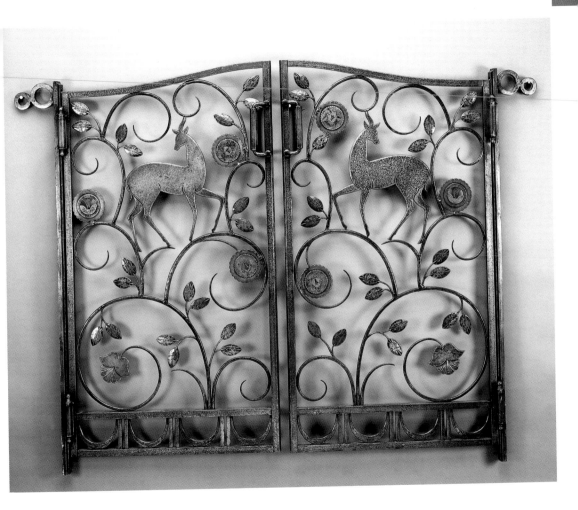

Brandt, Edgar

L'Oasis: a five-panelled screen, 1925

Courtesy of Christie's Images Ltd/© ADAGP, Paris and DACS, London 2005

Edgar Brandt's work marks a transition between two distinct stages of the Art Deco period: the hand-crafted and the machine-made. While his designs show enormous attention to detail, parts of them are repetitive and could be created on assembly lines using mechanical stamping processes.

This ornate screen depicts an oasis and makes use of a popular Art Deco motif, the fountain. The jets of water are highly stylized and mimic the parallel lines that appeared so frequently in the work of Charles Rennie Mackintosh. While superficially the screen depicts a scene from nature, a closer look reveals that the elements owe more to geometric design and stylized shapes than organic matter.

Edgar Brandt also trained other young metalworkers. Gilbert Poillerat (1902–88) spent the early part of his career learning his craft from the master metalworker and eventually forged his own successful career designing and creating grilles, panels, screens, and jewellery for French couturiers. He also designed the bronze doors for the swimming pool of the French luxury liner *Normandie*, which began regular Atlantic crossings in 1935.

MOVEMENT

Art Deco

MEDIUM

Brass and iron

SIMILAR WORKS

Oak and wrought-iron table by Gilbert Poillerat, *c.* 1938

Edgar Brandt *Born* 1880 Paris, France

Died 1960

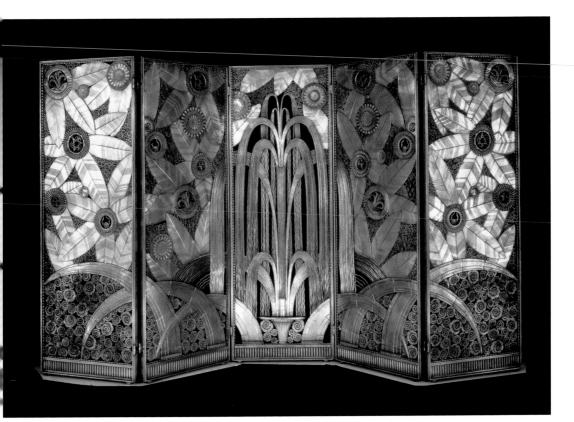

Mackintosh, Charles Rennie
Sign for the Willow Tea Rooms, Glasgow, 1903–04

© Anthony Oliver

The work of Charles Rennie Mackintosh does not sit comfortably into any of the great movements of his time – Art Nouveau, Arts and Crafts or Art Deco. Part of Mackintosh's significance lies in the fact that his work was unique; it was unorthodox in its simplicity, elegance and originality. Born in Glasgow in 1868, Mackintosh was influenced by the Arts and Crafts movement. He was apprenticed to a local architect and took evening classes at the Glasgow School of Art. Mackintos died in poverty and was largely forgotten until a revival of his work in the late twentieth century. He is now celebrated as Scotland's greatest architect and designer, and one of the most significant talents to emerge during the period from the mid 1890s to the late 1920s. The stark simplicity of his designs appeal to a contemporary audience and many of his furniture designs are reproduced today.

Mackintosh strove to incorporate all the elements of a building into a single design and this can be seen at the refurbished Willow Tea Rooms in Scotland. Mackintosh and his wife, Margaret Macdonald, designed every aspect of the building's appearance, from the exterior to the waitresses' dresses.

MOVEMENT

Arts and Crafts

SIMILAR WORKS

The Glasgow School of Art designed by Charles Rennie Mackintosh, 1896–1909

Hill House in Helensburgh, a domestic building by Charles Rennie Mackintosh, 1902–03

Charles Rennie Mackintosh *Born* 1868 Glasgow, Scotland

Died 1928

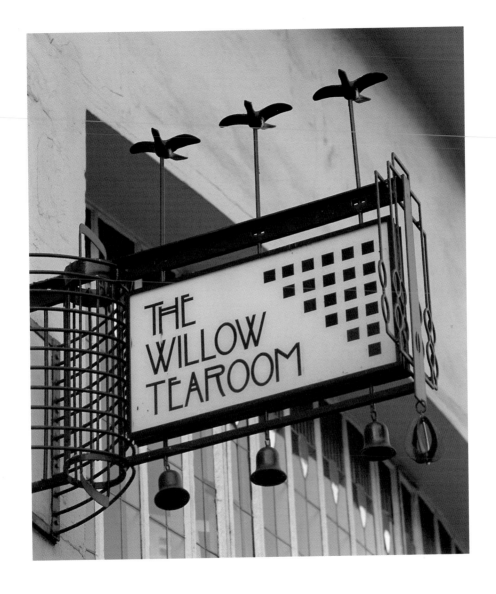

Mackintosh, Charles Rennie

Domino Clock, 1917

Charles Rennie Mackintosh's early works were largely influenced by Art Nouveau and the British Arts and Crafts movement, but he gradually pared this decorative style down as he rejected the highly ornamental elements that typified these earlier aesthetics. His designs became characteristically linear, elegant and geometric.

Linear motifs, as seen on this wooden clock and at Mackintosh's Willow Tea Rooms (see page 240) are distinctive features that were to become synonymous with Art Deco, particularly in the later stages of the movement. They were to be incorporated into graphic designs as well as architectural ones, and came to symbolize streamlining – an important concept in Art Deco design.

Mackintosh's influence on the era began early in his career. In 1900 he was invited to exhibit his works in Vienna, where his innovative style caught the attention of young artists and architects, such as Josef Hoffmann. Hoffmann incorporated Mackintosh's holistic philosophy into the Palais Stoclet in Brussels, a building that stood on the threshold between Art Nouveau and the emergent Art Deco.

MOVEMENT

Art Deco

MEDIUM

Ebonised wood with ivory and plastic inlay

SIMILAR WORKS

Erinoid Clock by Charles Rennie Mackintosh for Derngate in Northampton, *c.* 1917

Smoker's Cabinet in ebonized wood by Charles Rennie Mackintosh for Derngate, 1916

Charles Rennie Mackintosh *Born* 1868 Glasgow, Scotland

Died 1928

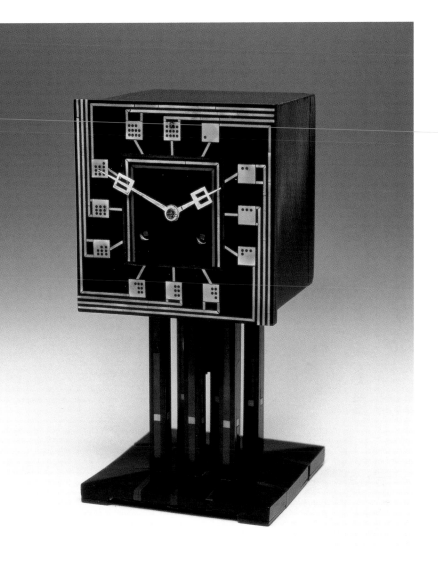

Hoffmann, Josef

Palais Stoclet (interior), Brussels, 1908

In the first years of the twentieth century, Art Nouveau still reigned supreme. The seeds of Modernism and Art Deco were being sown in Vienna, where architect-designers Josef Hoffmann, Otto Wagner and Koloman Moser were developing a new trend. They rejected the flowing, elegant, undulating lines of the Art Nouveau movement – their designs were rectilinear and contained patterns of regular grids and squares. Influenced by Charles Rennie Mackintosh, these designers adopted a fresh, new approach to their work that later influenced other artists and architects.

The Palais Stoclet is Hoffmann's best-known architectural work and demonstrates his holistic and functional approach towards design. In contrast to the exponents of the Art Nouveau movement, Hoffmann believed that good design could be incorporated into the new world of machine and man-made materials. He believed that artists and designers should be intimately involved in all stages of production, and that quality materials and work were essential to achieve top-quality design. The design of the Palais Stoclet was revolutionary in showing an attention to detail that does not detract from a sense of the whole. It is a significant work of architecture that marks the transition from Art Nouveau to Art Deco.

MOVEMENT

Wiener Werkstätte/Modernist

SIMILAR WORKS

Austrian Pavilion by Josef Hoffmann at the Paris Exhibition, 1925

Josef Hoffmann *Born* 1870 Moravia (now the Czech Republic)

Died 1956

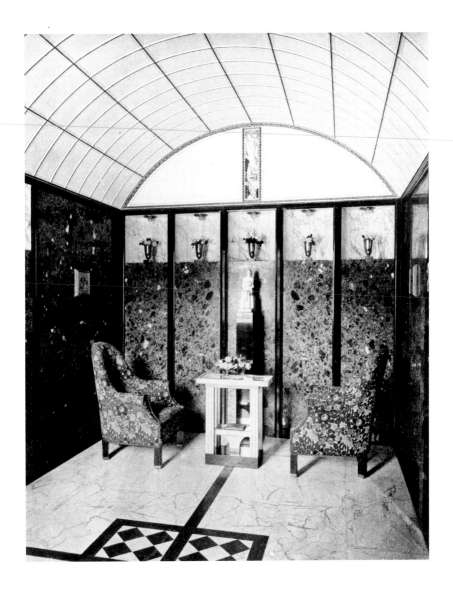

Hoffmann, Josef

Hall (design) from C.H. Baer, Farbige Raumkunst, 1911

© Estate of Josef Hoffmann/The Art Archive/Eileen Tweedy

Josef Hoffmann was a founding member of the *Wiener Werkstätte*, where he and his colleagues were intimately involved in every aspect of the design of buildings and interior furnishings. In the movement's early days, the design style was predominantly stark and uncompromising. The severity of the style can be seen in the design of this hallway, with its severe rectilinear form and geometric patterns. After the First World War, this sleek but inhospitable style gave way to more fluid, decorative designs in the workshops' output, perhaps as a result of the hardships that followed the war.

The influence of the *Wiener Werkstätte* movement on the Art Deco period can be seen in the work of other artists, such as the silversmith Jean Puiforcat (1897–1945). He adopted the radical austerity exemplified by Hoffmann but added a sensuousness that is not present in any aspect of the design of this hallway. Like many other Art Deco artisans, Puiforcat understood the importance of form and symmetry that Hoffmann had preached, but added elements of glamour and beauty.

MOVEMENT

Wiener Werkstätte/Modernist

SIMILAR WORKS

Silver and jade soup tureen by Jean Puiforcat, *c.* 1920

Vegetable dish by Jean Puiforcat, 1926

Josef Hoffmann *Born* 1870 Moravia (now the Czech Republic)

Died 1956

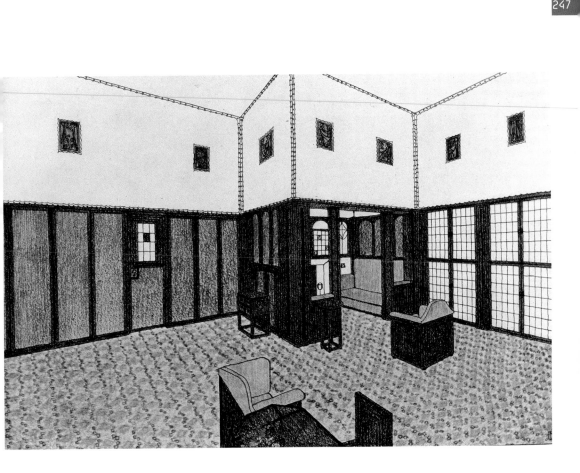

Mackintosh, Charles Rennie
Guest Room, Derngate, England, 1916–17

© Anthony Oliver

In 1916, English businessman Wenman Joseph Bassett-Lowke (1877–1953) commissioned Charles Rennie Mackintosh to remodel his first marital home, 78 Derngate in Northampton – a typical early nineteenth-century terraced house. Bassett-Lowke was interested in modern design and architecture and wanted to encourage good design in others. With his wife, Florence, he moved into the renovated building in March 1917, after nine months of extensive work had been carried out in accordance with Mackintosh's detailed plans. The house reached the height of modernity and was fitted out with central heating and indoor plumbing and the kitchen contained the latest electrical gadgets. Although Mackintosh was based in England at the time, it is believed that he never visited Northampton during the period of remodelling. All communication was conducted through letters and in person when Bassett-Lowke and Mackintosh met in London.

Mackintosh's stunning décor has since been restored and renovated, and the house is now open to the public. The guest room exemplifies Mackintosh's desire to incorporate space and light into every element of design, with its contrast of bold ultramarine and black and white stripes. The playwright George Bernard Shaw (1856–1950) was a visitor to the house and stayed in this room.

MOVEMENT

Art Deco

SIMILAR WORKS

Scotland Street School, Charles Rennie Mackintosh, 1904-06

Windyhill, a domestic house in Kilmacolm, Scotland designed by Charles Rennie Mackintosh, 1899-1901

Charles Rennie Mackintosh *Born* 1868 Glasgow, Scotland

Died 1928

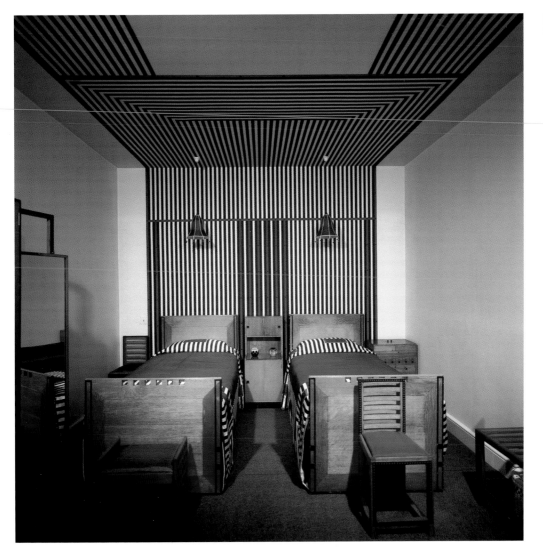

Mackintosh, Charles Rennie
Writing desk, *c.* 1902

This writing desk was designed by Charles Rennie Mackintosh for Hill House around 1902. It is made from mahogany but has been ebonized to achieve the classic look of the hard, dark heartwood that comes from the ebony tree. Crafted some time before Art Deco had become established as a design *tour de force*, this desk is striking in its rejection of the curved, fluid lines that so typified the Art Nouveau movement, the aesthetic of the time.

Hill House is the largest, and often regarded as the finest, of Mackintosh's domestic buildings. Walter Blackie, a wealthy Glaswegian publisher, commissioned the architect to build him a new home. By this time Mackintosh's reputation as an idiosyncratic designer was established, with two of his most celebrated architectural projects — Windyhill and the Glasgow School of Art — already complete. Mackintosh and his wife, Margaret Macdonald, undertook the project with their characteristic attention to every detail. They designed not only the house and most of its furnishings, but they even landscaped the gardens and dictated how the trees should be clipped to match Mackintosh's drawings.

MOVEMENT

Arts and Crafts

MEDIUM

Ebonized mahogany

SIMILAR WORKS

Silver christening set designed by Charles Rennie Mackintosh for his godson, 1904

Charles Rennie Mackintosh *Born* 1868 Glasgow, Scotland

Died 1928

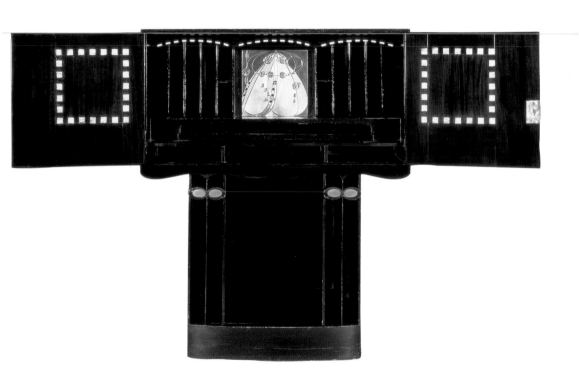

Ruhlmann, Jacques-Emile
Cla-cla table, *c.* 1925

The Art Deco period is often described as a time when design came to the masses through the growth of manufacturing technology and distribution channels. That is not, however, the way that the movement began. In its earliest days Art Deco celebrated the achievements of intellectual design, quality craftsmanship and materials – factors that made Art Deco artefacts prohibitively expensive for most ordinary people. There are few artists of the time that exemplify these principles better than Jacques-Emile Ruhlmann.

Ruhlmann was born in France, the son of a decorating contractor. On his father's death in 1910, Ruhlmann took over the family business and expanded into furniture design. His early work was influenced by Art Nouveau and the Arts and Crafts movement, but later influences included the work of modernist Viennese architect-designers such as Josef Hoffmann. He also found inspiration in Classicism, as previous French designers had done in the reign of Louis XVI.

Ruhlmann's furniture came to epitomize the glamour of the Art Deco period. He set extraordinary standards of craftsmanship that have rarely been equalled and he used the best and most expensive of materials.

MOVEMENT

Art Deco

MEDIUM

Macassar ebony

SIMILAR WORKS

Table with Macassar ebony veneer by Ruhlmann, 1918–19

Stéphany: wall covering in woven silk and cotton by Ruhlmann, 1925

Jacques-Emile Ruhlmann *Born* 1879 Paris, France

Died 1933

Ruhlmann, Jacques-Emile
Corner cabinet in rosewood, *c.* 1922

© The Art Archive/Musée des Arts Décoratifs Paris

The concept of modernity during the 1920s was a complex matter. French furniture designers had their eyes set on the luxury market, while British designers were still influenced by the ethos of the Arts and Crafts movement that had seen the development of styles that combined practical use with fitness of purpose. While British manufacturers were cautious and conservative, French designers, such as Jacques-Emile Ruhlmann, widened the boundaries of cabinet making and interior design. One of Ruhlmann's great skills lay in having a design vision for an entire interior; he provided all of the style elements needed to achieve the modern look, from ceramics to lighting, textiles and furniture.

This corner cabinet, designed by Ruhlmann around 1922 is a fine example of the designer's predilection for using various exotic and expensive hardwoods that were often inlaid with ivory, tortoiseshell or horn. He favoured amaranth, ebony, rosewood, mahogany, and others; these woods were used in the inlaid panelling of the Orient Express and the luxury liner, *Normandie*. Ruhlmann often styled his furniture with graceful arches and simple or tapering lines – as seen with the legs of this cabinet.

MOVEMENT

Art Deco

MEDIUM

Rosewood, ivory and exotic woods

SIMILAR WORKS

Rosewood cabinet by Ruhlmann, 1933

Lacquered dressing table by Paul Follot, *c.* 1930

Jacques-Emile Ruhlmann *Born* 1879 Paris, France

Died 1933

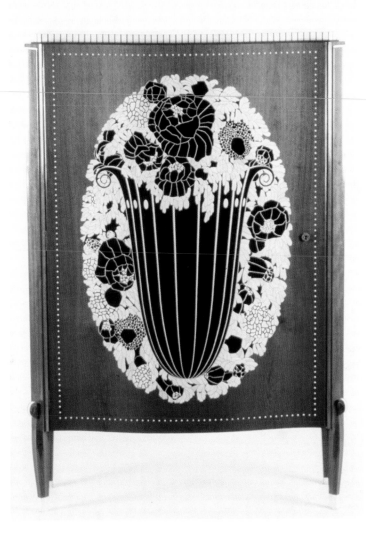

Legrain, Pierre

Chair in sycamore and leather, *c.* 1925

Pierre Legrain is renowned as Art Deco's most innovative bookbinder, but his successful career also encompassed furniture-making, which he usually carried out under commission from couturiers in the French fashion business.

Legrain originally studied at the *Ecole des Art Appliqués* in his native France, but had to abandon his course when his family fell on hard times. Legrain sold cartoons to help support his family but eventually found employment making bookbindings for the couturier and collector, Jacques Doucet (1853–1929). He proved to have a great talent and eventually assembled more than 1,200 bookbinding designs, many of them one-offs. Legrain's output of furniture was much smaller but equally significant.

Like his compatriot, Jacques-Emile Ruhlmann, Pierre Legrain believed in using the finest materials available, such as sharkskin, ebony, gilt, leather and ivory. Many of Legrain's furniture designs combine these luxurious elements with African tribal art. The designer's work was also influenced by the Cubist style that had been created principally by the artists Pablo Picasso (1881–1973) and Georges Braque (1882–1963) in the period between 1907 and 1914, in Paris. This leather chair, for example, is almost devoid of ornamentation and its form and function are united in a simple but bold structure.

MOVEMENT

Modernist

MEDIUM

Sycamore wood and upholstery covered with leather

SIMILAR WORKS

Zebra chaise-longue in black lacquer by Pierre Legrain, 1925

Pierre Legrain *Born* 1889 France

Died 1929

Ruhlmann, Jacques-Emile
Tapestry armchair, c. 1925

This luxurious chair by Jacques-Emile Ruhlmann was one of a set that comprised two chairs and a banquette, all created from the exquisite Macassar ebony that was one of the French designer's favourite woods. The legs are characteristically sleek and elegantly tapered, and the grain of the wood creates a soft but striking pattern that complements the soft curves and simple line of the piece.

Ruhlmann had never trained as a craftsman and employed more than 100 workshop assistants, including draughtsmen, upholsterers and master cabinet-makers, to execute his designs. He was meticulous in his approach and it was not unusual for him to ask his cabinet-makers to start a piece again if it did not match his vision. In 1923 Ruhlmann told a journalist that the cost of materials used to create a piece of furniture frequently exceeded the price paid for the work. He was content to suffer a loss on such pieces because he had "faith in the future". Ruhlmann knew his furniture was exceptional and he became one of the most renowned designers of his day.

MOVEMENT

Art Deco

MEDIUM

Macassar ebony and bronze, upholstery covered with tapestry

SIMILAR WORKS

Five-piece giltwood and Beauvais tapestry drawing room suite by Maurice Dufrène, c. 1925

Oak games table with four chairs by Ruhlmann, for the ocean liner *Ile de France*, c. 1927

Jacques-Emile Ruhlmann *Born* 1879 Paris, France

Died 1933

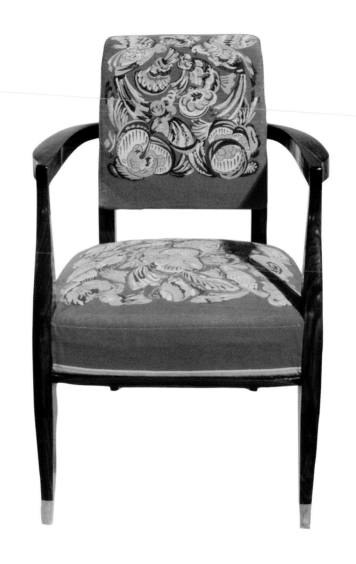

Legrain, Pierre
Pedestal table, c. 1923

The Art Deco period was characterized by a state of flux. Life was changing for most people at a rate previously unknown, but familiar to us in the twenty-first century. This mood of change and modernity was captured by the avant-garde artists of the time. A new visual language was being expressed by Fauvism, Cubism, Surrealism, Futurism, Constructivism and De Stijl. In the first two decades of the twentieth century these art forms were known to an elite few, but by the early 1930s an increasing number of people had become familiar with them through the ever-expanding media.

Art Deco designers, such as Pierre Legrain, shared social circles with many avant-garde artists and they exchanged ideas and enthusiasm. The Cubists were fascinated by African tribal art, an interest shared by Legrain and Eileen Gray, amongst others. The influence of the avant-garde artists can be seen in works by some contemporaneous decorative artists. This pedestal table, for example, is a far cry from the elegant and delicate furniture of Jacques-Emile Ruhlmann. Its striking shape engages the mind through the effect of form rather than decoration.

MOVEMENT

Modernist

MEDIUM

Ebony and ivory

SIMILAR WORKS

Unique Forms of Continuity in Space: bronze sculpture by Umberto Boccioni, 1913

Suite of living room furniture by Félix Del Marle, 1926

Pierre Legrain *Born* 1889 France

Died 1929

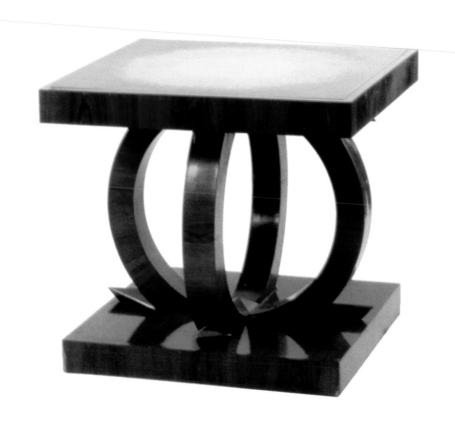

Ruhlmann, Jacques-Emile
Roll-top desk, 1923

© The Art Archive/Musée des Arts Décoratifs Paris

Jacques-Emile Ruhlmann believed that innovative design was elitist. In a magazine interview in 1920 he said, "Only the very rich can pay for what is new, and they alone can make it fashionable. Fashions don't start with the common people. Along with satisfying a desire for change, fashion's real purpose is to display wealth."

Ruhlmann first exhibited his work in 1910, and by the Paris Exhibition of 1925 he had become a celebrity: his featured work had attracted widespread attention. The Americans had, famously, not participated in the Exhibition because as the US government declared, "American manufacturers and craftsmen had almost nothing to exhibit in the modern spirit".

After the Paris Exhibition, the American Association of Museums arranged for exhibited items to tour the nation, while department stores played an even greater role in bringing the modern style to the attention of America. Artefacts by designers such as Ruhlmann, Jean Dunand (1877–1942) and Pierre Chareau (1883–1950) were displayed in stores and for those who could not afford the real thing, approximate copies were soon on sale. Ruhlmann's rich clients had made Art Deco fashionable; it was soon to become available to the masses.

MOVEMENT

Art Deco

MEDIUM

Ebony and ivory

SIMILAR WORKS

Macassar and ebony cheval mirror by Ruhlmann, c. 1920

Jacques-Emile Ruhlmann *Born* 1879 Paris, France
Died 1933

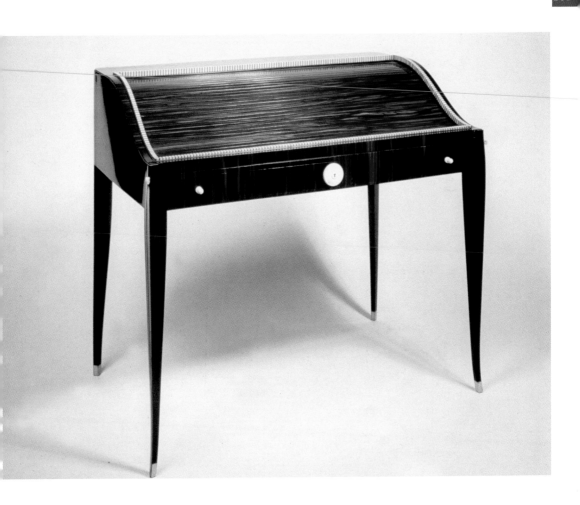

Bakst, Leon

Sur La Digue, Chapeau de Marthe Callot, from *Gazette du Bon Ton*, Issue 6, by Jean Bernier (fl. 1910-25)

This illustration is entitled 'On the Embankment – the hat of Marthe Callot' and is the work of one of the most influential artists of the Art Deco period, Leon Bakst.

The magazine in which this print appeared was the 'magazine of high society': the *Gazette du Bon Ton* was a witty, urbane magazine that focused on art and fashion from 1910–25. It was published monthly and captured the spirit of the Roaring Twenties for the smart set, before being absorbed into Condé Nast's *Vogue* in 1925. The leading fashion magazine of the era, the *Gazette du Bon Ton* attracted talented artists, such as fashion illustrator Georges Barbier (1882–1932) and Leon Bakst. The colour plates were produced by the laborious pochoir method, a process that preceded standard silkscreen printing.

The subject of this print, Marthe Callot, was one of four sisters known in their native Paris as the Callot Soeurs. They owned a couture house where they produced exquisite dresses using the finest materials including Chinese silks and lamé. The eldest Callot sister, Marie, was referred to as "the backbone of the fashion world of Europe".

MOVEMENT

Art Deco

MEDIUM

Magazine illustration

SIMILAR WORKS

Cover for *Vogue* magazine by Leon Bakst, 1920

Leon Bakst *Born* 1866 Russia

Died 1924

Bakst, Leon

Eunuch costume from 'Scheherazade' by Rimsky-Korsakov, 1910

Russian-born Bakst studied at the Academy of Arts in St Petersburg before being expelled for creating a *Pietà* (Weeping Madonna and Christ) with Jewish features. After completing his studies in Paris, Bakst returned to Russia where he founded the World of Art Group with Sergei Diaghilev (1872–1929) and Aleksandre Benois (1870–1960) in 1898. This group rejected contemporary art and sought inspiration from eighteenth and nineteenth century Russian culture. In 1908, Bakst returned to Paris with Sergei Diaghilev as a scenery painter and costume designer for the Ballet Russes, where his work would inject a sumptuous palette of colours in to the world of French couture.

Diaghilev saw dance as the ultimate opportunity to bring great artists of the day together. His vision produced the dynamic collaboration of composers such as Igor Stravinsky (1882–1971), Claude Debussy (1862–1918) and Sergei Prokofiev (1891–1953), choreographers such as Michael Fokine, legendary dancers Vaslav Nijinsky and Anna Pavlova, and great artists such as Pablo Picasso. The cultural effect of Diaghilev's brave experiment was, unsurprisingly, formidable.

MOVEMENT

Art Deco

MEDIUM

Watercolour

SIMILAR WORKS

Stage design for the Ballets Russes' *Scheherazade*: gouache and watercolour with gold highlights by Leon Bakst, 1911

Leon Bakst *Born* 1866 Russia

Died 1924

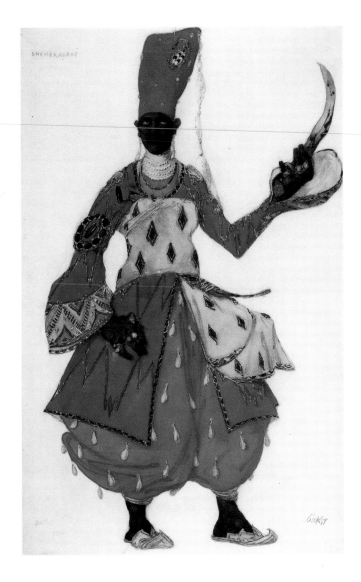

SHEHERASADE

Bakst

Bakst, Leon
Set design for 'Thamar', 1912

Leon Bakst began designing scenery in 1900, for the Hermitage Court Theatre in Russia and then at the Imperial theatres. He also taught drawing at a private art school – one of his pupils was Marc Chagall (1887–1985) – and he eventually founded a liberal school of painting in St Petersburg while producing plays for the Paris Opera.

It is for his work with Sergei Diaghilev, founder of the Ballet Russes, that Leon Bakst is best remembered. His innovative stage and costume designs were bold and luxurious. They drew on the Orient and Far East for inspiration and injected a new area of influence for the Art Deco movement. No longer were African tribal references enough: the Orient became exotic, and the soft, complementary colours associated with Art Nouveau were challenged by a vibrancy of colour that demanded attention.

Diaghilev's ballet and Bakst's exotic designs introduced a new element of sensuality to theatregoers of the period and challenged all preconceived notions of ballet and music. When the Ballet Russes staged Stravinsky's *Rite of Spring* at the Paris theatre in 1913 for the first time, the audience exploded with protestations at the difficult, dissonant score.

MOVEMENT

Art Deco

MEDIUM

Watercolour on paper

SIMILAR WORKS

Set design for Diaghilev's *Cléopâtra* by Leon Bakst, 1909

Leon Bakst *Born* 1866 Russia

Died 1924

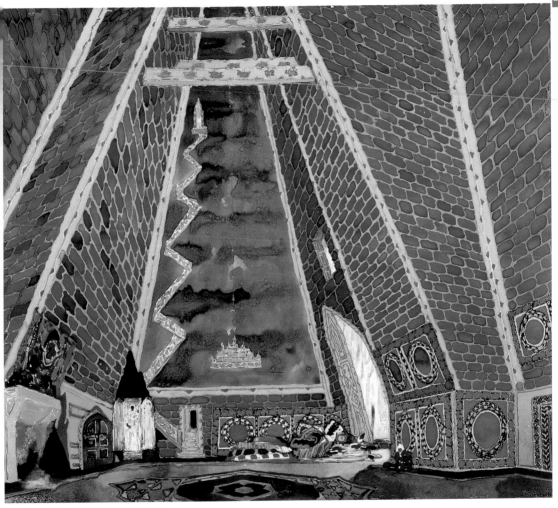

Bakst, Leon
Modern dress, Dione, 1910

The Art Deco period saw an unparalleled change in lifestyle for women, and the women's fashions of the time demonstrate this change. In 1895, just 15 years before Leon Bakst designed this fluid, revealing and delicate dress, women were encased in corsets, heavy skirts and shirts with high necks and leg-of-mutton sleeves. By the 1930s, women were liberated from the worst excesses of restrictive, cumbersome clothing, and Leon Bakst, with other contemporary designers, helped to bring about these changes.

Paul Poiret (1879–1944) was a French couturier who had trained at the House of Worth and with Jacques Doucet. He set up his own business in 1903; in 1908 he was creating sheath-like dresses for his clients, and by 1910, no doubt influenced by the Ballet Russes and Leon Bakst, he was filling his collections with oriental exotica in bold colours and luxurious fabrics. Poiret was instrumental in persuading women to do without corsets and adopt bras instead. Some of his most popular and innovative designs were based on the harem pants that had formed part of Bakst's stage costumes and many of his clothes were decorated in ornate beading, jewels and fur.

MOVEMENT

Art Deco

SIMILAR WORKS

Set design for Tchaikovsky's *Sleeping Beauty* by Leon Bakst, 1921

Directoire-style dresses by Paul Poiret, *c.* 1908

MEDIUM

Pencil and watercolour

Leon Bakst *Born* 1866 Russia

Died 1924

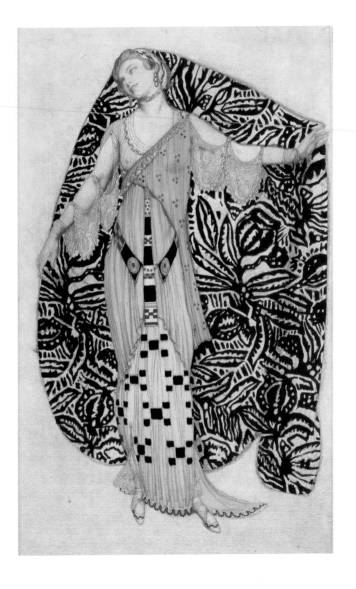

Bakst, Leon

Costume design for Nijinsky in the ballet 'La Peri' by Paul Dukas, 1911

© Bibliotheque de L'Arsenal, Paris, France, Giraudon/www.bridgeman.co.uk

The subject of this watercolour by Leon Bakst is Vaslav Nijinsky, possibly the greatest male ballet dancer of all time and principal dancer of Sergei Diaghilev's Ballet Russes.

The bold, exuberant costume depicted here is one of the many designed by Leon Bakst for the ballet company, and its flamboyance was typical of Bakst's preference for a strong Oriental style. Nijinsky is wearing harem pants and a turban – items that were to inspire French couturiers such as Paul Poiret. The contrasting colours, with bold geometric designs and embellishment with appliqué and beading gave inspiration to many other artists and designers of the day, including Paul Iribe (1925–1894), Georges Lepape (1887–1971), Erté (1892–1990) and Raoul Dufy (1877–1953).

These fashions typify the period leading up to the First World War, but for the luxuriously wealthy only. During the war a new sensibility saw opulence discarded in favour of sober clothing and sombre colours. Women worked outside the home more than ever before, and hemlines rose to provide greater freedom of movement to facilitate their new lifestyles.

MOVEMENT

Art Deco

MEDIUM

Watercolour on paper

SIMILAR WORKS

Bakst set designs for Diaghilev's ballets: *L'Après-midi d'un Faune* (1912) and *Le Spectre de la Rose* (1911)

Bakst *Born* 1866 Russia

Died 1924

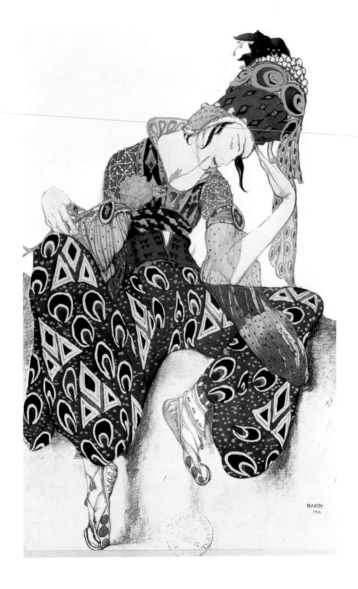

BAKST
1911

Bénédictus, Edouard

Book Plate 8, from *Relais*, Quinze Planches Donnant Quarante-deux Motifs Décoratifis, 1930

Fauvism was a modern art movement of the beginning of the twentieth century that was to have considerable effect on Art Deco, especially in the field of textiles and fabrics. Between 1901 and 1906 this new style of painting flourished in France. It incorporated pure, exuberant and bright colours, often squeezed straight from the tube onto a canvas. Artists such as Paul Gauguin (1848–1903), Vincent van Gogh (1853–1890) and Paul Cézanne (1839–1906) had helped create this art movement with their use of non-naturalistic colours to achieve an explosion of light, texture and colour in their art. Depth and meaning were achieved through colour rather than perspective; as Van Gogh said "Instead of trying to render what I see before me, I use colour in a completely arbitrary way to express myself powerfully."

This brash, vibrant style inspired many other trends in art, and by the 1920s electric colours dominated fabric design, especially in Paris. Artists such as Edouard Bénédictus and Raoul Dufy were experimenting with colours and patterns in a totally new way, inspired by Fauvism and Cubism.

MOVEMENT

Art Deco/Moderniste

MEDIUM

Pochoir

SIMILAR WORKS

The Birth of Venus by Paul Véra, 1925

Edouard Bénédictus *Born* 1878 Paris, France

Died 1930

Bénédictus, Edouard

Book Plate 9, from *Relais*, Quinze Planches Donnant Quarante-deux Motifs Décoratifis, 1930

Edouard Bénédictus was a French graphic designer and print-maker. He was also a talented book binder, painter and fabric designer, probably most famous for his beautiful folios of designs for wallpaper and fabrics in the Art Deco style. Using a colouring process known as pochoir, he created albums including *Variations* (1924), *Nouvelles Variations* (1925) and *Relais* (1930). His designs remain popular today, with many of his carpet and fabric designs still in use. The renowned English ceramicist Clarice Cliff (1899–1972) sought inspiration from Continental artists such as Bénédictus, Amedeo Modigliani (1884–1920) and Piet Mondrian (1872–1944) for elements of Modern Art that appeared on her pieces.

During the 1920s a shawl was a prerequisite for any woman who considered herself a follower of fashion. Shawls provided glorious opportunities for designers to display their boldest and bravest patterns, and textile artists such as Bénédictus produced flamboyant Art Deco designs by repeating geometric designs set in semi-naturalistic plant forms, woven with bright colours and metallic threads.

MOVEMENT

Art Deco/Moderniste

MEDIUM

Pochoir

SIMILAR WORKS

Myrbor dress for Natalia Goncharova in appliquéd silk, 1924–26

Edouard Bénédictus *Born* 1878 Paris, France

Died 1930

Bénédictus, Edouard

Book Plate 1, from *Relais*, Quinze Planches Donnant Quarante-deux Motifs Décoratifis, 1930

Fauvism influenced the bold, almost unnatural, colours of Art Deco pattern and fabric design, and the influence of Cubism was just as important. Cubism was an intellectual revolt against the soft, expressive art forms of the late nineteenth century, and like the Fauvists, Cubist painters sought ways to achieve depth other than through a scientifically calculated perspective. They examined still life objects and discovered a new way to imply three dimensions: each form was fragmented, or broken up and replaced to enable the viewer to simultaneously observe an object from different angles. In the initial phases of development Cubism had a limited palette, and many works of art from this period feature dull colours. By the 1920s brighter colours and collage were being employed to enrich the technique.

Cubist pictures commonly incorporated geometric shapes and gave objects from nature hard and angular edges. This print by Edouard Bénédictus contains the bright, unrealistic colours of Fauvism. The life forms, fish, are disjointed and angular. At the foot of the print is a geometric and repeated pattern so common to Art Deco.

MOVEMENT

Art Deco/Moderniste

MEDIUM

Pochoir

SIMILAR WORKS

Fabric designs by Robert Bonfils, 1925–30

Edouard Bénédictus *Born* 1878 Paris, France

Died 1930

Bénédictus, Edouard

Book Plate 5, from *Relais*, Quinze Planches Donnant Quarante-deux Motifs Décoratifis, 1930

© Victoria and Albert Museum, 2005

This vibrant print by Edouard Bénédictus was created using the pochoir process. This highly labour-intensive technique involved applying every colour separately by hand using a different zinc or copper cut-out stencil for each one. The paints used were either watercolours or gouache and the overall effect was to produce prints that always appeared fresh, almost wet and with crisp lines. Here, the artist has employed colour and Cubist principles to create a vibrant and innovative effect.

Pochoir was commonly used in French fashion journals, such as the *Gazette du Bon Ton* and *Le Jardin des Dames et des Modes*. They were also employed in books of design and patterns that were used by fabric and interior designers of the 1920s and 1930s. Edouard Bénédictus produced his own books, or folios of design: this pattern comes from *Relais*, which was printed in 1930, the year of the designer's death. Prints by designers such as Eileen Grey (1878–1977), Ruth Reeves (1892–1960), Robert Mallet-Stevens (1886–1945) and Charlotte Perriand (1903–99) influenced the manufacturers, architects and interior designers of the Art Deco period and beyond.

MOVEMENT

Art Deco/Moderniste

MEDIUM

Pochoir

SIMILAR WORKS

Arc-en-Ciel: carpet by Eric Bagge, c. 1925

Edouard Bénédictus Born 1878 Paris, France

Died 1930

Bénédictus, Edouard
Decoration samples from *Relais*, 1930

Art Deco designers created patterns that might eventually adorn fabrics, carpets, wallpapers and ceramics. Some patterns included classic Art Deco motifs, such as sunbursts and fountains, while others concentrated on geometric forms, such as chevrons, rectilinear shapes, zigzags and broad bands of colour.

The texture of fabric came to be as important as the colour or pattern. Modernists abandoned printed patterns and sought new ways of bringing pattern and decoration in to the weaving process. This allowed the material to develop its innate beauty and be 'true to itself' rather than relying on superficial and 'deceptive' decoration. American textile designer Ruth Reeves chose subdued colours to permit the strong patterns of the weave to dominate her textiles. This principle was also applied to carpets and rugs; strong patterns and colours remained, nevertheless, the predominant style of the time.

In the 1920s the German Bauhaus project was involved in, and influential in, the field of woven design. The workshops produced carpets, fabrics and woollen wall hangings in strong colours and geometric designs. The Bauhaus principle was to manufacture functional and aesthetically pleasing objects on a large scale, rather than creating individual artefacts for the wealthy elite.

MOVEMENT

Art Deco/Moderniste

MEDIUM

Pochoir

SIMILAR WORKS

Repeat Pattern of Cubist Forms by Donald Deskey, c. 1930s

Edouard Bénédictus *Born* 1878 Paris, France

Died 1930

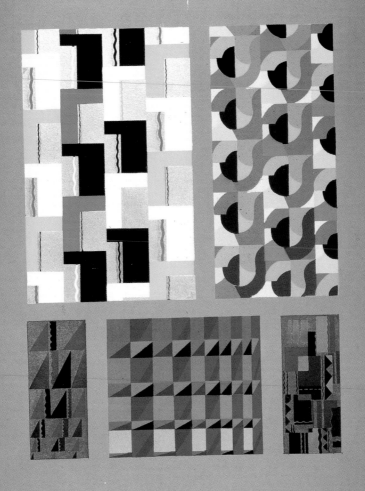

Cappiello, Leonetto
Perroquet, c. 1922

The Italian artist Leonetto Cappiello is renowned for his advertising posters, many of which have become world-famous images — Cappiello is often referred to as the Father of the Modern Poster. The artist gave his first public exhibition in Florence before settling in Paris in 1898. He worked for the Parisian magazine publication *Le Rire* before embarking on his hugely successful career designing posters.

The success of posters at the turn of the century owed much to the work of Cappiello's predecessor, Jules Chéret (1836–1932) the first of the great modern poster artists. Chéret was not only a skilled artist, but he also improved techniques in the colour printing process to speed up production.

When Cappiello began designing posters, he drew on the influences of the great artists who had been designing at the beginning of the century: Toulouse-Lautrec (1864–1901), T.A. Steinlen (1859–1923), Alphonse Mucha (1860–1939) and Chéret. His innovative style broke away from the fluid shapes and swirls of Art Nouveau; he favoured strong images, bold colours and humour.

MOVEMENT

Art Deco

MEDIUM

Watercolour and crayon maquette

SIMILAR WORKS

Wall-hanging for Bianchini-Férier by Raoul Dufy, 1925

Leonetto Cappiello *Born* 1875 Livorno, Italy

Died 1942

Cappiello, Leonetto
Cachou Lajaunie, 1920

Cachou Lajaunie was the trademark name of tiny liquorice sweets that were sold in the 1880s as breath-fresheners. A series of posters was used to market the lozenges, especially to smokers. One of the artists to work on the series was Leonetto Cappiello, an acclaimed master of the commercial poster.

Art Deco posters can generally be put into one of two categories: those that advertised theatrical events, and those that advertised products and services. By the 1930s they were also becomingly increasingly common tools in the propaganda war, especially in fascist Germany and Italy.

While Cappiello's early poster designs marked the transition from Art Nouveau to the blossoming era of Art Deco, his later works were set firmly in the Modern age. He was a prolific designer and caricaturist, capturing images of many celebrities of the time, including Sarah Bernhardt (1844–1923), Oscar Wilde (1854–1900) and Edward VII (1841–1910). His work was popular during his lifetime, influencing other great poster artists such as Cassandre (1901–68), and remains iconic today.

MOVEMENT

Art Deco

MEDIUM

Lithograph in colours

SIMILAR WORKS

Divan Japonais by Toulouse-Lautrec, 1893

Cachou Lajaune: poster by Francisco Tamagno, c. 1890s

Leonetto Cappiello *Born* 1875 Livorno, Italy

Died 1942

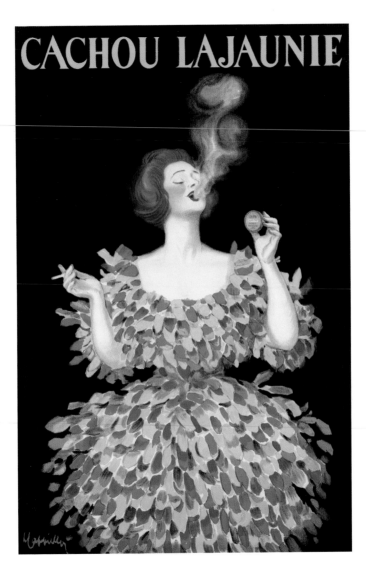

Cappiello, Leonetto
Mossant, 1938

Poster designers of the Art Deco period drew on many influences to achieve their goal – producing powerful symbols that helped promote new products or services. Posters were, after all, mostly commercial media, designed to grab attention, sell a brand and be memorable. Avant-garde art movements were a particularly rich source of inspiration for poster designers such as Leonetto Cappiello, Georges Barbier, Cassandre and Julius Englehard. Italian Futurism – an art movement that developed around 1910 to express the energy and values of the Machine Age – and Cubism both had much to contribute to this burgeoning medium. Cubism offered bold and symbolic forms, fragmentation and abstraction, overlapping planes of colour and image. Futurism, which was obsessed by speed and power, appeared on posters in images of sleek liners, trains and automobiles: streamlined, shiny and new.

The public found Cubism and Futurism hard to swallow, but these modern movements offered ideas and inspiration to more commercial artists who translated the concepts brilliantly onto posters. The poster artists made the innovative more palatable and comprehensible to the public.

MOVEMENT

Art Deco

MEDIUM

Lithograph in colours

SIMILAR WORKS

Lithographic poster for the Nord Express by Cassandre, 1927

La Revue Nègre au Music-hall: poster by Paul Colin, 1925

Leonetto Cappiello *Born* 1875 Livorno, Italy

Died 1942

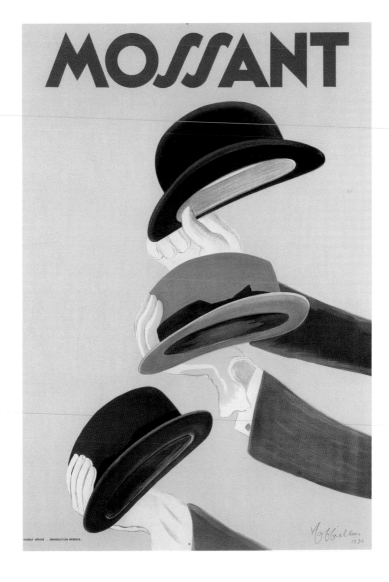

Braque, Georges
Man with a Guitar, 1914

Georges Braque was born in France, close to one of the centres of the Impressionist movement. When he was 15, Braque attended evening classes at Le Havre Academy of Fine Arts where he mastered the skills, techniques and materials necessary to pursue his dream of becoming a professional artist. After completing his military training, Braque continued his art studies at a private Parisian academy. Braque's early works show the influence of the Impressionist painters but by 1905, after seeing Fauvist works at the Paris *Salon d'Automne*, he had begun to develop his own style. The controversial Fauvists ('Les Fauves', literally 'the wild beasts') were led by Henri Matisse (1869–1954) and they painted from nature, like the Impressionists, but employed explosions of colour to create movement, emotion and a sense of space.

In 1907 Braque was introduced to Pablo Picasso. The two men worked closely together for the next few years and through their collaboration invented Cubism. Although Cubism and Art Deco appear diametrically opposed, they both sought inspiration from many of the same sources, together forging much of the art and design of the early twentieth century and beyond.

MOVEMENT

Cubism

MEDIUM

Oil on canvas

SIMILAR WORKS

L'Estaque by Braque, 1908

Des Demoiselles d'Avignon by Pablo Picasso, 1907

Georges Braque *Born* 1882 Argenteuil, France

Died 1963

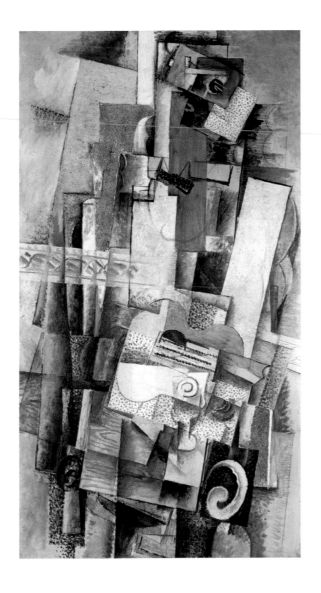

Braque, Georges
Pedestal Table, 1930

Georges Braque and Pablo Picasso were largely responsible for the style of art now known as Cubism during the early years of the twentieth century. Through their close collaboration they developed an abstract style of art that reduced objects to slabs of sombre colouring and placed them in warped perspectives. The effect was to create a piece of art that examined the form of a shape by fragmenting it and removing the distractions of colour and decoration. This deconstruction of form and space was unlike anything that had been created in art before, and it provoked a hostile reaction.

Cubism created a new visual language, and by the middle of the 1920s this language had affected all the decorative arts of the time, from prints and posters to photography and film, both in Europe and the USA. Although the public had not taken to Cubism when it first emerged, poster artists such as Cassandre and Cappiello, and photographers such as Man Ray (1890–1976) and Cecil Beaton (1904–1980), had introduced surrealist images into their art and made it more accessible.

MOVEMENT

Cubism

MEDIUM

Oil on canvas

SIMILAR WORKS

Tour Eiffel by Robert Delaunay, 1911

Still Life with Playing Cards by Braque, 1919

Georges Braque *Born* 1882 Argenteuil, France

Died 1963

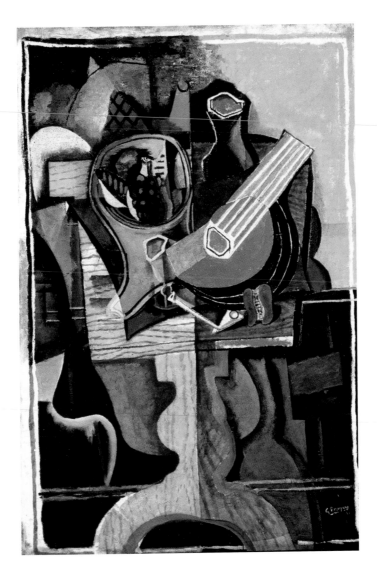

Braque, Georges
Basket of Fish, 1910

The Art Deco movement grew from the roots of Art Nouveau and the Arts and Craft movement and was partly defined by the desire to harmonize all elements of any context; entire interiors were stylized in one common theme. Cubism, by contrast, aimed to produce art that stood alone, independent of its context. Cubist art studied the effect of colour and form and aimed to evoke emotion autonomously – as a singular entity.

The work of Georges Braque and other Cubists exemplified this aesthetic, yet it could not stand entirely independent of the burgeoning Art Deco movement. The two contemporaneous art forms could not help but influence one another at a time when anything that was labelled 'modern' was eagerly grasped by a public that embraced the future. They were, of course, both powered by other sets of influences that pervaded society. African tribal art and Sergei Diaghilev's Ballet Russes, for example, inspired Art Deco artists and Cubists alike. Despite the fact that early Cubists had spurned decoration and the holistic approach of their Art Deco peers, a number of them branched out into the decorative arts and designed fabrics, ceramics and even clothes.

MOVEMENT

Cubism

MEDIUM

Oil on canvas

SIMILAR WORKS

American walnut desk and bookcase by Paul T. Frankl, *c.* 1928

Unique Forms of Continuity in Space: bronze sculpture by Umberto Boccioni, 1913

Georges Braque *Born* 1882 Argenteuil, France

Died 1963

Braque, Georges

Le Compotier (The Fruit Bowl), 1908

During the early part of the Art Deco movement, ornament and decoration were considered an essential part of design. The Modernist movement, typified by the Cubism of Braque and Picasso, sought to reduce art to its simplest form, without ornament. The techniques employed by Cubists, of sober colours and flat and angular planes juxtaposed in peculiar perspectives, brought shape, form and space to life without the need for extraneous embellishment. By the middle of the 1920s, however, the lines between these two dominant art forms were becoming less clear.

Georges Braque experimented with new materials and techniques, incorporating them into his work. In 1912, for example, he created what is considered the first *papier collé* – abstract art forms in which paper or other materials are glued to the artwork. He introduced paper, sawdust and paper onto his canvases and by the 1930s he was producing small, decorative sculptures.

Cubists had considered that 'ornament is crime' and this aesthetic increasingly influenced the Art Deco style. In its love for all things modern, Art Deco embraced the futurist notion of streamlining, and by the 1930s designers were creating objects with sleek, undecorated profiles that conveyed modernity and elegance.

MOVEMENT

Cubism

MEDIUM

Oil on canvas

SIMILAR WORKS

Figures with Still Life: wall hanging by Ruth Reeves, 1930

Georges Braque *Born* 1882 Argenteuil, France

Died 1963

Art Deco

Techniques

Atkinson, Robert

The Barber Institute of Fine Arts, University of Birmingham (gallery exterior), 1936–39 (built)

The Institute of Fine Arts in Birmingham was established in 1932 by Dame Martha Constance Hattie Barber (1869–1932), in memory of her husband, the property developer William Henry Barber, who gained his wealth from developing the city's sprawling suburbs. Dame Barber died shortly after establishing the Institute, but left money for the development of the building and art collection.

Robert Atkinson was one of Britain's leading architects when he was commissioned to design the Institute. When it opened, the Institute was described by *The Times* as "the purest example of his work" and in 1946 it received a bronze medal from the Royal Institute of British Architects. The building is centred around a music atrium, which is surrounded by offices, lecture halls and libraries on the ground floor, and art galleries on the first floor.

This was one of Robert Atkinson's many successful architectural projects in which he displayed his Moderne approach to building, with the rectilinear lines of Modernism combining with a subtle surface decoration. The form and function of the building were closely linked: it was designed to fulfil its objective of providing a suitable home for great works of art and learning – and successfully continues to meet this objective today.

MOVEMENT

Art Deco/Moderne

SIMILAR WORKS

Graham Roberts and Students' Rooms at the Fitzwilliam Museum, Cambridge by Atkinson, opened 1955

Robert Atkinson *Born* 1883 Cumberland, England

Died 1952

Manship, Paul

Libra: detail from the Zodiacal Band on the Statue of Prometheus, Rockefeller Center, 1934

During the early days of the twentieth century, sculptors were greatly influenced by the art and cultures of archaic societies. Archaeologists were uncovering treasure troves of artefacts throughout the ancient world and, understandably, these evoked the interest of those who sought meaning and inspiration for their own artistic works. The artefacts of Egyptian, Etruscan, Roman, Hellenic and Cretan societies were filtering through to museum displays and galleries and the artistic styles of these cultures were, for the first time in the modern era, readily accessible to a wider audience.

The gilt-bronze statue of Prometheus at the Rockefeller Center in New York is one of Paul Manship's most famous works, and is one of the world's most popular sculptures. It is cast in bronze and hand-gilded in 24-carat gold leaf. Manship found inspiration for this sculpture in the mythological story of Prometheus, a member of the group of Roman gods called the Titans. Prometheus formed mankind out of clay and was, therefore the 'sculptor of man'. He gave man fire, for which he suffered eternal punishment at the hands of Zeus.

MOVEMENT

Art Deco

MEDIUM

Bronze

SIMILAR WORKS

Woman with Gazelles: bronze sculpture by Jacques Lipchitz, 1911

Paul Manship *Born* 1885 Minnesota, USA

Died 1966

Manship, Paul

The Flight of Europa, 1925

Paul Manship studied art in Minnesota and New York and trained with the sculptor Solon Borglum (1868–1922). In 1909 he won a scholarship to the American Academy in Rome and travelled throughout Europe. He was particularly affected by the archaic art of Greece and Minoan, Egyptian and Assyrian cultures. The themes and styles that Manship studied at this time remained primary influences for all of his sculptural work, but he also sought to bring a greater dimension to it: "I like to express movement in my figures. It's a fascinating problem which I'm always trying to solve... what matters is the spirit which the artist puts into his creation – the vitality, the rhythm, the emotional effect."

A mythological tale from Ancient Greece inspired this sculpture by Paul Manship. Europa was a beautiful princess who was spied by the god Zeus as she picked flowers. Zeus transformed himself into a white bull and appeared beside Europa, who laid garlands of flowers around the tame bull's neck and climbed upon his back. The bull fled with Europa to Crete, where the princess agreed to marry him once she discovered that her abductor was actually Zeus. The bull is immortalized in the zodiac as 'Taurus'.

MOVEMENT

Art Deco

MEDIUM

Gilt bronze on marble base

SIMILAR WORKS

Dancing Maenad: bronze sculpture by Carl Milles, 1912

Rhythm: marble sculpture by Boris Lovet-Lorski, *c.* 1936

Paul Manship *Born* 1885 Minnesota, USA

Died 1966

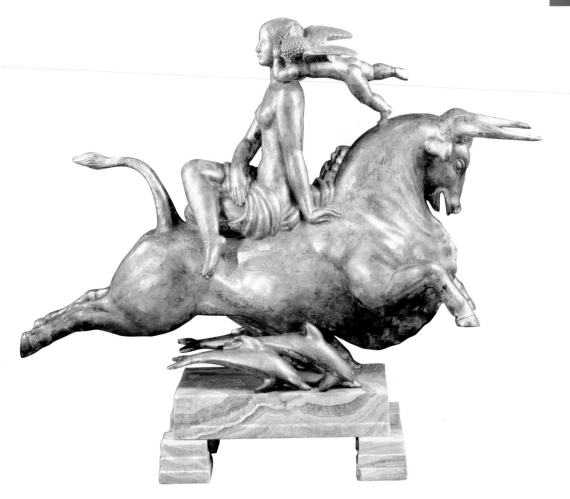

Manship, Paul
Hercules Upholding the Heavens, 1918

© Estate of Paul Manship/Museum of Fine Arts, Houston, Texas, USA, Gift of Mrs Mellie Esperson/www.bridgeman.co.uk

The art of ancient cultures such as Greece, Rome and Egypt enjoyed a revival during the Art Deco period and often provided inspiration for sculptors of the time. In the first few decades of the twentieth century, figurative modelling was the most popular form of sculpture – as it had been in the ancient cultures – and it is therefore no wonder that Art Deco sculpture shows the influence of its archaic predecessors. Paul Manship, along with others such as Libero Andreotti (1875–1933) and Jacques Lipchitz (1891–1973), became particularly well-known for sculptures that demonstrated classical and archaic influences. They are deemed to be Art Deco, however, because they were not mere mimics of earlier styles. Manship's sculptures often demonstrated linear, powerful compositions with their freely modelled forms and striking gestures.

The story of Hercules was told in Roman mythology. Hercules was given 12 tasks, or labours, to complete after being tricked into killing his own family. Atlas held the heavens upon his shoulders, and Hercules temporarily assumed this task so Atlas could help him complete one of his labours.

MOVEMENT

Art Deco

MEDIUM

Bronze

SIMILAR WORKS

Eros and Pysche: pencil on tracing paper by Manship, 1925

Study for Venus Anadyomene: bronze sculpture by Manship, 1924

Paul Manship *Born* 1885 Minnesota, USA

Died 1966

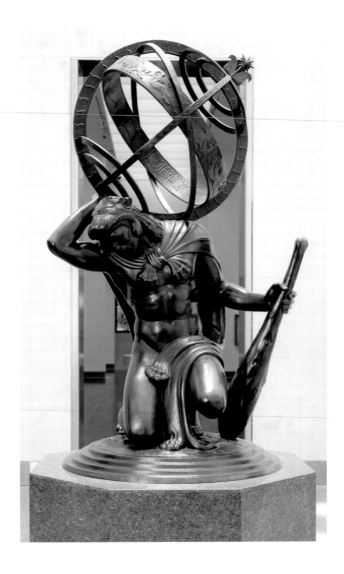

Manship, Paul
Atalanta, 1921

The American sculptor Paul Manship enjoyed a highly successful career. His sculptures commonly depicted themes and figures from classic and mythological sources but they also bore a measure of modernity in their execution.

The Beaux Arts style had been a popular architectural aesthetic prior to the 1920s. Architects and designers, trained at the *École des Beaux Arts* in Paris, had brought this grandiose style back to the United States, where it became very popular. It promoted the principles of Classical design inspired by Roman and Greek architecture, and was typified by its order, symmetry and formal ornamentation. Manship rejected this aesthetic: his figures are highly stylized and often demonstrate an awareness of streamlining, fluidity of movement and expression that was clearly a rejection of the Beaux Arts. His work, in its innovative form and pattern, came to typify early American Art Deco.

Atalanta is a character from Greek mythology. She was a fine athlete and loved hunting, enjoying a reputation as a woman who never shied away from men's activities and could be both brave and brutal.

MOVEMENT

Art Deco

MEDIUM

Gilt bronze

SIMILAR WORKS

Héraklès Archer: bronze sculpture by Antoine Bourdelle, 1909

Paul Manship *Born* 1885 Minnesota, USA

Died 1966

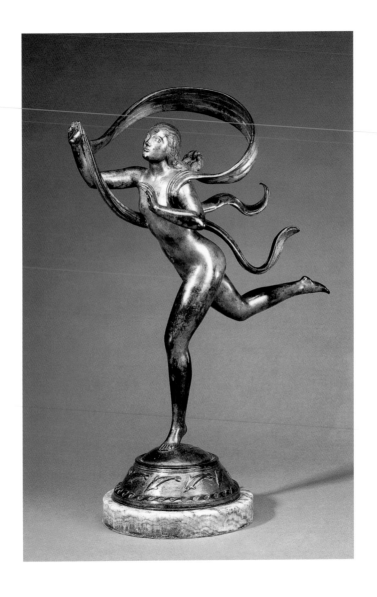

Gray, Eileen

La Destin: screen in red lacquer with abstract design, *c.* 1923

© Estate of Eileen Gray/Private Collection/www.bridgeman.co.uk

Eileen Gray was one of the most accomplished furniture designers and architects of the Art Deco period. Her speciality was lacquer work, and this screen is a stunning example of her achievements in this challenging medium. Gray was born in Ireland, studied art in London then moved to Paris to continue her studies in 1901. It was in Paris that Gray became interested in Japanese lacquer, a subtle medium that involves treating tree resin before applying it in layers to wood or metal, creating a beautiful sheen in a range of colours. It accentuates the form of a piece of furniture while lending itself to decoration and inlays of complementary materials.

Seizo Sugawara, a celebrated master of lacquer work, was brought to Paris to maintain a Japanese lacquer collection, where Eileen Gray was introduced to him. Sugawara trained Gray in the art of creating different colours and textures from the lacquer, and she painstakingly experimented and practised the technique until she too became a master of the craft. As a result, Gray's furniture designs became sleeker in form, since this suits the application and appearance of lacquer.

MOVEMENT

Art Deco

MEDIUM

Lacquered wood

SIMILAR WORKS

Lacquered wood table by Gray (commissioned by Jacques Doucet for his Neuilly Studio), 1915

Eileen Gray *Born* 1878 Enniscorthy, Ireland

Died 1976

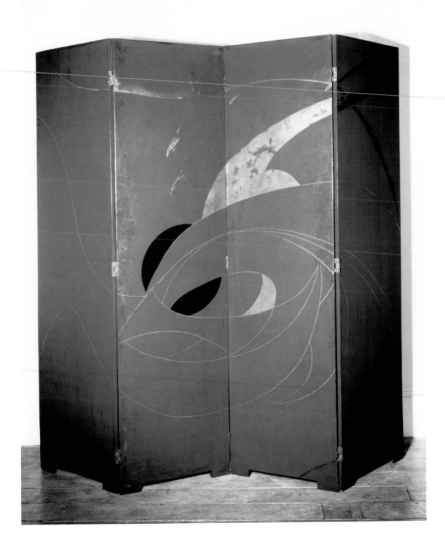

Lalique, René

Victoire: The Spirit of the Wind, car mascot, 1928

René Lalique has been called one of the greatest jewellers since the Renaissance, but it is for his Art Deco work in glass that the artist is best known.

In the late 1920s Lalique added car mascots to his range of jewellery, glass perfume bottles and other products. A total of 29 designs were made up into car mascots, although they were often used as paperweights too. Each mascot was attached to the bonnet of a car by means of a metal mount and a fixing ring. The process of fitting the mascot to the car often involved damage to the delicate glassware and, even if this procedure was carried out successfully, the heat from the engine was likely to damage the mounting and possibly fracture the glass. For all of these reasons, Lalique car mascots in good condition are highly collectible.

Each piece of glassware could come in a range of colours and finishes. The glass could be opalescent, clear, frosted or satin-finished. Tints, commonly amethyst or blue, were sometimes added, although coloured car mascots were comparatively unusual. Mascots were often fitted with light bulbs and wired up to the car's electrical system.

MOVEMENT

Art Deco

MEDIUM

Frosted and clear glass with a pale amethyst tint

SIMILAR WORKS

Epsom: car mascot (horse head) by Lalique, 1929

Guinea Hen: car mascot by Lalique, 1929

René Lalique *Born* 1860 Ay, France

Died 1945

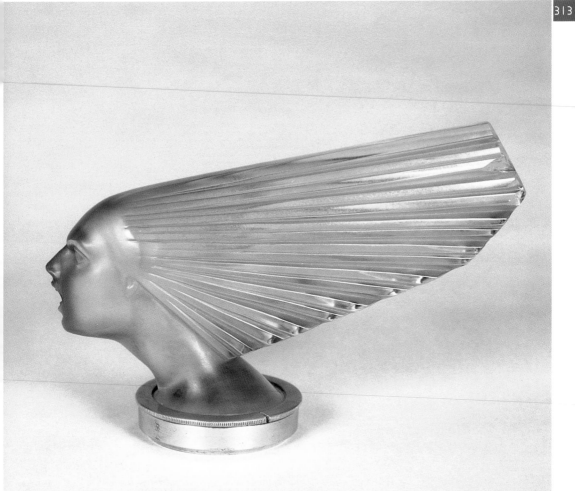

Lalique, René

Comb

René Lalique began his formidable career as a jeweller-artist and was hailed as the first jeweller to work in the fashionable Art Nouveau style at the turn of the century. He broke with tradition and showed an imaginative flair for using new materials and creating astoundingly dramatic designs. Lalique was fortunate to work in Paris, where he was surrounded by creativity and skill. The city was renowned for its innovative jewellery design, and French craftsmanship was considered supreme.

Lalique tapped into a growing interest in alternative materials. While gold and diamonds would always remain popular because of their intrinsic beauty and their extrinsic show of wealth, jewellery buyers were becoming open-minded about other, less valuable materials. Semi-precious stones, enamel, horn and glass were used to create a fresh vibrancy and originality in jewellery. Lalique was a keen photographer and studied nature, and these interests inspired him to design jewellery that often featured animals or plants. Some of Lalique's most naturalistic jewellery featured bugs and beetles, but they proved unpopular with women who did not like the life-like creatures near their décolletage!

MOVEMENT

Art Nouveau

MEDIUM

Gold enamel and amethyst

SIMILAR WORKS

Orchid: hair comb in gold, glass, horn and enamel, 1902

Brooch with blister beetles on silver branches by Lalique, *c.* 1900

René Lalique *Born* 1860 Ay, France

Died 1945

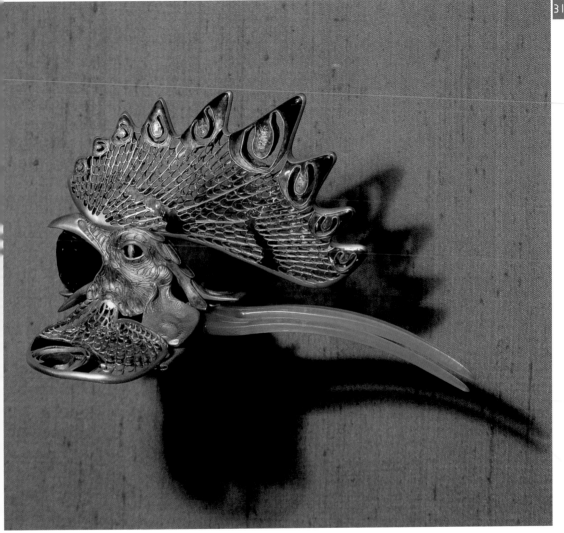

Bel Geddes, Norman
Patriot Midget Radio, c. 1940

The early days of Art Deco were typified by the superb craftsmanship and quality of materials displayed in fine furniture, such as that created by the French master of design, Jacques-Emile Ruhlmann (1879–1933). It is an idiosyncratic feature of this art movement that it developed into an almost total contradiction of itself in its latter years – in the 1930s, mass-produced objects in new, cheap materials became the testaments of Art Deco for ordinary people, especially in the USA.

Plastic was seen as "the hallmark of modern design" by industrial designers, such as Peter Müller-Munk (1904–67) and Norman Bel Geddes. Since plastics such as Bakelite were cheap, designers were keen to exploit them in their desire to democratize good design. Plastic also had a number of extremely useful properties: it was light, durable, malleable and tough. It could also be moulded, formed and coloured.

The design for this Patriot Radio was based on the American flag to celebrate the 25th anniversary of the company that produced it, Emerson Radio and Phonograph Corporation. It was made of Catalin – a new plastic that could be cast in a range of textures and colours.

MOVEMENT

Art Deco/Machine Age

MEDIUM

Blue Catalin case

SIMILAR WORKS

Streamliner: radio made in yellow and orange Catalin by Fada Radio and Electric Company, 1940s

Norman Bel Geddes *Born* 1893 Michigan, USA

Died 1958

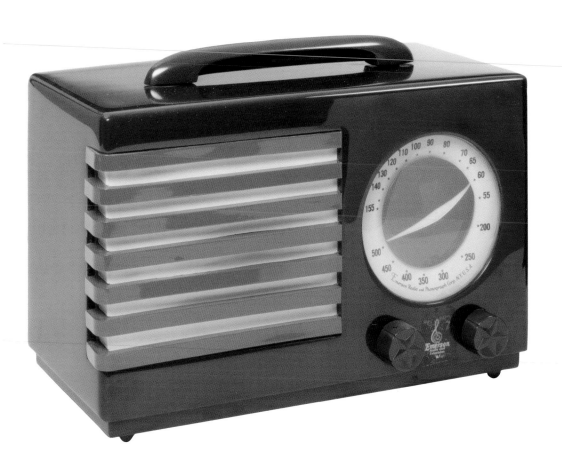

Teague, Walter Dorwin
Sparton Radio, c. 1936

© Estate of Walter Dorwin Teague/Christie's Images Ltd

Of all the modern materials that became popular in the 1930s, Bakelite is one of the best known. This synthetic resin is formed from a combination of phenols and formaldehydes, and the large scale production of Bakelite was developed by L.H. Baekeland (1863–1944) in the US in 1909. This useful plastic is a non-conductor of electricity and it can, like similar materials, be easily moulded and coloured. These two properties rendered Bakelite especially suitable for the manufacture of electrical goods, such as radios and phonographs.

Plastics soon became the material of choice for many consumables, as they could be formed by machines, thus reducing the need for expensive hand-assembly. Geometric designs were easier to mould than intricate curves or decorations and this contributed to the prevalence of simple geometric motifs in plastic goods of the 1930s.

Aluminium, chromium and stainless steel were other new materials that excited industrial designers such as Raymond Loewy (1893–1986). He explained how design and industry had become united: "We seem to find that the aesthetics of an industrial product take care of themselves after we have provided a balance between function, simplicity and utility."

MOVEMENT

Art Deco/Machine Age

MEDIUM

Blue-mirrored glass, chromium-plated metal and wood

SIMILAR WORKS

Soda siphon by Norman Bel Geddes, 1935

Walter Dorwin Teague Born 1883 Indiana, USA

Died 1960

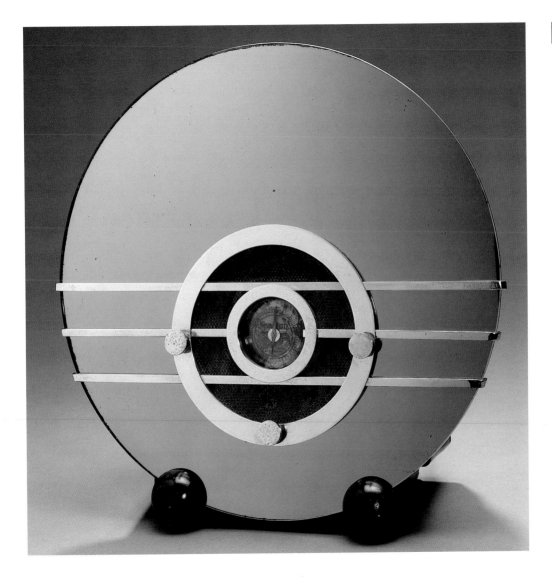

Cooper, Susie

Kestrel tureen, *c.* 1932

Susie Cooper is less well known than her peer, the ceramicist Clarice Cliff (1899–1972), but she is widely regarded as one of the most influential designers who worked in the pottery industry during the twentieth century. Cooper's career spanned more than 70 years and she was responsible for over 4,000 designs. Cooper's work was not only highly popular during the peak years of her career; they have remained popular today and are highly collectible. It is remarkable, given the time in which they worked, that Cooper and Cliff – both women – not only achieved acclaim for their progressive designs, but also achieved commercial success in their businesses.

Pictured here is Susie Cooper's tureen from the *Kestrel* line. The entire range proved to be one of Cooper's most successful: it was functional and practical, could be cleaned easily and suited different decorative motifs. The tureen was a particular hit with the public because its lid doubled up as another serving dish. This range exemplifies Cooper's great talent: she understood her customers and responded quickly to changes in fashion. Cooper had always believed that customers should not have to pay for style and the company logo was 'Elegance with Utility'.

MOVEMENT

Art Deco

MEDIUM

Earthenware

SIMILAR WORKS

Moon and Mountains design by Cooper, 1920s

Chalet design by Clarice Cliff, 1930s

Susie Cooper *Born* 1902 Stoke on Trent, England

Died 1995

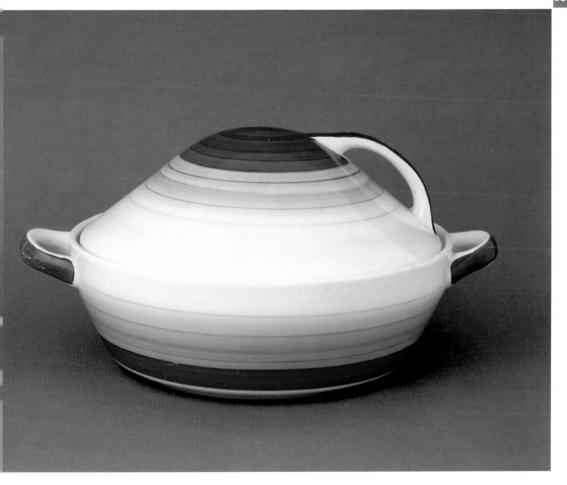

Cooper, Susie

Falcon teapot, late 1930s

Susie Cooper was born in Burslem, Stoke on Trent, in the heart of English pottery. She originally aspired to work in the fashion industry but was rejected by the Royal College of Art because she was not working in industry at the time of her application. Cooper was persuaded to work for a local pottery, A.E. Gray, and train as a painter to gain the experience required by the college. She showed such talent that she was soon promoted to resident designer at the factory.

Cooper's progress was rapid and by 1929 she had established her own pottery, taking control of the design of the ceramics as well as the decoration. Initially, Cooper's wares were hand-painted, as were those of her contemporary Clarice Cliff. One of Cooper's great contributions to ceramics, however, was to produce ware that was affordable to ordinary people: this meant mass-produced rather than hand-crafted objects. Cooper developed vastly improved techniques in lithographic transfer. This method created an 'instant' picture on a piece of pottery, but the technique was so good that it was difficult to tell the difference from a hand-painted piece.

MOVEMENT

Art Deco

MEDIUM

Earthenware

SIMILAR WORKS

May Blossom: design on a *Trieste* plate by Clarice Cliff, 1935

Aurea: design on an *Early Morning Conical* tea set by Clarice Cliff, 1934

Susie Cooper *Born* 1902 Stoke on Trent, England

Died 1995

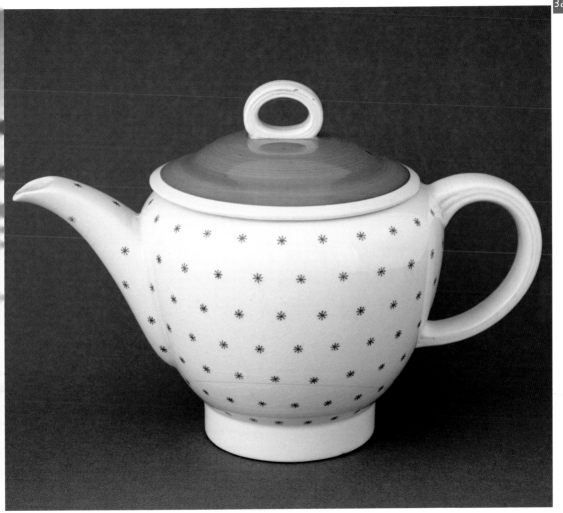

Cooper, Susie

Kestrel coffee set, 1932

When British ceramicist Susie Cooper boldly set up her own business in 1929, she decided to concentrate on the less-expensive earthenware ranges. Earthenware is cheaper than bone china, which was usually kept for 'Sunday best'. Cooper wanted to create stylish ceramics that would be pleasurable to use every day, for every occasion. She continued to produce ceramics that were hand-painted and in these early days her designs were often banded, or depicted flowers. The designs were a success, and by 1931 Cooper needed to move into bigger premises.

Susie Cooper was offered space in the factory of a local pottery, Wood and Sons. The factory, the Crown Works in Burslem, proved an ideal site since it gave Cooper the opportunity to directly influence the shape and quality of the ceramic ware that her painters decorated. The move was successful and productivity was high. Cooper experimented with new techniques, such as improved lithographing, and she ensured that her designs were in tune with the changes in fashion in interior design. In 1932 she began to produce the famous *Kestrel* line, which is shown here with a typically bright, geometric pattern. The sgraffito marks are made by incising a pattern into the soft clay, or wet glaze, before firing.

MOVEMENT

Art Deco

MEDIUM

Earthenware with banded, painted and sgraffito decoration

SIMILAR WORKS

Gloria Lustre: range of ceramic ware by Cooper for A.E. Gray & Co Ltd, 1923

Susie Cooper *Born* 1902 Stoke on Trent, England

Died 1995

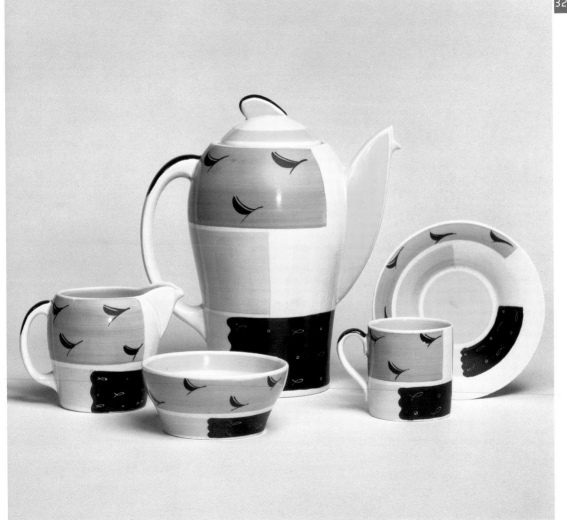

Cooper, Susie

Vase with Horse, *c.* 1938

Susie Cooper's ceramics were extremely popular in Britain during the 1930s, and had also begun to sell well abroad, particularly in the United States. Part of Cooper's success lay in her ability to mix high technical skill with innovative flair. Cooper had wanted her ceramics to be utilitarian but attractive and she achieved this by keeping abreast of developments in fashion and the world of interior design. As the business grew, Cooper turned towards mass production techniques, such as transfers, or lithographs. She ensured, however, that her designs remained fresh and that the quality of the finished product was never compromised. She kept the hand-painted look by employing skilled painters to add bands of colour or shaded borders.

Despite her ability to follow trends, Cooper's ceramic wares are noticeably more subdued than those of her contemporaries, Clarice Cliff and Charlotte Rhead (1885–1947). She produced geometric patterns when they were fashionable, but designs that featured animals and plants were always popular. She often chose muted, natural colours. Cliff, by comparison, produced pottery that was vivid and bold with a palette of lime greens, acidic yellows and vibrant oranges – colours that often vied for attention on a single piece.

MOVEMENT

Art Deco

MEDIUM

Earthenware

SIMILAR WORKS

Blue Peony: design by Charlotte Rhead, 1935

Susie Cooper *Born* 1902 Stoke on Trent, England

Died 1995

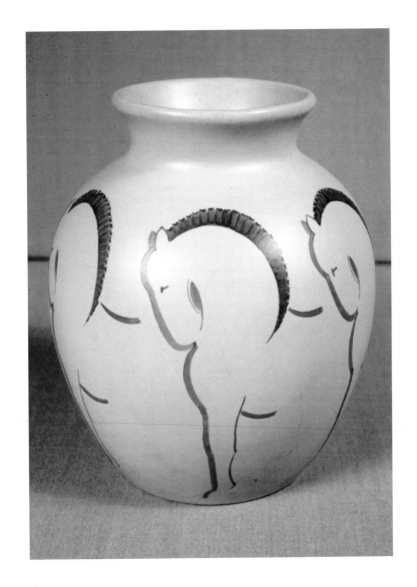

Cooper, Susie

Falcon coffee pot, cup and saucer & sugar bowl in *Chinese Blue* design (produced for John Lewis Department Stores), 1938-42

Amongst Susie Cooper's most popular ceramics were those lines that featured banding, a simple but modern style. One variation appeared so often on young couples' wedding lists that it became known simply as *Wedding Band*. These lines continued to sell well during the 1930s, by which time she had established a successful market in the US and Canada with special designs such as the *Turkey Range* for Thanksgiving. When the Second World War broke out, however, production at Cooper's factory virtually ground to a halt. Mass production all but ceased and Cooper reverted to hand-painting techniques and creating one-offs. By 1942 the factory had closed down, but the business re-started after the war, this time specializing in bone china which had become popular. The *Falcon* range of ceramic ware was to become one of Cooper's best-sellers. The name applies to the shape of the pieces, which could then be decorated in a variety of patterns.

MOVEMENT

Art Deco

MEDIUM

Earthenware

SIMILAR WORKS

Cockerel cocktail tray by Cooper for the North American market, 1930s

Susie Cooper *Born* 1902 Stoke on Trent, England

Died 1995

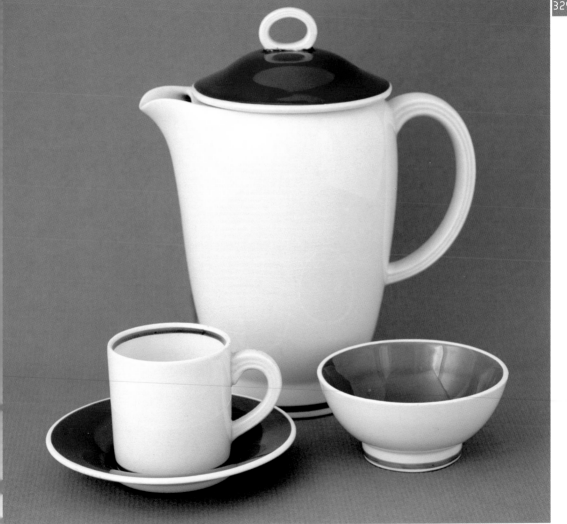

Lalique, René
Nanking Vase, 1925

Courtesy of Private Collection/www.bridgeman.co.uk/© ADAGP, Paris and DACS, London 2005

René Lalique trained as a jeweller, and he carved out a very successful career in this field while also experimenting with glass as a medium for jewellery. Most of his glass jewellery was created using the *pâte-de-verre* process, in which powdered glass is put into a mould and heated until it fuses, giving a misty hue to the finished product.

In 1907 entrepreneur and perfumier François Coty (1874–1934) commissioned Lalique to design the labels and stoppers for his perfume bottles. Finally, he awarded the skilled craftsman the commission for the bottles themselves, and Lalique's legendary relationship with glassware was soon put to the test for the mass market.

In 1910 Lalique bought the glassworks at Combs-la-Ville in France, which were famous for the quality of sand nearby; it was especially suitable for glass-making because it had a high silicon content. The perfume bottles were hugely popular and, thanks to his mass production techniques, Lalique's business venture was commercially successful. Up until the First World War, Lalique's designs followed the Art Nouveau aesthetic. After the war, however, Art Deco designs were in vogue, and Lalique demonstrated his versatility by responding to the market and producing geometric and abstract designs, such as the unusual Nanking Vase.

MOVEMENT

Art Deco

MEDIUM

Black enamel on glass

SIMILAR WORKS

Au Coeur des Calices: scent bottle for Coty by Lalique, pre-1914

René Lalique *Born* 1860 Ay, France

Died 1945

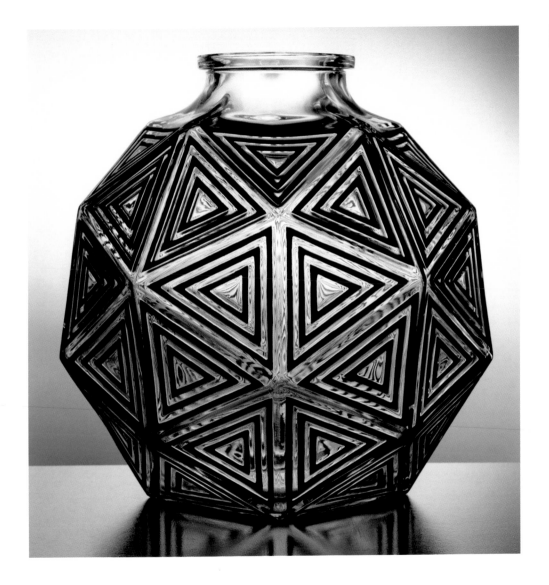

Lalique, René

Serpent Vase, 1924. Displayed at Lalique's showroom at the Paris Exhibition, 1925

Courtesy of Private Collection/www.bridgeman.co.uk/© ADAGP, Paris and DACS, London 2005

Lalique used a variety of techniques to create his vases. His earlier vases were often identical in shape, having been made by the mould-blown process. This method was relatively cheap – but the pieces were, by necessity, very simple. Extra adornment had to be added afterwards, individually. This raised the cost of production and Lalique soon abandoned this technique in favour of the more cost-effective press-moulding technique. This method involved forcing glass into a mould by a plunger, which was hand or machine operated. The mouth of the vessel, however, has to be the widest part of it for the plunger to be removed. With its obvious limitations, press-moulding enabled Lalique to move towards his ideal of the mass production of affordable glassware. It was also a technique that proved effective for creating decorative glass panels.

Cire perdue, or 'lost wax' is a technique Lalique sometimes used to create his pieces. The decorative feature is carved in wax, often laid into a vase or other vessel, and a mould is cast around the wax. The melted wax drains away through a tiny hole and molten glass is poured in to replace it. When cool, the mould is removed to reveal the finished piece.

MOVEMENT

Art Deco

MEDIUM

Amber glass

SIMILAR WORKS

Senlis: glass vase made using the mould-blown process by Lalique, 1920s

René Lalique *Born* 1860 Ay, France

Died 1945

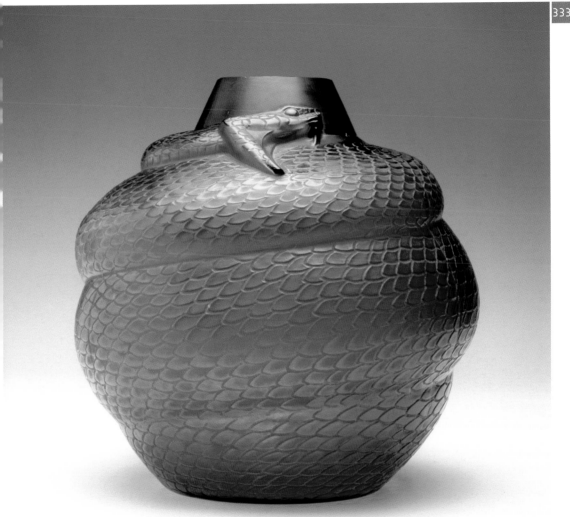

Lalique, René
Feuillages (Foliage) table lamps

Courtesy of Private Collection/Bonhams, London, UK/www.bridgeman.co.uk/© ADAGP, Paris and DACS, London 2005

During the 1920s, René Lalique applied his skill in glassware to the relatively new field of designing for electric lights. The lights of the Art Nouveau period were characteristically ornate, heavy and colourful. During the Art Deco period, light fittings became critical objects for the interior designer in they way they cast light on an entire room, or decorative features, rather than for the decorative quality of the fitting itself. Thus Art Deco lights were required to produce atmosphere and a quality of light. This was often achieved by wall lights in geometric shapes that threw light upwards to produce a gentle reflected light, in preference to the harsh, direct light created by a ceiling light fitting.

These table lamps are examples of Lalique's glasswork before he switched his designs from the naturalistic, figurative aesthetic of the Art Nouveau. Gradually, his lights became more stylized and featured geometric designs and repeated patterns, often in the motifs that were in vogue, such as sunbursts and streamlined shapes. Lalique produced more than 20 designs for table lamps and also designed chandeliers, mainly for shops and hotels rather than homes.

MOVEMENT

Art Deco

MEDIUM

Frosted glass

SIMILAR WORKS

Landscape: hair comb in horn and enamelled glass by Lalique 1899–1900

Opalescent wall-lights decorated with sunburst motifs by Lalique, *c.* 1930

René Lalique *Born* 1860 Ay, France

Died 1945

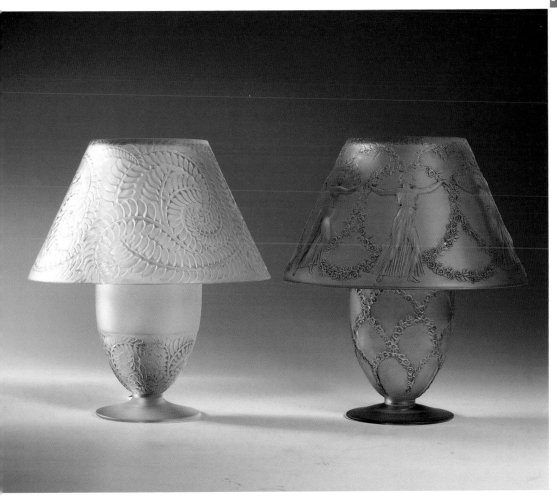

Reeves, Ruth

Figures with Still Life: furnishing fabric

The 1930s presented a problem for designers in the US. Awash with European influences that did not entirely suit the American concept of Modern, designers needed to find their own voice: it was time for America to develop its own cultural aesthetic. This development largely came about through the mass production of consumer goods, and streamlining became a style most commonly associated with American design of the time. There were, however, artist-designers who came to exemplify a strong American sense of individuality. Textile designer Ruth Reeves and Paul T. Frankl (1886–1962) were just such designers – they did not reject European influences, but instead used them to create their own, unique styles.

Paul T. Frankl was born in Prague but emigrated to America, where, with his contemporary Joseph Urban (1882–1934), he helped create a tradition of modern design within the US. Originally an architect, Frankl set up a business in New York in 1922, from where he sold modern textiles and wallpapers and supported the work of other émigrés, alongside that of American-born designers. Frankl said of Ruth Reeves "(she) dares to be profoundly, passionately herself."

MOVEMENT

Art Deco

MEDIUM

Velvet

SIMILAR WORKS

Americana, Moth Balls and Sugar: printed dress fabric by Edward Steichen, 1927

Ruth Reeves *Born* 1892 California, USA

Died 1960

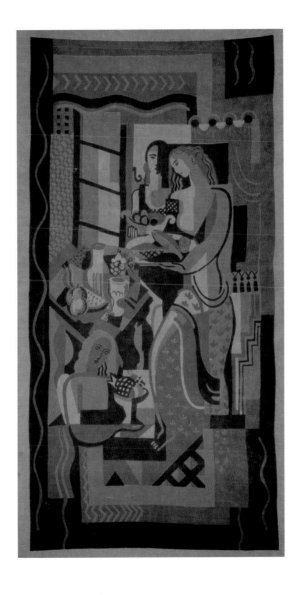

Reeves, Ruth

Homage to Emily Dickinson: furnishing fabric, 1930

American textile designer Ruth Reeves studied at the Pratt Institute in New York where she trained as a painter, and from 1920 to 1927 she studied in Paris with Fernand Léger (1881–1955). Léger is credited with having created 'Machine Art' – a style that contained mechanistic forms in bold colours and arranged in ordered compositions. He was working in Paris at a time when several new avant-garde art movements were developing, and he was greatly influenced by the Cubist work of Pablo Picasso (1881–1973) and Georges Braque (1882–1973). His pictures developed quickly and Léger evolved his own style which used contrasts – between colours, flat slabs and solids, and between straight and curved lines – to achieve maximum effect.

This fabric was created to celebrate the life and work of Emily Dickinson (1830–86), an American poet. Dickinson was a recluse and spent most of her adult life in her room, where she wrote more than 1,800 poems. The fabric shows a repeat pattern of a woman looking out from a window, onto a garden filled with birds, cats and flowers. Dickinson only published seven of her poems during her lifetime, but her poetry has received great acclaim posthumously.

MOVEMENT

Art Deco

MEDIUM

Cotton velvet

SIMILAR WORKS

Contrast of Forms by Fernand Léger, 1913

Man with a Cane by Fernand Léger, 1920

Ruth Reeves *Born* 1892 California, USA

Died 1960

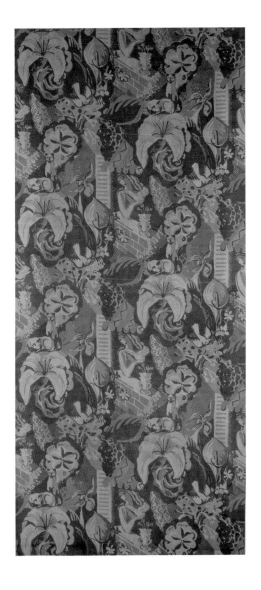

Reeves, Ruth
Play Boy: furnishing fabric, 1930

© Estate of Ruth Reeves/Victoria and Albert Museum, 2005

Through studying with Fernand Léger in Paris, Ruth Reeves learnt about Cubism and other avant-garde art movements of the time, and these influences were to affect her work greatly. Eventually she experimented with hand printing and turned towards textiles as a medium for her art. She returned to the US, where she became one of the country's most important designers in this field. Reeves' work was well known at the time, and she was widely respected as a designer who was interested in depicting contemporary American life. In 1929 Reeves participated in the first American Designer's Gallery exhibition, and in 1930 the US department store W. & J. Sloan displayed 29 of her designs. Reeves' work reached ordinary people; along with her contemporaries she helped the modern American textile industry find its own unique style, one that was characterized by simplicity in form and colour.

The *Play Boy* textile demonstrates the importance of archaic art as an influence during the 1920s and 1930s. Aztec-block motifs are used to represent figures as they shoot, ride and drive. In 1934 Reeves travelled to Guatemala to study the indigenous art of Central America, and this further influenced her designs.

MOVEMENT

Art Deco

MEDIUM

Printed cotton and monk's cloth

SIMILAR WORKS

Woollen rugs by Ivan da Silva Bruhns, 1928

Man's Smoking Room: interior design by Donald Deskey for the American Designers' Gallery, 1928

Ruth Reeves *Born* 1892 California, USA

Died 1960

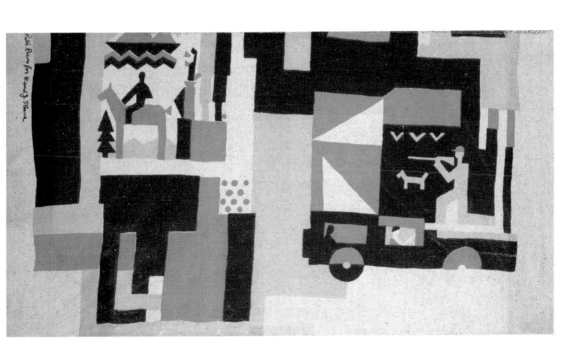

Reeves, Ruth

Essex Hunt: furnishing fabric, 1930

During the 1920s and 1930s America struggled to find its own design style. The Paris Exhibition of 1925 brought European, especially French, style to the attention of the Americans. The US had not participated in the Exhibition because its government had decided that "American manufacturers and craftsmen had almost nothing to exhibit in the modern spirit", but inspired by what they had seen, influential American designers determined that the stagnant phase in their own country's arts and crafts would come to an end.

The Moderne movement in France was particularly prevalent in the 1925 Exhibition, adapting new designs for a wide and fashionable market. It adapted Modernism by stressing the decorative rather than the purely functional, and quickly became an international phenomenon. Although American textile designer Ruth Reeves was greatly influenced by the Cubist movement, her work became more figurative, gentle and mellow; more appropriate to the decorative requirements of her customers. This furnishing fabric by Ruth Reeves depicts a hunt. Scenes of a house, a meet and the hunt itself alternate but are unified by a frame of foliage, the colours typically muted. Reeves' designs appeared on various fabrics, from woven carpets to delicate chintzes, voiles and muslins.

MOVEMENT

Art Deco

MEDIUM

Printed cotton

SIMILAR WORKS

Knaresborough: design on silk tissue for London's Claridges Hotel by Bertrand Whittaker, 1926

Ruth Reeves *Born* 1892 California, USA

Died 1960

Follot, Paul
Carpet, 1919–20

In 1923 the influential Swiss architect Le Corbusier (1887–1965) was to say that a modern house should be "a machine for living in". In the same year Walter Gropius (1883–1969), director of the Bauhaus, stated that "art and technology should form a new unity" and should move away from arts and crafts towards industrial design.

During the 1920s the movement towards Modernism was swift: designers followed the tenet that 'form must follow function' and emphasis was therefore placed largely on the materials used. Modernists argued that excellent design and mass production were not mutually exclusive. It was believed that affordable, stylish and beautiful items could be created by machines, if designed well in the first instance. The central tenets of Modernism created a challenge for French designers of the 'old school' such as Paul Follot and Maurice Dufrène (1876–1955), whose style had developed from the highly decorative aesthetic of Art Nouveau and was influenced by Fauvism. Fortunately for these designers of pure or 'high' Art Deco, customers were not ready to eschew all ornamentation in favour of purely utilitarian objects.

MOVEMENT

Art Deco

MEDIUM

Wool

SIMILAR WORKS

Dining room furniture, decorated with motifs of baskets of flowers by Follot for the *Salon d'Automne*, 1912

Occasional table in exotic woods by Clément Rousseau, *c.* 1921

Paul Follot *Born* 1877 Paris, France

Died 1941

Follot, Paul,

Stool, c. 1920

The seeds of the Art Deco style were sown in France in the early years of the twentieth century. Parisian designers aspired to the development of a purely 'French mode' and aimed to remove all traces of foreign influence from their work. They wanted to continue the tradition of sublime French design, such as they had owned in the Louis-Philippe style, and designers returned to classical French styles for inspiration. A secondary objective was to distance French design from the Art Nouveau movement, with its characteristic curves, sensuality and almost excessive ornamentation.

These objectives gave rise to the development of early Art Deco, a style that was to become known as 'high' or 'pure' Art Deco and presented an alternative to the revolutionary austere 'new design' that found favour amongst the more radical German and Austrian artist-designers. 'High' Art Deco relied largely upon Historicism: the adoption of elements from an earlier period for the design of objects that are, nevertheless, characteristic of their own time.

This stool, designed by Parisian furniture-maker Paul Follot exemplifies the Art Deco period in France during the early 1920s. Luxurious fabrics and woods are combined in a simple and perfect shape.

MOVEMENT

Art Deco

MEDIUM

Ebony and stained maple, upholstered in brocaded silk

SIMILAR WORKS

Tables and chairs in ebonized wood and mother of pearl by Joseph Urban, 1922

Paul Follot *Born* 1877 Paris, France

Died 1941

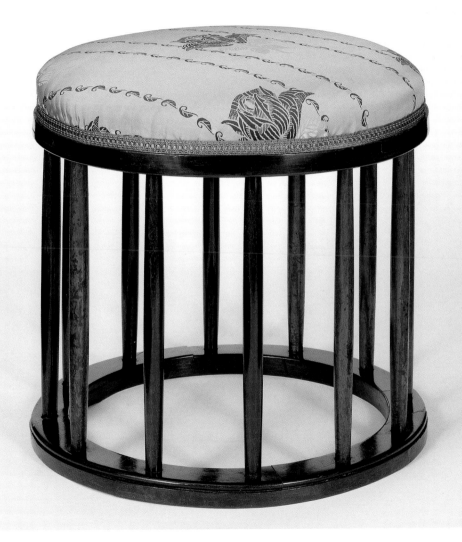

Follot, Paul
Chair, *c.* 1928

In the early stages of the twentieth century, French, particularly Parisian, designers are regarded as having reached the apotheosis of style. Designers such as Paul Follot and Jacques-Emile Ruhlmann used Historicism to achieve a modern aesthetic by employing an innovative approach to form (the shape of objects), subject matter (the themes and characters depicted) and techniques and materials (such as quality, rare woods and inlays). By employing skilled craftsmen from different trades, artist-designers were able to create a holistic ideal in interior design: they turned their eyes to lighting, ceramics, textiles and wall coverings, as well as furniture. This approach carried on into the 1930s, especially in Europe and America, where interior designers became preoccupied with the appearance of a whole range of products.

At the time of the Paris Exhibition in 1925, British furniture was still steeped in traditionalism, the Arts and Crafts Movement and Art Nouveau. On the continent, the German designers were influenced by the French aesthetic. Despite the rise of Modernism in Germany, typified by the work of the Bauhaus, many designers, such as Bruno Paul (1874–1968), created objects in opulent materials and fine veneers.

MOVEMENT

Art Deco

SIMILAR WORKS

Commode in lacquered wood by Bruno Paul, 1914

Dining Room: interior design for the Paris Exhibition, 1925 by R. Quibel

Paul Follot *Born* 1877 Paris, France

Died 1941

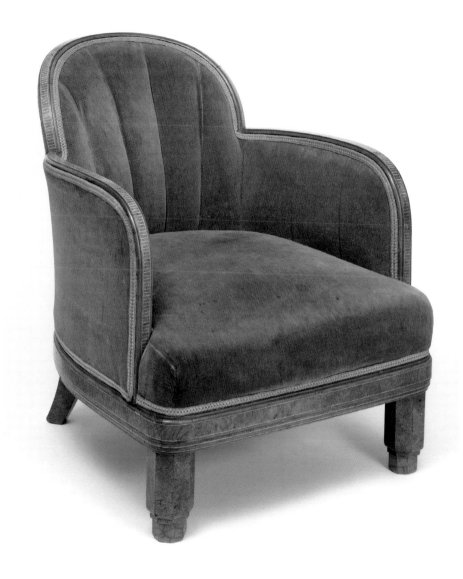

Follot, Paul
Dressing table

Parisian designers such as Paul Follot used traditional French furniture to inspire their modern creations. As the 1920s progressed, however, the historical influences became less obvious. This dressing table by Paul Follot, with its radical shape, rounded drawers and use of modern materials such as chrome, displays a clear move away from his earlier works. In 1919, for example, Follot created a dressing table in carved gilt and lacquered wood. It was shown at the *Salon des Artistes Décorateurs* in 1920, a piece that pays homage to the style of Louis XVI while combining elements of the modern. It is opulent, sumptuous and striking, but its gilt decoration is geometric, linear and planar.

In 1912 a prominent French collector of art and artefacts, Jacques Doucet, sold his historic collection of superb eighteenth century French fine art and furniture. He decided, instead, to concentrate his collection on contemporary works. This move, by a Parisian trend-setter, must have affected the artist-designers of the day and may, in part, explain why designers such as Follot moved away from their historical roots towards the modern style shown here. They did not, however, reject one of the central tenets of their design philosophy: the importance of quality materials combined with superb craftsmanship.

MOVEMENT

Art Deco

SIMILAR WORKS

Dressing table of oak with mahogany and amaranth veneer, inlaid with ebony and ivory by Jacques-Emile Ruhlmann, 1925

Paul Follot *Born* 1877 Paris

Died 1941

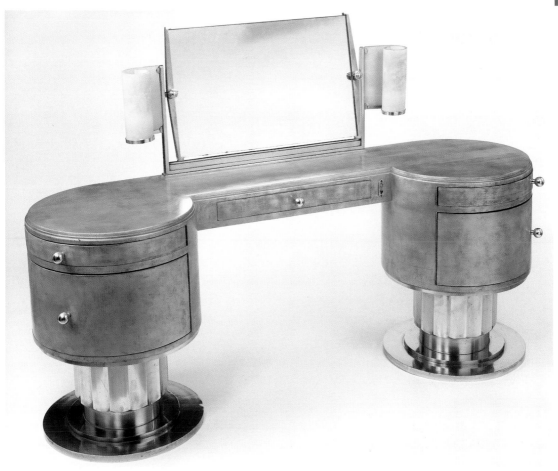

Follot, Paul

Cabinet and occasional table, *c.* 1925

During the early stages of the Art Deco period there was an emphasis on techniques that required highly skilled labour and experience. The techniques required for inlaying, creating veneers and lacquering were not easily mastered and were at odds with the growing belief amongst designers that style should not be the prerogative of the wealthy. The exotic woods required by designers such as Maurice Dufrène, Jacques-Emile Ruhlmann and Paul Follot were expensive, as were the inlays they used, such as ivory and shell. Art Deco style could only become democratized when a reliance on luxury materials was replaced by modern materials that could be created or worked by machines.

It is the paradox of the Art Deco movement that it embraces two such disparate techniques as the hand-crafted skill of the ébéniste (worker in ebony and other fine woods) and the chrome-plating of the Machine Age. During the late 1920s and 1930s, the work of artist-designers began to shift towards the Machine Age aesthetic and a growing use of modern materials such as chrome and aluminium were in evidence. In the initial stages, many compromise pieces were produced: parts were manufactured but skilled hand-finishing was required for the decorative elements.

MOVEMENT

Art Deco

MEDIUM

Amboyna with mahogany veneer, ivory feet, handles and inlays.

SIMILAR WORKS

Pair of chaises-longues in sculptured gilt wood and upholstered in silk by Follot, *c.* 1920

Paul Follot *Born* 1877 Paris, France

Died 1941

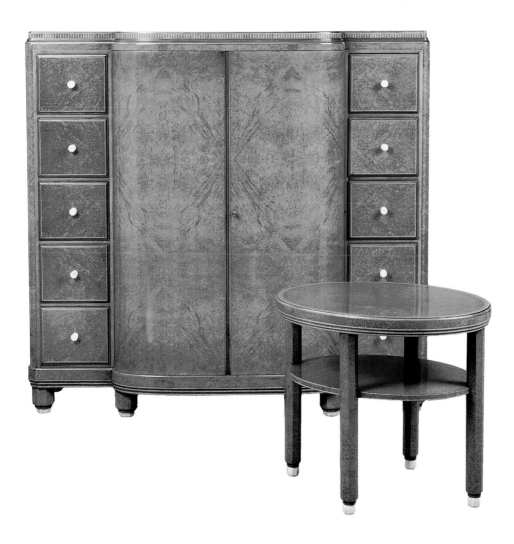

Dupas, Jean
Angels of Peace, 1948

Jean Dupas was a painter and poster artist who also designed a number of significant murals of the Art Deco period, including the *Chariot of Aurora*, which decorated the luxury French cruise liner *Normandie*. He studied at the *Ecole des Beaux-Arts* in Paris and won the *Prix de Rome* in 1910. Dupas' most famous painting, *Les Perruches*, was a centrepiece at the Grand Salon of the *Hôtel d'un Collectioneur* at the Paris Exhibition in 1925.

Dupas moved quickly away from the Neoclassical roots of his training and absorbed influences from the various avant-garde art movements that operated in Paris between the wars. Surrealism was one such movement: it was European in origin and favouring the visual imagery of the subconscious. This imagery was partly inspired by the psychologist Sigmund Freud (1856–1939) who was investigating the workings of the mind and analyzing dreams. From the middle of the 1920s, artists such as Salvador Dali (1904–89) and René Magritte (1898–1967) produced realistic and highly detailed 'dream paintings'. Surrealists took such images to an extreme and many of their paintings appear illogical, disorientated and unreal. Their effect on other artists of the day such as Dupas is, however, undeniable.

MOVEMENT

Art Deco/Surrealism

MEDIUM

Oil on card

SIMILAR WORKS

La Procession: gouache by Dupas, 1918

Jugement de Paris and Les Antilopes by Dupas, early 1920s

Jean Dupas *Born* 1882 Lyon, France

Died 1964

Dupas, Jean

Arnold Constable Commemorating the Mode of Yesterday: poster, 1928

Although printed advertising material appeared as early as the fifteenth century, it was not until around 1860 that modern posters emerged. The advancement of printing techniques, especially lithography, fuelled the rise of this advertising medium, which reached its zenith during the Art Nouveau and Art Deco periods.

During the late nineteenth century, artists such as Toulouse-Lautrec (1864–1901) and Jules Chéret (1836–1932) created bold, dramatic posters printed with vibrant, radiant colours. Decorative brilliance and symbolism emerged during the Art Nouveau period, but it was during the First World War that posters became an art form that could influence history. Artists began to understand the power, propagandist or otherwise, of a bold visual image and simple slogans. As consumerism developed, especially in Europe and the US, so the innovative and imaginative work of poster artists reached new heights. This poster by Jean Dupas advertised the New York department store Arnold Constable and Company. Established in 1827, the store was popular with notable personalities of the day such as the Carnegies and the Rockefellers.

MOVEMENT

Art Deco

MEDIUM

Poster

SIMILAR WORKS

Poster for the World's Fair at Bordeaux by Dupas, 1937

Jean Dupas *Born* 1882 Lyon, France

Died 1964

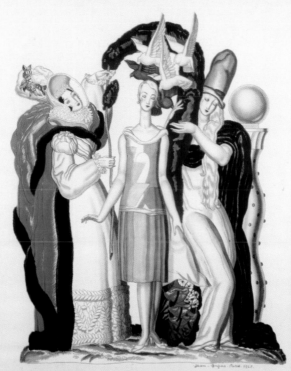

ARNOLD CONSTABLE

COMMEMORATING THE MODE OF YESTERDAY
PRESENTING THE MODE OF TO-DAY
FORECASTING THE MODE OF TO-MORROW

Dupas, Jean

A set of ten murals from the ocean liner *Normandie*, 1935

© Estate of Jean Dupas/Christie's Images Ltd

One of the great technical developments of the Art Deco period was found in the craft of artist-decorators. The term 'decorative arts' had first appeared in the late 1870s and its existence demonstrates the degree to which decoration and ornamentation were recognized as distinct from architecture. No longer was an architect expected to control all aspects of a building: a new breed of expert had developed – the artist-decorator – assuming responsibility for a total look.

In 1927 a ship was commissioned that was to bring the mastery of the interior decorator to a new height. The French flagship *Ile de France* was designed in the Art Deco style and, in the attention paid to detail and luxury, captured the zeitgeist of the era. Her successor, *Normandie*, was quickly commissioned but was not launched until 1932 after suffering delays owing to the Great Depression. The *Normandie* took interior design to a new level of resplendence – this mural designed by Jean Dupas was one of several specially commissioned. She was taken out of service when the Second World War began, however, and later caught fire and sank when she was being refitted to join the Navy.

MOVEMENT

Art Deco

MEDIUM

Mural

SIMILAR WORKS

Chariot of Aurora: lacquer and metal leaf on plaster relief designed by Dupas and produced by Jean Dunand for the *Normandie*, 1935

Jean Dupas *Born* 1882 Lyon, France

Died 1964

Dupas, Jean
Les Perruches (The Parrots), 1925

During the Art Deco period, the rise of the artist-decorator led to the development of a new area of design. Artist-decorators often began their careers in workshops, as skilled artisans in fields such as ironwork, upholstery or cabinet-making. Alternatively, they were industrial artists, the product of specialist schools that had been established to develop art and design in Europe after the British Great Exhibition of 1851.

At the Paris Exhibition in 1925, one of the greatest artist-decorators of the Art Deco period, Jacques-Emile Ruhlmann, unveiled the apogee of interior design: the *Hôtel d'un Collectioneur*. Designed by Pierre Patout (1879–1965), this French pavilion was laid out as a suite of elegant rooms with a vast oval room at its centre: the Grand Salon. Ruhlmann created the interior design and he garnered the help of leading designers of the day to fill it with their artefacts. Jean Dunand (1877–1942), Edgar Brandt (1880–1960) and Antoine Bourdelle (1861–1929) were amongst those leading lights of the day who contributed to this apotheosis of design. Jean Dupas' painting of *Les Perruches* was a focal point of the Grand Salon. Colourful, sumptuous, elegant and refined, the Grand Salon was lauded when it was first unveiled and is now regarded as one of the finest achievements of the French Art Deco period.

MOVEMENT

Art Deco

MEDIUM

Oil on canvas

SIMILAR WORKS

Araignée: table in Macassar and ivory by Jacques-Emile Ruhlmann displayed in the Grand Salon, 1918-19

Jean Dupas *Born* 1882 Lyon, France

Died 1964

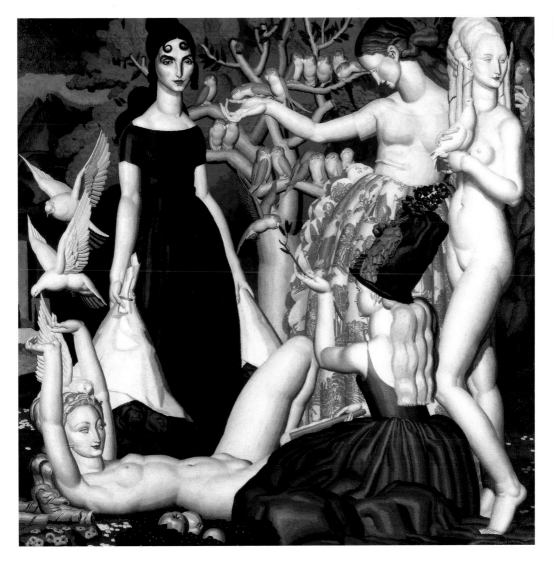

Bénédictus, Edouard

Plate 8 from *Nouvelles Variations*: Soixante-quinze Motifs Décoratifs en Vingt, *c.*1929

It was common for designers and artists of the Art Deco era to produce sample books of their patterns or artefacts. A pattern, such as those created by French artist Edouard Bénédictus, could be used for a variety of mediums, such as dress andupholstery fabric, rugs, wall-hangings and wallpaper. The artist-decorator, or ensemblier, used books of samples to compile a range of interior design effects for a home or commercial building.

French artist-decorators established their identity when they created the *Société des Artistes Décorateurs* in 1901 and organized exhibitions of their works over the ensuing years. Various specialist stores, or salons, opened up in Paris to sell luxury designer artefacts and by the late 1920s these salons, such as the *Salon des Arts Ménagers*, which had been established in 1923, were hugely popular. They no longer sold just the hand-crafted and unique items of skilled craftsmen: they now stocked mass-produced, quality items that suited the pockets of ordinary people. The artist-decorators fulfilled an important role in the democratization of Art Deco vogue: they encouraged mass production, industrial design and consumerism.

MOVEMENT

Art Deco

MEDIUM

Colour pochoir

SIMILAR WORKS

Notre-Dame, une Fin d'Après-midi: Fauvist painting by Henri Matisse, 1902

Edouard Bénédictus *Born* 1878 Paris, France

Died 1930

Bénédictus, Edouard

Plate 20 from *Nouvelles Variations*: Soixante-quinze Motifs Décoratifs en Vingt, *c.* 1929

This pattern by designer Edouard Bénédictus was printed by the pochoir method, a technique particularly popular in the first half of the twentieth century because of the crisp lines and vibrant colours that it produced. The images retain an almost wet, and therefore fresh, appearance, and pochoir was commonly used for illustrations of pattern design, fashion and interiors from 1900 to around 1930. A time-consuming and labour-intensive process, pochoir involves the hand-cutting of many stencils, one for each colour or pigment. This attention to detail produces a high quality of print, but also makes it an expensive method. Lithography was a much cheaper and quicker method and, with the improvement of this technique and the development of photography as a method of reproducing images, pochoir eventually fell out of favour.

This pattern by Bénédictus shows the bright colours of Fauvism and the planar qualities of Cubism: both avant-garde art movements that influenced the French designer in their attempts to achieve perspective by using colour or form rather than the traditional mathematical techniques.

MOVEMENT

Art Deco

MEDIUM

Colour pochoir

SIMILAR WORKS

Jour: Cubist painting by Georges Braque, 1929

Edouard Bénédictus *Born* 1878 Paris, France

Died 1930

Bénédictus, Edouard

Book Plate 15, from *Relais*, Quinze Planches Donnant Quarante-deux Motifs Décoratifs, 1930

French designer Edouard Bénédictus trained as a painter and later worked as a decorator. He eventually specialized in fabric and textile designs and produced his own folios of designs: the print here comes from *Relais*, produced in 1930. The designs from such books might be produced in connection with textile manufacturers, then commissioned by artist-decorators.

Rugs, textiles and tapestries of the time often featured clear elements of Cubism and other contemporary art movements. Some of Bénédictus' works, especially his early designs, are vivid in colour and depict stylized images from nature. This later image demonstrates a move towards the geometric and streamlined. The liner in the background shows the force of the emerging Machine Age, which celebrated the speed and elegant beauty that can be achieved through mechanical power. The muted colours and restrained composition contrast starkly with the flamboyant, clashing colours of his floral designs. Banded colours, here seen arching towards the window, became a popular motif for the Art Deco designer: British ceramicist Susie Cooper achieved great commercial success using simple bands of colour on her pieces.

MOVEMENT

Art Deco

MEDIUM

Colour pochoir

SIMILAR WORKS

Woollen carpet in reds and oranges by Bénédictus, *c.* 1925

Edouard Bénédictus *Born* 1878 Paris, France

Died 1930

Bénédictus, Edouard

Floral design from 'Treatise on the Illuminating of Stencils', published 1925

Part of the success of the Art Deco style lay in its ability to modernize classical forms that had already proved to be pleasing to the eye. This print – *Floral Design*, by Edouard Bénédictus – demonstrates this marriage of styles well. The primary images are drawn from nature: flowers are shown in glorious full bloom and details of light and dark have been attended to assiduously. The audacious colours chosen by the artist, however, are borrowed neither from nature's palette, nor from the classical artists of previous times. Bénédictus, like many of his contemporary Art Deco colleagues, sought to challenge the traditional method of portraying recognizable forms and motifs. The acid colours of the flowers are set against a backdrop that shows other stylized flowers – this time distinctly two-dimensional.

The technique used to achieve these effects in print is called pochoir and it is commonly associated with Art Nouveau and Art Deco. Stencils were cut by hand from aluminium, copper, zinc or, later, celluloid. Layers of colour (watercolour and gouache) were applied by specialist painters to achieve the depth and intensity of hue required.

MOVEMENT

Art Deco

MEDIUM

Pochoir print

SIMILAR WORKS

Natalia Goncharova: Russian dress in silk appliqué made by Myrbor, *c.* 1925

Edouard Bénédictus *Born* 1878, Paris France

Died 1930

De Lempicka, Tamara
La Musicienne, 1929

The paintings of Polish-born artist Tamara de Lempicka have become iconic, representing the sophistication, decadence and superficiality of high society in the Art Deco world. De Lempicka was a celebrity artist who painted other celebrities enjoying the rarefied air of an elitist set in Europe between the wars. While she painted the fashionable, rich or titled, other artists were stretching their medium to its limits: Cubism, Dadaism, Fauvism, Surrealism – these are just some of the highly influential art movements of the first four decades of the twentieth century. It is little wonder that de Lempicka's stylized portraits were not always well-received by her fellow artists.

De Lempicka's glory years were from 1925 to 1940, after which she left Paris to live in America. During this time she produced more than 100 portraits. Her figures were often curvaceous, soft and even erotic in their poses, and juxtaposed against an angular background of skyscrapers. The pictures are often alarmingly superficial: bright colours and draped fabric grab the eye but the personality or emotion of the sitter are rarely evident.

MOVEMENT

Art Deco

MEDIUM

Oil on canvas

SIMILAR WORKS

Girl with Gloves by de Lempicka, 1929

High Summer by de Lempicka, 1928

Tamara de Lempicka *Born* 1900 Warsaw, Poland

Died 1980

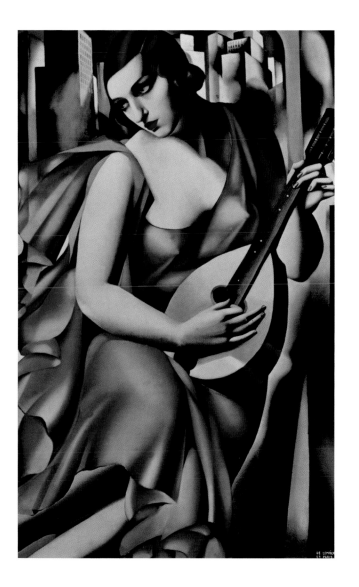

De Lempicka, Tamara

Perspective, 1923

One of the reasons that Tamara de Lempicka's portraits are perceived as having reached the pinnacle of Art Deco style is the recurring figure of the female. In sculpture and paintings, figurative art formed the basis for many images. De Lempicka's women were often young, beautiful and flawless. Many of her paintings depicted the nude female form, often draped in sensual, sometimes sexual, poses. At a time of emergent sexual liberation, the provocative nature of these paintings captured the mood of the time.

Art of the period between the wars rarely ties in with today's image of what Art Deco means. Surrealism, Cubism and Expressionism were practised in Europe and further abroad and challenged all previous notions of what qualified as 'great art'. The true Art Deco painters, such as de Lempicka and Jean Dupas, absorbed some of the innovative concepts that lay behind these movements, but retained their unique identities as decorative artists who distilled the lifestyle and fashions of high society. Paintings such as this, *Perspective*, demonstrate how capably de Lempicka used sombre backgrounds, which are almost two-dimensional and angular in the style of Georges Braque, to contrast with the voluptuous figures of two women who tempt the viewer to contemplate their relationship.

MOVEMENT

Art Deco

MEDIUM

Oil on canvas

SIMILAR WORKS

La Naissance d'Aphrodite: oil on canvas in a Cubist style by Paul Véra, 1925

Tamara de Lempicka *Born* 1900 Warsaw, Poland

Died 1980

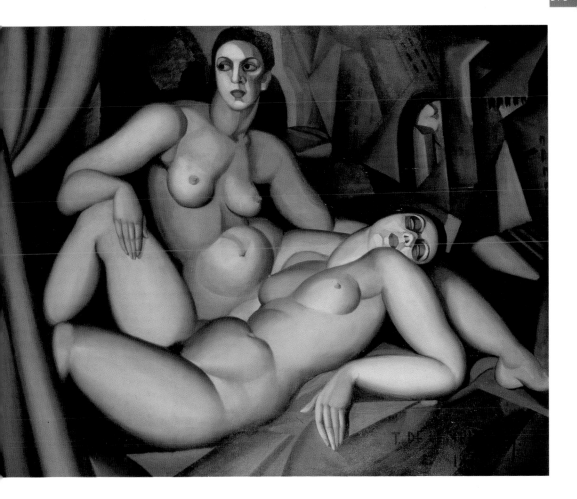

De Lempicka, Tamara
The Green Turban, 1930

One of the reasons that Tamara de Lempicka's work enjoys a status as the definitive style for Art Deco painting is that the artist was not a mere observer of life for the fast set: she lived it herself. She succeeded in immortalizing the atmosphere of decadence and wealth that is now associated with the 1920s.

De Lempicka was born into a prosperous Polish family in 1900 and married while still a teenager. With her Russian husband, de Lempicka fled to France to escape the Bolshevik revolution towards the end of the First World War. When her marriage collapsed, she enrolled at the Académie Ransom and studied art in the conviction that she could support her young daughter and herself through her talent. De Lempicka's style was to evoke the world of hedonism: seductive images capture the milieu for the wealthy elite. An astute businesswoman, de Lempicka charged high fees for her portraits, and in an era when celebrity was gaining a new status she created a public image for herself that often overwhelmed that of her subjects. She commissioned Robert Mallet-Stevens (1886–1945), a French architect and interior designer, to create an Art Deco apartment for her in Paris where she threw wild parties. By reproducing a lifestyle in paint, de Lempicka secured herself a historic place in the Art Deco world.

MOVEMENT

Art Deco

MEDIUM

Oil on canvas

SIMILAR WORKS

Adam and Eve by de Lempicka, c.1932

Tamara de Lempicka *Born* 1900 Warsaw, Poland

Died 1980

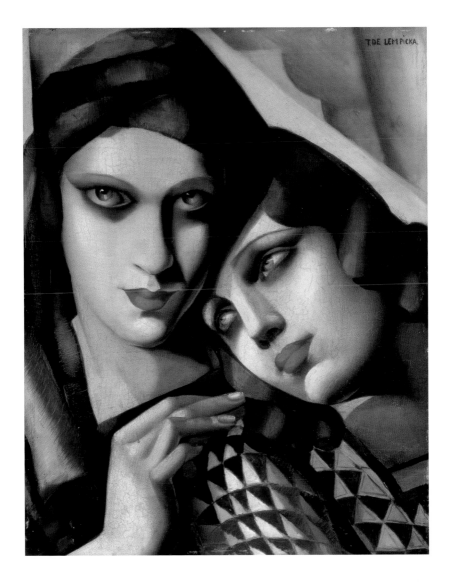

De Lempicka, Tamara
Portrait of Arlette Boucard, 1928

Courtesy of The Art Archive/Eileen Tweedy/© ADAGP, Paris and DACS, London 2005

The art of Tamara de Lempicka was popular in her day and she commanded very high prices for her work. Celebrities and the wealthy commissioned their portraits from de Lempicka despite this, as the enigmatic quality of her work captured the zeitgeist of the decorative age. Paintings by Tamara de Lempicka sat well amongst the fashionable interiors of her day.

The distinctive appearance of a de Lempicka portrait was encapsulated in the bright colours she chose. Every fold of material is exaggerated by the use of light and dark, suggesting movement and texture while remaining curiously static. Women were shown with the short bobs and carefully crimped hairstyles that were in vogue during the 1920s and 1930s. There is little that is carefree in her paintings: figures are draped sensuously against a severe background of angular buildings that suggest Modernism. These were typical paintings of the period and they evoke the prevailing taste. Paul Klee (1879–1940), Pablo Picasso (1881–1973) and Piet Mondrian (1872–1944) were contemporaries of de Lempicka, and her work, sometimes labelled soft-Cubism, demonstrates the prevalence of avant-garde art, even in the mainstream.

MOVEMENT

Art Deco

MEDIUM

Oil on canvas

SIMILAR WORKS

Portrait of Prince Eristoff: oil on canvas by de Lempicka, 1925

Tamara de Lempicka *Born* 1900 Warsaw, Poland

Died 1980

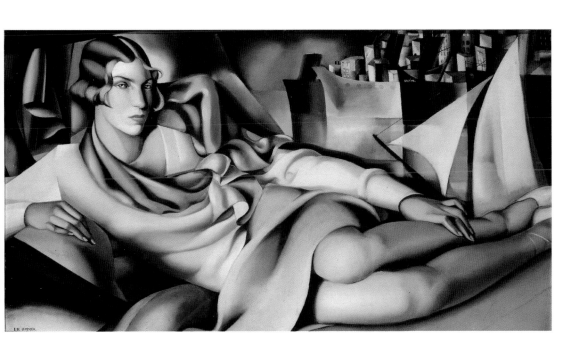

Author Biographies

Camilla de la Bedoyere (author)

Camilla de la Bedoyere is a graduate of Bristol University. She is an experienced researcher, writer and journalist who has a special interest in modern art and design, particularly the Art Deco era. She is a regular contributor to magazines and newspapers and has written numerous educational books for children and non-fiction titles for adults. She is also the author of *World's Greatest Art: Art Nouveau*. Camilla lives in London, where she combines writing and research with raising a family.

Alan Powers (Foreword)

Alan Powers is Reader in Architecture and Cultural History at the University of Greenwich. He specializes in the history of twentieth century art, architecture and design, and has written books on textiles, houses, shop fronts and book jacket design. He has had a long involvement with the Twentieth Century Society as a caseworker, Vice-Chairman and currently as one of the editors of its journal, *Twentieth Century Architecture*.

Picture Credits: Prelims and Introductory Matter

Further Reading

Adam, P., *Gray Eileen: a Biog*, Harry H Abrams, Inc, 1987

Arwas, V., *The Art of Glass: Art Nouveau to Art Deco*, Andreas Papadakis Ltd, 1997

Baker, G.H., *Le Corbusier: An Analysis of Form*, Spon Press, 1996

Bayer, P., *Art Deco Architecture: Design, Decoration and Detail from the 1920s and 1930s*, Thames and Hudson Ltd, 1999

Benton, T. and C., et al., *Art Deco 1910–1939*, V & A Publications, 2003

Blondel, A. and Brugger, I., *Tamara de Lempicka: Art Deco Icon*, Royal Academy of Arts, 2004

Breon, E., *Jacques-Emile Ruhlmann: The Designer's Archives, Furniture Bk. 1*, Flammarion, 2004

Brooker, P., *Bohemia in London: The Social Scene of Early Modernism*, Palgrave Macmillan, 2004

Brunhammer, Y., *The Jewels of Lalique*, Flammarion, 1999

Cooper, D. and Tinterow, G., *Essential Cubism, 1907–20: Braque, Picasso and their Friends*, Tate Gallery, 1983

Cranfield, I., *Art Deco House Style: An Architectural and Interior Design Source Book*, David & Charles, 2004

Cunningham, H. C., *Clarice Cliff and her Contemporaries: Susie Cooper, Keith Murphy, Charlotte Rhead and the Carlton Ware Designers*, Schiffer Publishing, 1999

Dufrene, M. (ed.), *Art Deco Interiors: From the 1925 Paris Exhibition*, Antique Collectors' Club, 2002

Duncan, A., *Art Deco Furniture: The French Designers*, Thames and Hudson Ltd, 1992

Frantz Kery, P., *Art Deco Graphics*, Thames and Hudson Ltd, 2002

Gardner, J., *Houses of the Art Deco Years*, Braiswick, 2004

Gaston, M., *Collector's Guide to Art Deco*, Collector Books, 1997

Greenidge, D. (ed.), *Josef Hoffman: Furniture, Design and Objects*, Delano Greenidge Editions, 2002

Griffin, L., *Clarice Cliff: The Art of Bizarre*, Pavilion Books Ltd, 2001

Hillier, B. and Escritt S., *Art Deco Style*, Phaidon Press, 2003

Kodicek, A. (ed.), *Diaghilev: Creator of the Ballets Russes*, Lund Humphries, 1996

Krekel-Aalberse, A., *Art Nouveau and Art Deco Silver*, Harry N. Abrams, Inc., 1989

Lussier, S., *Art Deco Fashion*, V & A Publications, 2003

Raulet, S., *Art Deco Jewelry*, Thames and Hudson Ltd, 2002

Samuels, C., *Art Deco Textiles*, V & A Publications, 2003

Schlansker Kolosek, L. and Bonney, T. (photographer), *The Invention of Chic: Therese Bonney and Paris Moderne*, Thames and Hudson Ltd, 2002

Spencer, C., *Leon Bakst and the Ballets Russes*, Wiley-Academy, 1995

Stravitz, D., *The Chrysler Building*, Princeton Architectural Press, 2002

Tinniswood, A., *The Art Deco House*, Mitchell Beazley, 2002

Warmus, W., *The Essential René Lalique*, Harry N Abrams, Inc., 2003

Wilhide, E., *The Mackintosh Style*, Pavilion Books Ltd, 1998

Wood, G., *Essential Art Deco*, V & A Publications, 2002

Index by Work

General Index